Life
Drawing
Class

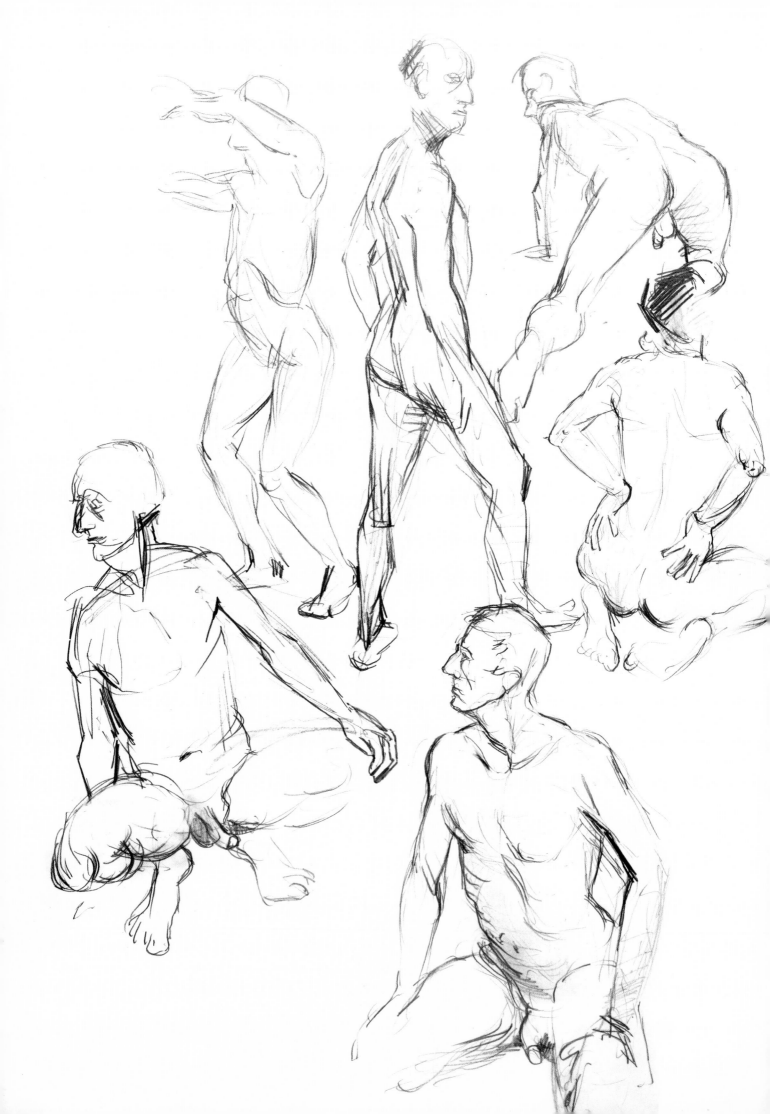

Life Drawing Class

Diana Constance

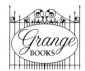

A QUANTUM BOOK

Published by Grange Books
An imprint of Grange Books plc
The Grange
Grange Yard
London SE1 3AG

Copyright ©1991 Quarto Publishing plc

This edition printed 2000

1-84013-080-6

QUMLDC

This book is produced by
Quantum Books Ltd
6 Blundell Street
London N7 9BH

Printed and bound in Singapore

Senior Editor: Hazel Harrison
Design: Nick Clark, Steven Randall

Photography: Paul Forrester, Ian Howes

Art Director: Moira Clinch
Assistant Art Director: Chloë Alexander
Publishing Director: Janet Slingsby

Typeset by Bookworm Typesetting, Manchester
Manufactured in Hong Kong by
Regent Publishing Services Ltd

Special thanks to David Carr and Camden School of Art, also
to Canonbury Art Shop and Falkiner Fine Papers.

1003480140

Contents

INTRODUCTION

Francesco Primaticchio
1504/5–1570
Venus and Cupid
Red chalk

Life drawing has always appealed to amateur artists, but for some time the discipline of drawing from the figure has been largely ignored in art schools. It is now taking centre stage again, however, and this volume has been planned to meet a need for a new kind of book that gives the student a clear picture of anatomy as well as exploring new approaches to drawing. The core of the book is a series of over 20 separate lessons incorporating advice on techniques and media. This is preceded by a section on anatomy, illustrated with photographs and drawings, and the final section provides some stimulating advice on picture-making, as opposed to simply drawing what is there. By using existing work as a basis for monoprints, linocuts and collages the student can move into the realm of true artistic expression, creating works that will be worth preserving, framing and perhaps even exhibiting.

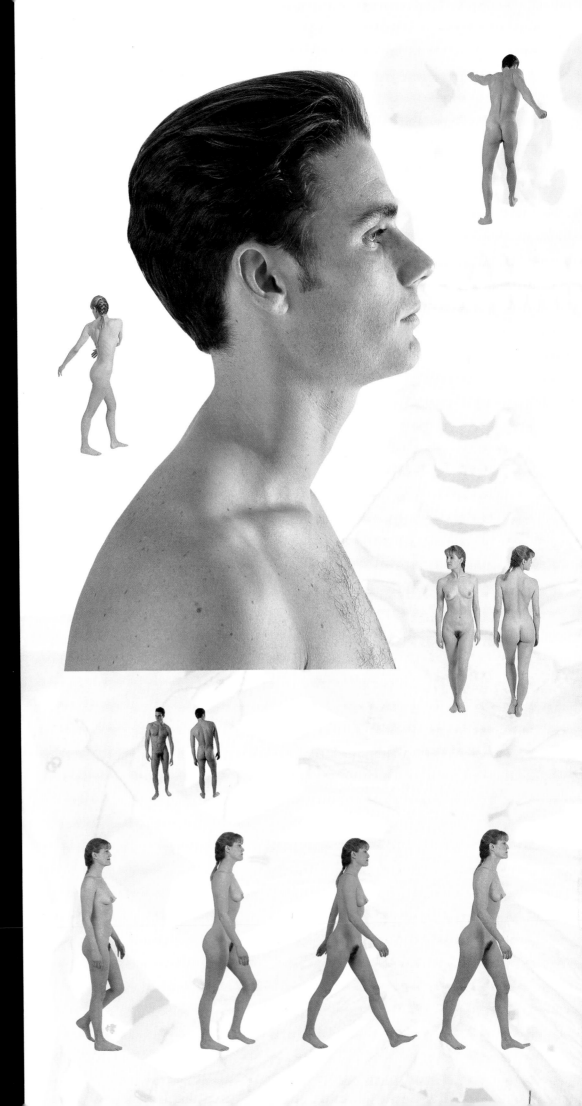

THE HUMAN BODY

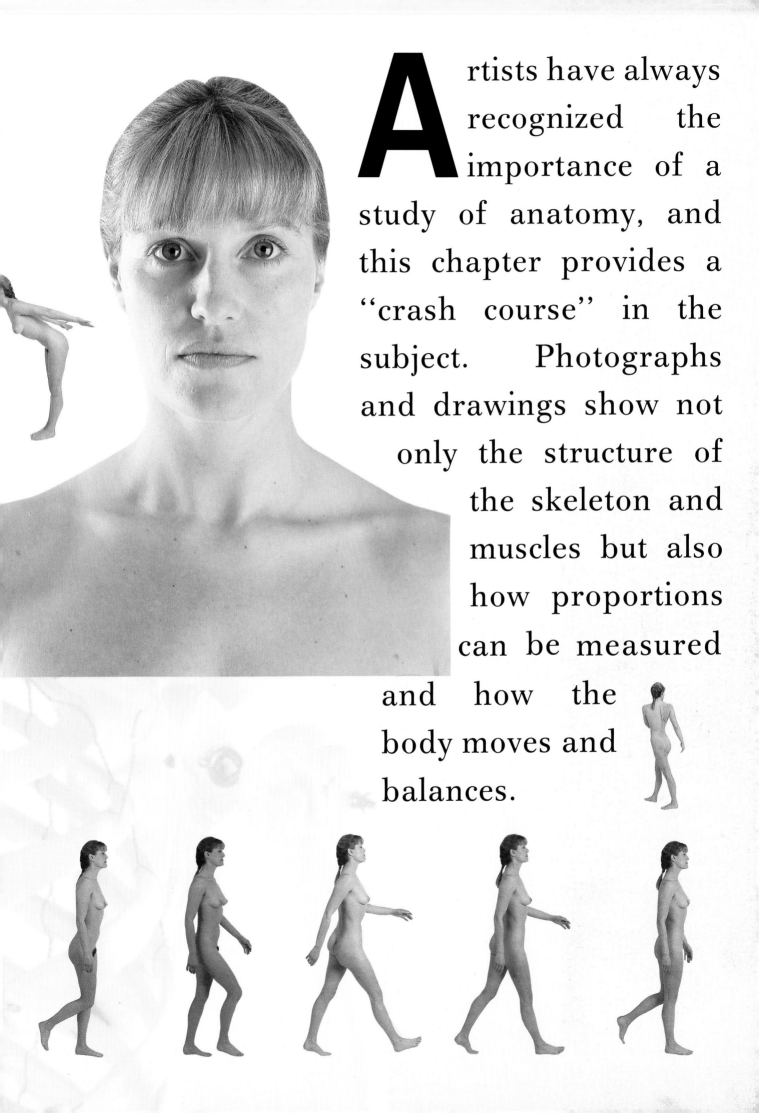

Artists have always recognized the importance of a study of anatomy, and this chapter provides a "crash course" in the subject. Photographs and drawings show not only the structure of the skeleton and muscles but also how proportions can be measured and how the body moves and balances.

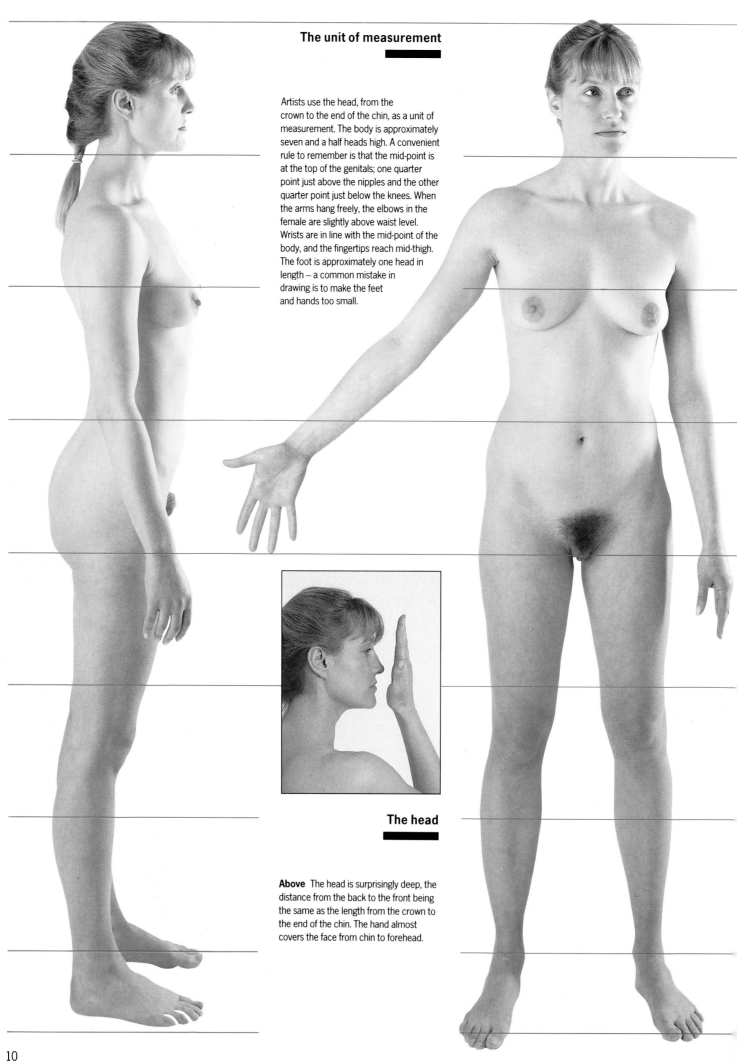

The unit of measurement

Artists use the head, from the crown to the end of the chin, as a unit of measurement. The body is approximately seven and a half heads high. A convenient rule to remember is that the mid-point is at the top of the genitals; one quarter point just above the nipples and the other quarter point just below the knees. When the arms hang freely, the elbows in the female are slightly above waist level. Wrists are in line with the mid-point of the body, and the fingertips reach mid-thigh. The foot is approximately one head in length – a common mistake in drawing is to make the feet and hands too small.

The head

Above The head is surprisingly deep, the distance from the back to the front being the same as the length from the crown to the end of the chin. The hand almost covers the face from chin to forehead.

The back

Left When a figure is seen from behind there are three head lengths from the beginning of the spine (at the base of the skull) to the end of the spine.

Proportion

The ideal or standardized proportions of the human body are one thing, and reality quite another. Almost no one looks exactly like the "standard model" – ask any industrial designer who has to cope with a wide range of limbs and torsos when planning furniture or cars. Michelangelo threw out the rules completely; some of his figures tower to twelve heads high, as do El Greco's, producing in both cases superb evocations of power and soaring spirit. In contrast, the German Expressionist artist Max Beckmann frequently compressed and distorted proportions to express the anxiety and claustrophobia he felt in contemporary society.

The novice, however must make a beginning with the standard proportions, as shown here, while observing the natural variations and the right of artistic expression.

The face

Above The bottom of the eye sockets is the mid-point on the face, the ears lining up with the brow and the end of the nose. Many artists prefer to divide the face into three equal parts for measuring; crown to brow; brow to end of nose, and end of nose to chin. There is approximately one eye's width between the eyes. Portrait painters always measure the triangle made by the eyes and the end of the nose, as this gives a very accurate picture of the shape of an individual's face.

Measuring

When you are drawing an actual model, who will probably vary considerably from the "ideal" bodies shown here, it is useful to take measurements to work out individual proportions. Triangles such as these are one device used by artists. That from the shoulders down to the pubic area establishes the width relationship of shoulders to trunk, while that from the hips to the base of the neck gives you the proportion of hips to trunk.

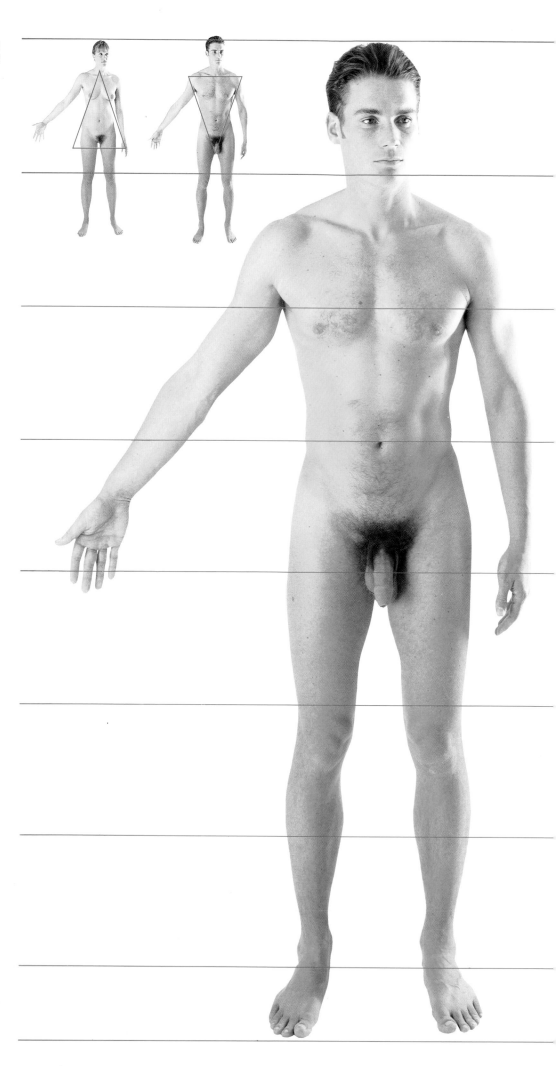

Male proportions

The main characteristics of the male are a larger, heavier skeleton and greater muscular development. The trunk is shorter than the female's, and the shoulders wider than the hips and more squared; a female's shoulders tend to drop slightly. The fibia, the bone of the upper arm, is a little longer in the male, so that the elbows are at waist level when the arms hang freely. The man's legs are proportionately longer than the woman's, and the hands and feet proportionately larger.

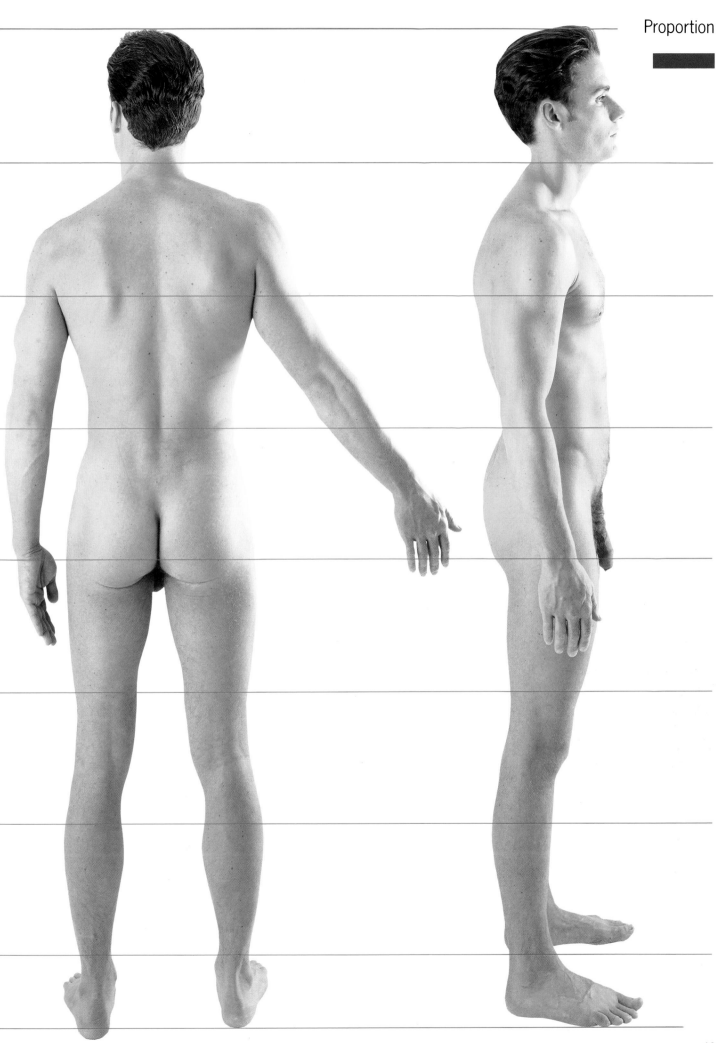

Frontal bone, the dome of the forehead.

The zygomatic arch, the cheekbone .

Mandible, lower jaw.

Cervical vertebrae.

Clavicle, the collarbone, connected by ligaments to both breastbone and shoulderblade.

Greater tubercle, a bony projection on the humerus to which muscles attach.

Sternum, breastbone.

Ribs.

Humerus, the upper arm bone.

Radius, the lateral bone of the forearm.

Ulna, gives power to the elbow.

The pelvis, composed of three bones that fuse together after puberty.

The eight carpal bones of the wrist.

Metacarpals, separate bones of the hand that slide over one another.

Phalanges, the bones of the fingers.

Femur, longest bone in the body.

Patella, the knee-cap.

Fibula, to which many muscles and ligaments attach.

Tibia, the shinbone.

Talus.

The seven tarsal bones that articulate the foot.

Metatarsals, separate bones lining the foot.

Phalanges, the toe bones.

14

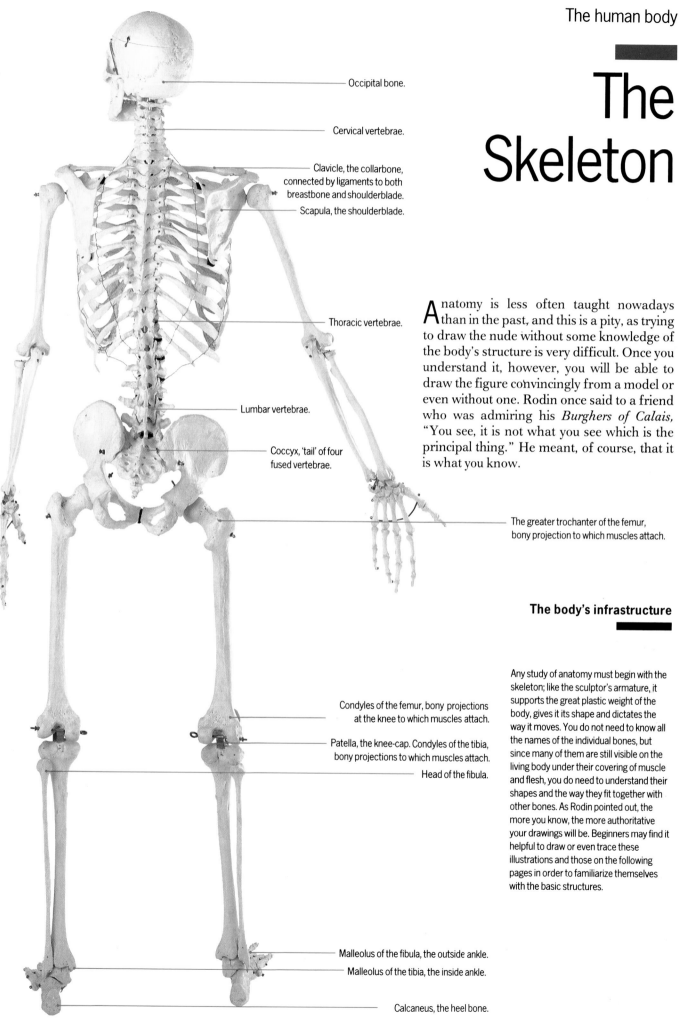

The Skeleton

Occipital bone.

Cervical vertebrae.

Clavicle, the collarbone, connected by ligaments to both breastbone and shoulderblade.

Scapula, the shoulderblade.

Thoracic vertebrae.

Lumbar vertebrae.

Coccyx, 'tail' of four fused vertebrae.

The greater trochanter of the femur, bony projection to which muscles attach.

Condyles of the femur, bony projections at the knee to which muscles attach.

Patella, the knee-cap. Condyles of the tibia, bony projections to which muscles attach.

Head of the fibula.

Malleolus of the fibula, the outside ankle.

Malleolus of the tibia, the inside ankle.

Calcaneus, the heel bone.

Anatomy is less often taught nowadays than in the past, and this is a pity, as trying to draw the nude without some knowledge of the body's structure is very difficult. Once you understand it, however, you will be able to draw the figure convincingly from a model or even without one. Rodin once said to a friend who was admiring his *Burghers of Calais,* "You see, it is not what you see which is the principal thing." He meant, of course, that it is what you know.

The body's infrastructure

Any study of anatomy must begin with the skeleton; like the sculptor's armature, it supports the great plastic weight of the body, gives it its shape and dictates the way it moves. You do not need to know all the names of the individual bones, but since many of them are still visible on the living body under their covering of muscle and flesh, you do need to understand their shapes and the way they fit together with other bones. As Rodin pointed out, the more you know, the more authoritative your drawings will be. Beginners may find it helpful to draw or even trace these illustrations and those on the following pages in order to familiarize themselves with the basic structures.

The skull

This is widely used as the unit of measurement for the body. It is composed of twenty-two plate-like bones – eight of which make up the cranium which protects the brain – and fourteen facial bones which protect our sense organs. All of these bones are connected by suture joints except for the lower jaw, the mandibular. The jaw seen from below is a wide horseshoe shape. The upper and lower dental arches are narrower but in roughly the same alignment. If this curvature of the mouth bulge is lost in a drawing the mouth will not be properly integrated into the curved surface of the face. It is also important to remember that the jaw is one of the most mobile parts of the body; a slack jaw or gritted teeth change the expression profoundly. The jaw also moves sideways; this can be observed when someone sits with head resting on hand. This sidewards drift in the jaw is frequently forgotten, which can result in a stiff expression. Understanding the complete mobility of the jaw is essential if at a later time you want to recreate a face expressing strong emotion. The eyes also contribute dramatically to facial expression, and are another common cause of failure. The eyeball itself is almost completely spherical. Although the iris protrudes only slightly, it can be seen to affect the curve of the eyelid, which follows closely the form of the eyeball. The depth at which the eyes are set into the eye socket varies enormously from person to person, and must be closely observed if you want to catch a likeness.

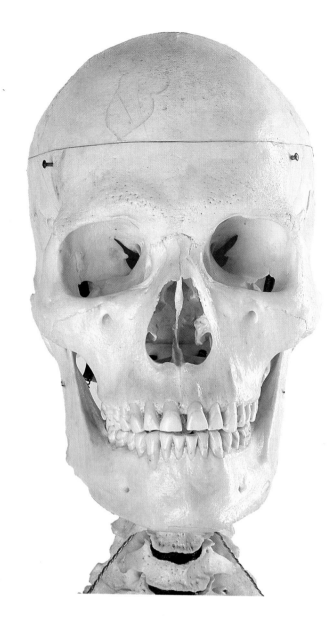

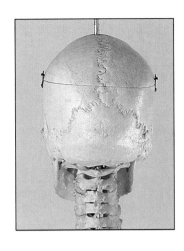

The back of the skull

If you look at the skull from above, it is roughly oval-shaped, but viewed from behind it is almost spherical. When drawing, it is important to remember that the planes of the skull taper slightly from the back of the cranium at its widest point to the frontal bones. This indeed is how the bones grow in the womb, forming the round brain case and moving forward to the face.

The head and neck

The spine is connected to the head by the atlas vertebra, at the top of the cervical vertebrae, and so called because it holds the "globe" of the head. This allows the head to move both from side to side and backwards and forwards. In profile, the line of the back of the neck is formed by the curvature of the cervical vertebrae. This line is roughly parallel to the front of the neck due to the shape of the larynx. Looking at the neck from the front you see the two sterno-cleido-mastoid muscles, which run from behind and under the ear to the collarbones, wrapping around the axis of the neck. The back of the skull varies considerably from person to person (babies who are put on their backs will grow up with less rounded skulls than those laid on their sides). I find it very useful to ask my class to place their fingers at the base of their skulls where the spine joins. If you follow around you find that the earholes, the jaw hinge, the cheekbones and the bottom of the nose are all roughly on the same level. Moving up around the eye sockets, you can feel the two slight depressions – the temporal fosso – on either side of the temples, and the roundness of the forehead – the frontal eminence. It is this roundness or axis of the head which is so vital to remember when placing the features.

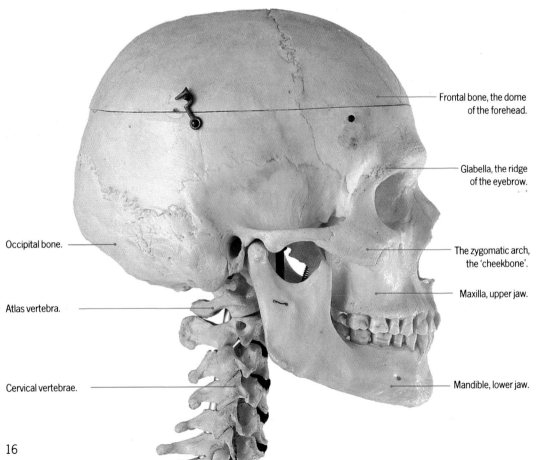

Frontal bone, the dome of the forehead.

Glabella, the ridge of the eyebrow.

Occipital bone.

The zygomatic arch, the 'cheekbone'.

Maxilla, upper jaw.

Atlas vertebra.

Cervical vertebrae.

Mandible, lower jaw.

The rib cage

This is a slightly flattened egg shape with the narrow part at the top. Because much of it is covered by the shoulder girdle its size is often underestimated, but in fact it is quite large – half again as big as the head. It is important to understand its angle or thrust, which is downwards and outward, not straight up and down. The sternum, or breastbone, at the front of the ribcage, runs parallel to the lower curve of the spine. The male ribcage is more barrel-shaped than the female, which is shorter and more conical. The weight of the upper part of the body continues on its way down the spine to the triangular-shaped sacrum, which is fixed between the hipbones in the back pelvis (see pages 14-15).

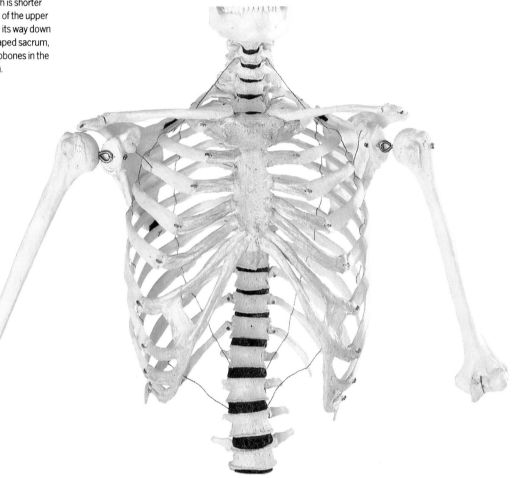

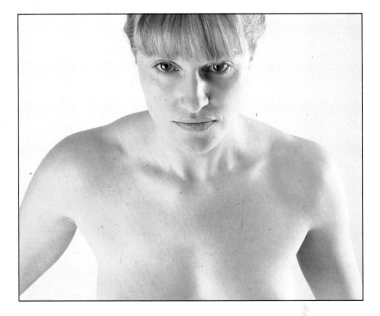

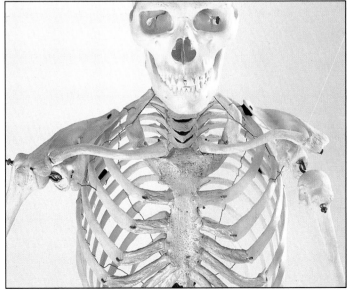

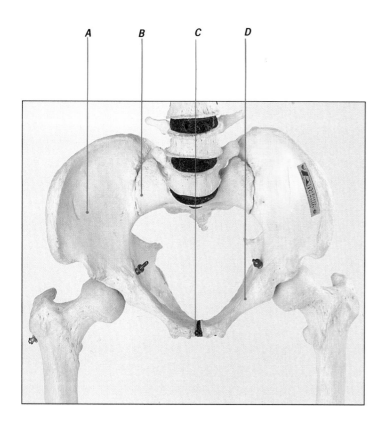

A B C D

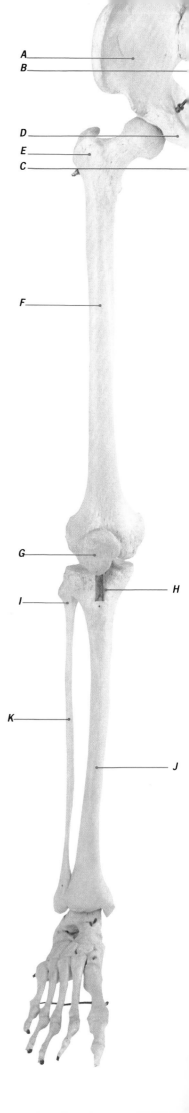

A
B

D
E
C

F

G

H

I

K

J

Like the arm, the leg has three major bones, excluding those of the knee. The thighbone, or femur, is the longest bone in the body – more than two heads or 45.7cm (18 inches). The top consists of two projections, one being the ball, which sets at an angle into the hip socket, and the other the great trochanter, the name of the hipbone. This is in fact the beginning of the main straight shaft of the bone, which slants inwards from pelvis to knee.

E Great trochanter, hipbone.

F Femur, thighbone.

G Patella, the knee-cap.

H Condyles of the tibia, bony projections to which muscles attach.

I Head of the fibula.

J Tibia, the shin-bone.

K Fibula, to which many muscles and ligaments attach.

The shinbone

This bone, the tibia, has a massive head, and carries the weight down to the foot, with the inside edge extending downwards to form the prominence of the inner ankle. This is half of the joint that holds the foot firmly, allowing it to swing back and forth but not sideways. The second bone of the lower leg is the fibula, which means spike. It runs just under the outside edge of the larger tibia to form the outside part of the ankle joint.

The knee

This is the largest joint in the body, with a complicated structure which makes it difficult to draw well. The kneecap itself is a rather flat inverted triangle. It does not float in the joint, but is contained within a massive ligament called the patellar, which connects it to the thigh muscles.

The pelvis

This bone is shaped rather like a high-backed saddle, and is equal in height to the head, approximately 21.6 cm (8½ inches). The male pelvis is carried more vertically than the female, which is broader and projects forward slightly to carry the weight of the foetus. The ball and socket hip joints at each end of the pelvis are the most critical in the body, both for our own locomotion and for the artist's understanding of movement and balance. The slightest shift of weight through these joints changes the way the torso, neck and

head are carried. The compensatory movement can easily be seen in the shoulder girdle. Try shifting your weight from one leg to the other without moving the line of your shoulders – it is very awkward.

A Ilium, the hip bone, one of three elements that fuse together after puberty.

B The sacrum, bone of five fused vertebrae.

C Pubis, becomes fixed to the ilium.

D Ischium, becomes fixed to the pubis.

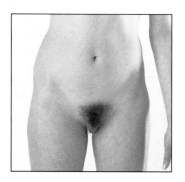

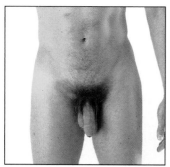

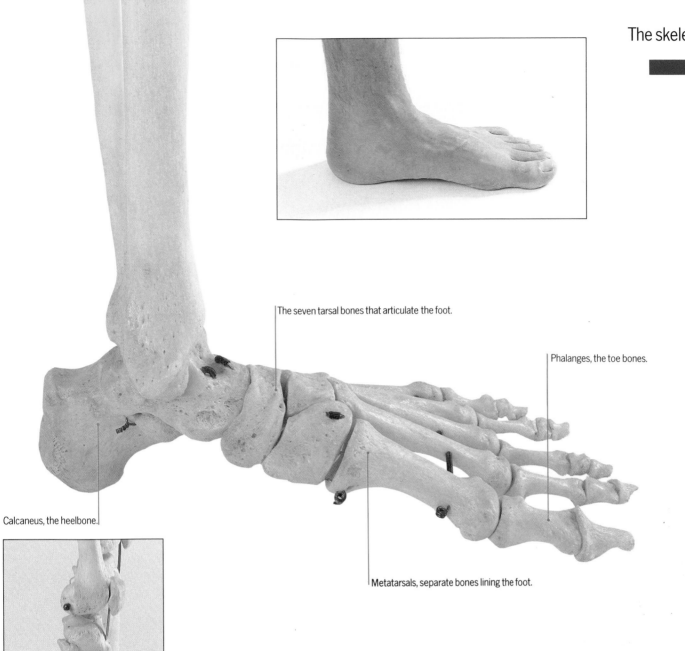

The seven tarsal bones that articulate the foot.

Phalanges, the toe bones.

Calcaneus, the heelbone.

Metatarsals, separate bones lining the foot.

Movement of the knee

When the leg is flexed the tendon pulls the kneecap downwards to shield the joint, and when the leg is straightened it is pulled upwards, causing the pad of fat behind the cap to be squeezed outwards around the top and sides of the knee. It is this that is responsible for the familiar dimpled-looking fold of flesh in the standing nude.

The ankle and foot

The ankle is a swing joint formed by the lower ends of the two leg bones meeting the tarsals of the foot, which allows rotation of the foot. The bones of the ankle and foot resemble those of the wrists and hands (see following pages). The big toe, like the thumb, has two bones and the others three, while the big toe lies flat and the others curve downwards. This complex of nineteen bones can be simplified by observing the structure of the foot. The arch is only seen on the inside of the foot, while the outside lies flat. The toes form a rounded, wedge formation with the big toe at the longest point (a generalization, as some people have a longer middle toe). The heelbone, heavy and rounded, projects out from the back so that the line coming down the calf through the Achilles tendon is rounded and bulges out slightly; it does not form a straight right-angle to the flat of the foot.

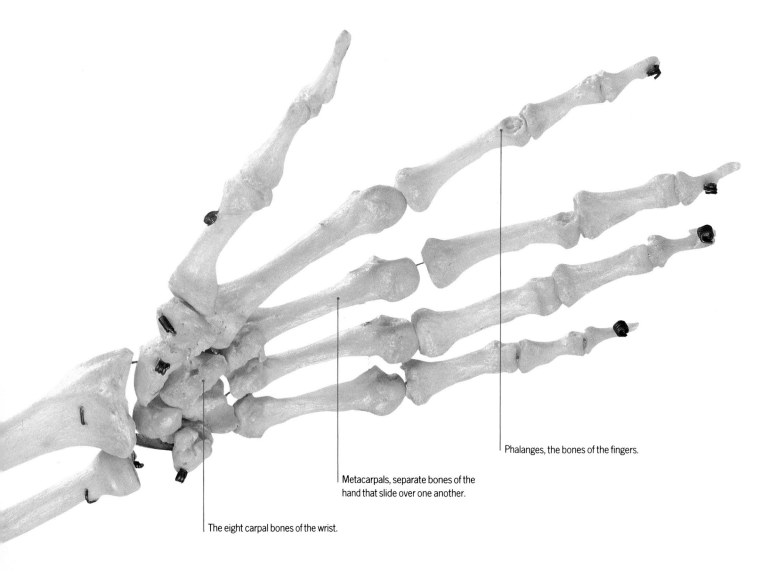

Phalanges, the bones of the fingers.

Metacarpals, separate bones of the hand that slide over one another.

The eight carpal bones of the wrist.

The hand and wrist

There are five metacarpal bones in the hand, starting at the wrist, fanning out across the back of the hand, and continuing to form the fingers and thumb. Counting from the wrist, the metacarpal bones of the fingers have four sections, while the thumb has three. The wrist consists of eight carpal bones, small and irregularly shaped, which give the wrist great flexibility and a graceful curve from arm to hand. By putting your fingers on your wrist and moving the fingers of that hand up and down you should be able to feel where the carpal bones meet the metacarpal, or finger bones. This will also give you a better appreciation of the depth of the wrist. I have found that the best method of understanding the hand is to make a map. Lay your hand flat on a sheet of paper and carefully trace around the edges, making little marks as you pass the knuckles and joints. When you have finished, connect the marks so that they show the alignment of the knuckles and joints. You will find that the body of the hand from the wrist to the knuckles is not square; the distance from the wrist to the

knuckle of the index finger is a quarter greater than that of the wrist to the knuckle of the little finger. The first and second joints of the fingers are not straight across but form arches, the highest points being reached at the middle finger. The thumb knuckle is on a line approximately half-way up the hand, the thumb tip never reaching more than the first joint of the index finger. With the hand flat and the thumb stretched out, you can draw a line from the end of the wrist straight up to, and stopping at, the knuckle of the index finger. Using this line as a base, you will find that the thumb knuckle forms the apex of a triangle whose two sides are equal. This will remain so as the thumb is moved around to a right-angle to the body of the hand. The best way to learn to draw hands is to copy your own and keep making measurements.

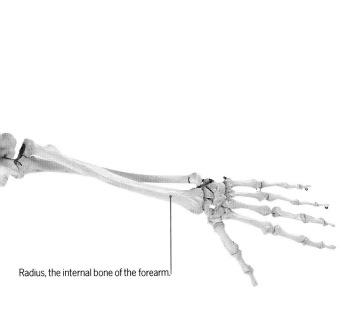

Radius, the internal bone of the forearm.

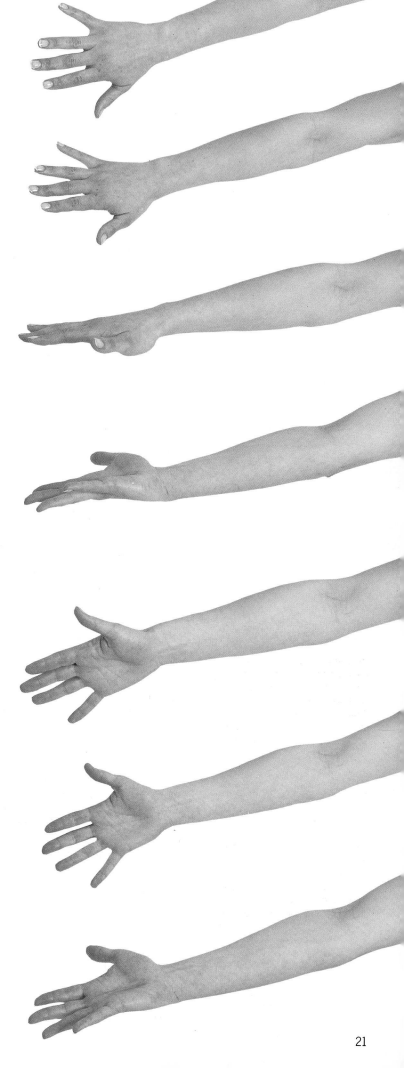

The arm

There are three bones in the arm: the humerus – the bone of the upper arm, which is about one-and-a-half heads in length and quite heavy – and the two bones of the lower arm, the radius and the ulna. The latter two are often misunderstood, resulting in unsuccessful drawings. They are both shorter and thinner than the humerus, and being reverse curves, are in a sense mirror images of each other. The ulna is thickest at the top, where it forms the elbow. It curves down, passing close to its sister bone, the radius, and ends just above the wrist, near the little finger. The radius, which takes its name from the round button head which fits into the notch (the pivot point) at the top of the humerus, allows the slender bone to revolve and cross over the stationary ulna. The radius enlarges as it descends, and arches away from the lower part of the ulna to form the wide, flat, hollow ellipsoid joint,

accommodating the bones on the thumb side of the wrists. To understand the workings of this complicated structure I suggest using your own forearm. Lay it on a table palm upwards, then slowly rotate your hand so that the palm lies flat on the table. You will then have seen the radius crossing over the ulna. It is also useful to look at your arm in a mirror, resting it on the elbow. Slowly turn the forearm from the back of the hand to the palm, and you will be able to see the muscles making a long spiral twist diagonally around the stationary ulna as they move with the radius. It will help the learning process if you make sketches of this action, either with a mirror or a friend posing, as it takes time to study it thoroughly.

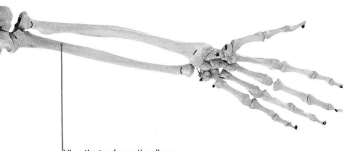

Ulna, the top forms the elbow.

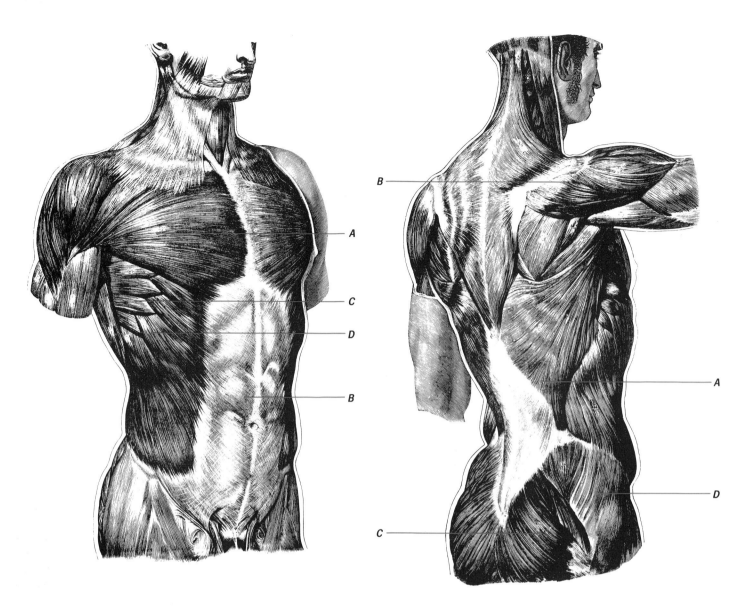

The abdomen

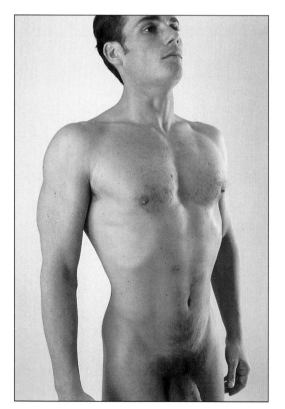

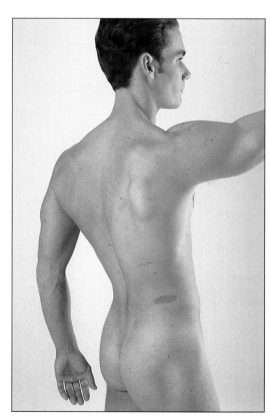

Left and above left The crease that runs down the front of the body is very clear in the photograph. It starts where the pectorals, or chest muscles **A** are anchored to the sternum, or breastbone, and is continued downward by the tendious band that runs between the two long abdominal muscles, the Rectus abdominis **D**. Directly under the Pectoral is the Serratus magnus **C**, which forms a zigzag furrow as it weaves between a muscle called the external oblique **D**, where both connect to the ribs. The Serratus magnus runs downward and backward along the rib cage, controlling the movement of the shoulders, while the external oblique runs downward, the fleshy edge creating the slight fold running from the back and over the top of the hips.

Muscles

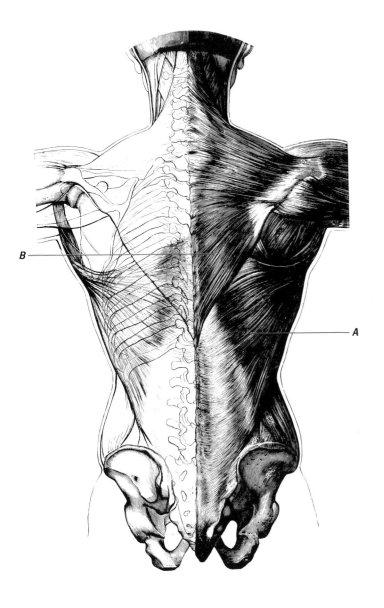

From the 15th century until the earlier decades of our own, the traditional method of studying the muscle structure of the body was drawing from plaster casts. This method is now out of favour in art schools, but I still think it has considerable value, as it gives the student time to analyze the forms in a way that is seldom possible with a living model. However, there is a danger here: it must be realized that a plaster cast has little to do with the reality of individual bodies, which not only are constantly changing, but are also far from solid – we are composed of about 73 percent water.

Approximately one half of that watery mass is muscle. There are 200 muscles on each side of our bodies. Some of these are for movement, but they are also necessary for us simply to stand still – in a sense they hold our bodies together. If a person faints, the voluntary muscles, which are the ones that control movement, cease contractions and relax. The body not only falls; it also loses its familiar shape, with the limbs taking on a haphazard, incoherent posture. Even when a model takes up a seemingly relaxed pose, this relaxation

The trunk

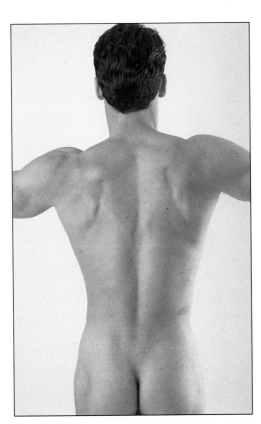

Left and top left A large sheet of muscle called the Latissimus dorsi **A**, which wraps around the side of the trunk and is connected to the lower vertebrae, is the main factor in turning the body. The head is kept upright by the Trapezius muscle **B**, which contracts to pull the shoulders back, making its diamond shape visible. The area directly between the shoulders, where the muscles join the vertebrae with thick, fan-shaped tendons, remains flat. These effects can be seen in the photograph, as can the depression caused by the convergence of the two main muscles of the posterior, the Gluteus maximus **C** and the Gluteus medius **D**.

The back

Left and top Like the abdomen, the back has two powerful long muscles that run down its entire length on either side of the spine, forming a crease where they tuck into the spine. There are different layers of muscles, and these are overlaid by the Latissimus dorsi **A** at the bottom and the Trapezius **B** at the top.

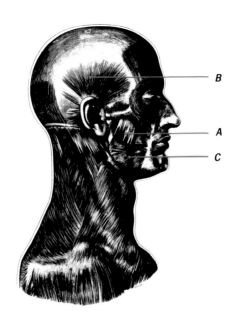

The face and head

Above Unlike other muscles, those that control facial expression are connected into the skin, and can thus be moved independently of the underlying structures. The main muscle that moves the jaw, the masseter **A**, runs from the cheekbone to the lower jaw, while the temporal muscle **B**, which fills the hollow on the side of the skull, also acts to raise the jaw. The eyes and mouth are ringed with muscles which allow them to open and close, while the buccinator **C** stretches the cheeks. This is overlaid with a pad of fat which gives the cheeks their shape.

is to some extent a sham. After about twenty minutes the muscles, which have been in the unnatural state of sustained contraction, pulling against each other to counterbalance and hold the pose, begin to ache.

It is important in a drawing to be able to differentiate between the tensed muscles and those that are relaxed. The length of a muscle can change up to 10 per cent when it flexes. In the classic graceful pose which the French call the *dehanchement,* where the model stands with the weight on one foot, the swing of the hip and the tensed muscles on the weight-carrying side of the body contrasts with the long, flowing line of soft curves coming down through the hip and leg on the opposite side. In a good drawing this flow of movement from tension to relaxation – or extended muscles – is clearly apparent.

The muscles of the body are far too numerous and complex to attempt a complete analysis here, but some helpful general observations can be made. The outer muscles, which are the ones that concern artists, can be grouped into main categories. One is the fusiform (from *fucus,* the Latin for spindle), which is clearly seen in the biceps of the upper arm and in the calf of the leg. This

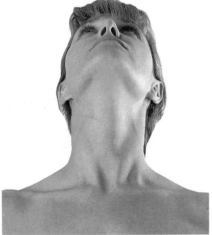

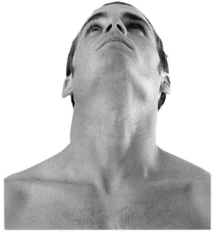

Left The most obvious difference between the male and female neck, besides that of size, is the fact that the Adam's apple can be seen in the man and the thyroid gland in the woman. The two sterno-mastoid muscles that help us to turn our heads come from behind the ear and cross over the side of the neck, with one connecting to the breastbone and the other to the clavicle, or collarbone. This division can be seen in the photograph of the woman.

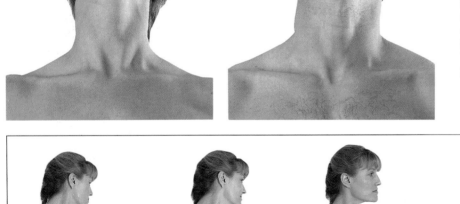

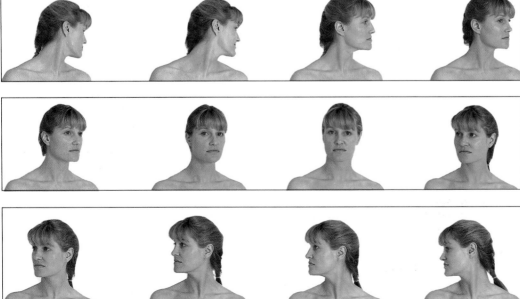

Left This series of photographs shows the action of the sterno-mastoid. In the profile, it stretches down in a straight line from the back of the ear to the pit of the neck. The thyroid gland and the "voice box" come out between these two muscles to curve gracefully into the lower jaw.

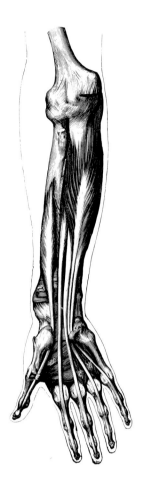

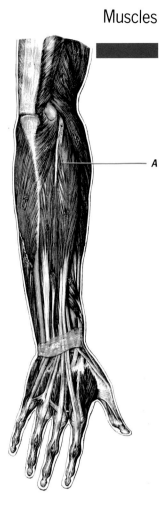

A

The arm and hand

Left and above The muscles of the forearm taper, being thick and fleshy above, and ending in long tendons at the wrist. The inner shape of the forearm is flat, but this changes as the arm is rotated, when the outside surface comes round and twists over the inner one as the two bones of the forearm cross over one another.

Right and above The muscles of the outer side of the arm are connected higher up than those on the inner side, but like the latter, they end in long tendons at the wrist. The two sides of the arm have quite different profiles, due mainly to a muscle called the Supinator longus **A** which crosses over from the back on the outside as a thick, fleshy muscle tapering to a tendon joining to the wrist in front.

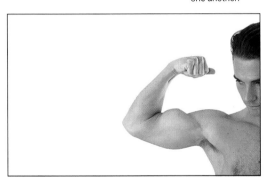

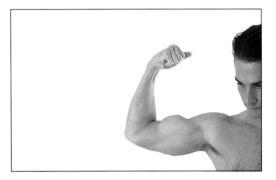

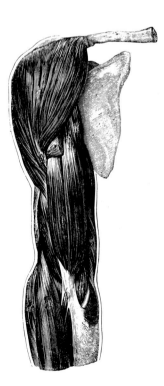

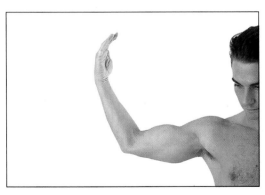

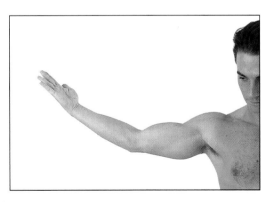

Above and above right The form of the upper arm, with its great lifting capacity, is similar to a hoist. The deltoid muscles that form the shoulder cap raise and lower the arm from the sides. Three large muscles called the triceps occupy the entire back of the lower arm, and they pull the lower arm straight or down. The

two muscles at the front, the biceps, pull the lower arm up. In the photographs you can see how the biceps swell as they pull up the arm, while the triceps under the arm stretch. As the arm is lowered, the biceps relax and the triceps in their turn contract and swell.

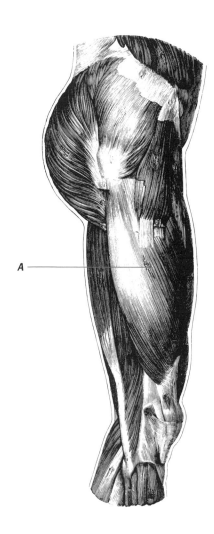

A

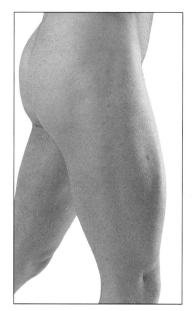

The thigh

Left and above In the drawing we can see the large thigh muscle, the outer Vastus **A**. This is overlaid by a tight-fitting "stocking" of connective tissues, thickest on the outside of the thigh. This, called the Iliotibial band, runs down the outside of the leg to the outer side of the knee. Its effect, flattening the side of the thigh, can be seen in the photograph.

thick elastic spindle acts as a lever, with the tendons on the two ends firmly anchored in the bone. This is a common form of long muscle found throughout the body.

Wherever greater strength is needed the length of the muscle is shorter, with several joined together along a long shaft of tendon. Muscles like this are called penniforms or bipenniforms because of their resemblance to one or two-sided feathers. These very versatile flat shapes can be seen on the back, where they wrap smoothly around it, and are firmly anchored into the spinal vertebrae on both sides. They are also laced across the abdomen, and as the Pectoralis major, form the chest muscles, attached to the breastbone.

These different types of muscles produce either the rounded surfaces or the flatter planes of the body. The illustrations provide more detail about these complicated forms. For those who do not have access to three dimensional plaster casts to work from, I would suggest copying these anatomical drawings in some detail; the drawings can be enlarged by photocopier for greater clarity.

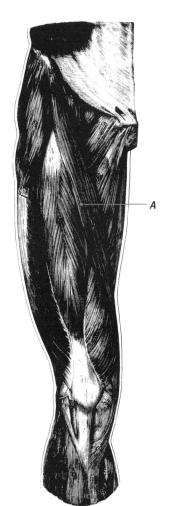

A

Left and above The line of the curve made by the outer Vastus is also followed by a strap-like muscle called the Sartorius **A** which runs diagonally downwards from the hip, crosses over the front of the thigh and joins the inside of the knee. The result is the graceful inward twist which can be seen in the photograph.

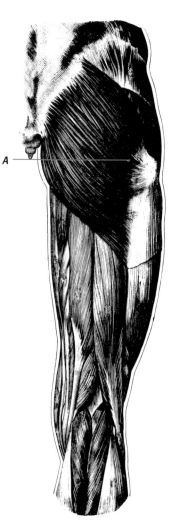

A

Left and above The Gluteus maximus **A** runs diagonally across and downwards from the back, joining the flat Iliotibial band on the side of the thigh. This, together with the accumulation of fat over the muscle, give the buttock its form and cause the familiar fold below, but the fat also confuses the form, making it appear more horizontal.

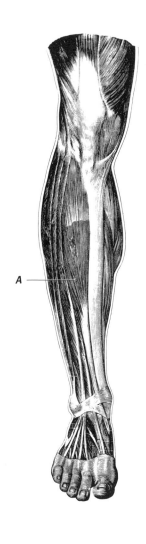

A

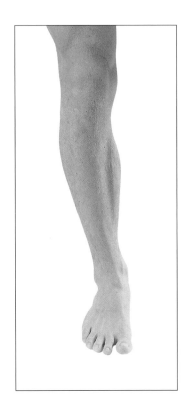

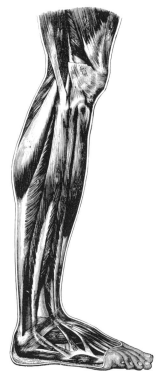

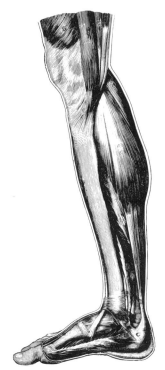

Left and above The graceful curve of the tibia (shinbone) dominates the front of the lower leg. The Tibia anticus muscle **A**, a spindle shape, crosses the bone and tapers into a long tendon that joins the inner side of the first metatarsal.

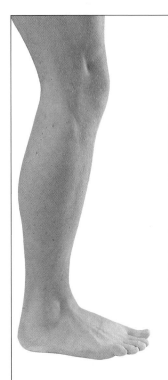

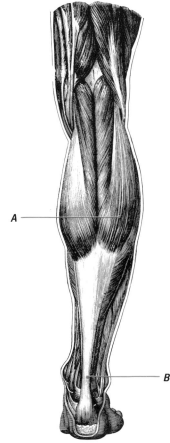

A

B

Left It is important to remember when drawing that although the body is symmetrical the side profiles of the limbs are not, and the curve on the outer side of the calf is considerably higher than that on the inner. The Gastrocnemius or calf muscles **A** are attached to the strongest tendon in the body, the Achilles tendon **B**, connecting it to the heel. The photograph shows the Gastrocnemius muscle contracting to pull the leg back.

Top and above The drawings clearly show the difference between the inner and outer profiles of the foot. The main muscles, with their tendons controlling the movements of the foot and toes, run down the outside of the lower leg. The photograph shows them being tensed and contracted as the body moves forwards.

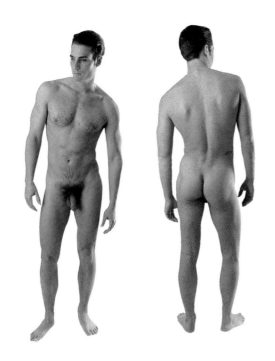

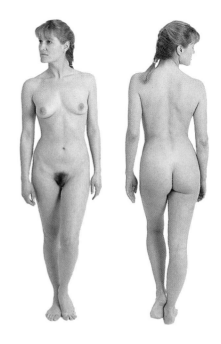

Balance and counterbalance

Left The photographs on these two pages show how the body maintains its equilibrium whatever the pose. What artists refer to as the balance line is taken from specific points known as balance points, the pit of the neck (or the mid-point at the root of the neck for a back view) being the main one. For a side view the balance point is the ear. A plumbline dropped from one of these points would fall somewhere between the feet or on one foot. If the model has all the weight on one foot the line will be through the arch, but if he or she is distributing the weight evenly between both feet it will be midway between them.

Right If the weight is on one leg the hip joint above that leg is pushed up, while the shoulder over the weight-bearing leg drops down slightly. The neck and head bend in opposition to the shoulders, and the body swings at the waist so that the weight of chest, head and neck can fall over the leg. This action, called "Contraposto" (literally "counterposing") is particularly evident in a back view, where you can see a curve coming down the spine and through the hip and then reversing to form a graceful S curve as it travels down to the weight-bearing foot.

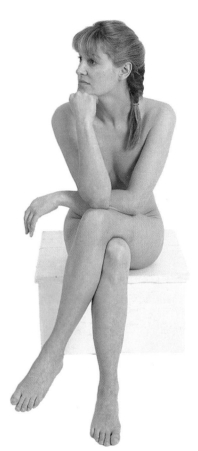

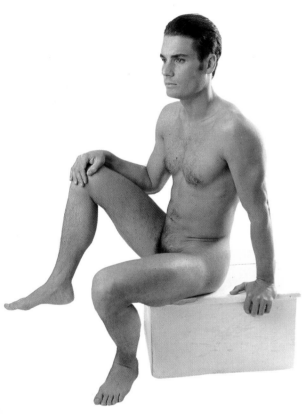

Below A seated figure presents a slightly different problem, because if the model is leaning back or forwards the weight may be partly on the feet or arms. The main weight, however, is supported by the buttocks, so the balance line will fall somewhere between this area and mid-thigh.

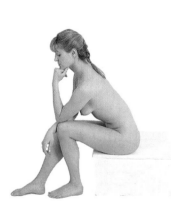

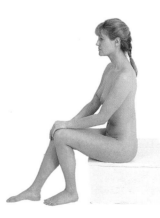

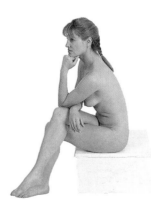

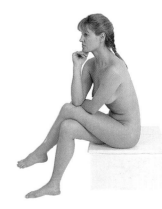

Balance

Opposing movements

In a really good drawing the artist makes us aware of the physical weight of the body. Rembrandt's figures, firmly rooted, can almost be seen to both yield to and strain against a gravitational force, whereas Tiepolo's and Boucher's seem ready to take flight. Both effects are achieved by a deep knowledge of balance and counterbalance.

No matter how well-drawn a figure may be the whole effect is spoiled if it appears to be tilting and about to fall over. Thus, the first step in life drawing involves finding the balance line (see Lesson 2) and understanding how the body compensates, counterposing one movement against another to keep its equilibrium.

Above When you remember that the body is seven and a half heads high and the feet only about one head in length it becomes obvious that the body must make adjustments to remain in balance – in fact it is most unstable when rigidly upright. In order to remain in balance one movement is opposed to another, something you will notice when sketching.

Left and right If the model takes a pose bending as far forwards or backwards as possible, the balance line will still fall somewhere between the radius of the feet. The body will counterpose the movement by bending in the middle, with the pelvis and hips moving backwards against a forward thrust and vice versa. A sideways bend requires less obvious counter-posing, as the shift of the top half of the body is compensated for mainly by the tensing of the muscles on the weight-bearing leg.

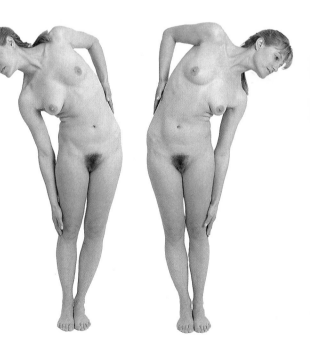

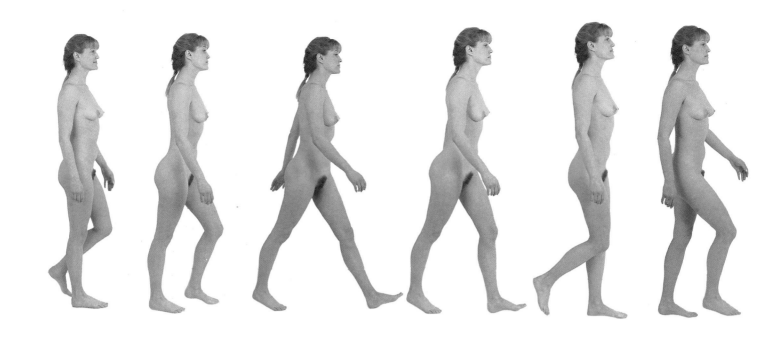

The mechanics of movement

Movement is achieved by the deliberate displacement of balance or the line of gravity of the body. The previous pages explained that the main balance point is at the pit of the neck. As we walk, this is thrust forward, which causes the body to actually fall for a split second. We then bring a leg out to recapture the balance and rock forward on it. Balance is thus continually lost and recaptured, and the momentum carries the body forward, with the balance point always leading.

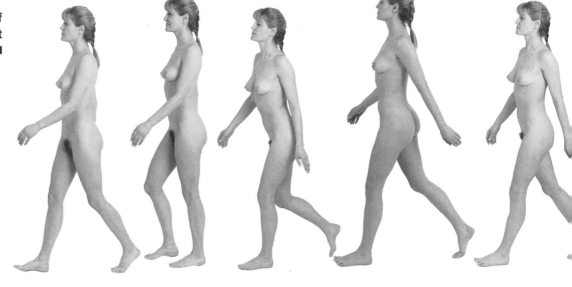

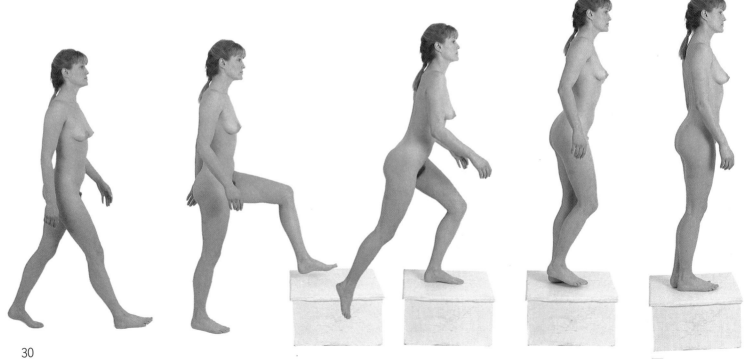

Movement

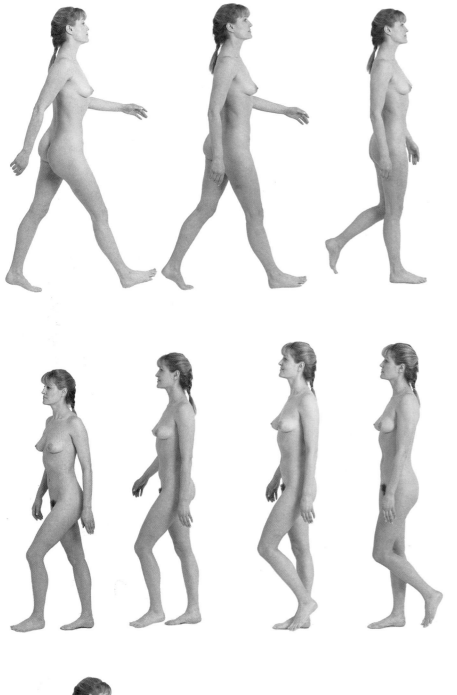

The words of Leonardo da Vinci, who made exhaustive studies of movement and expression, have as much relevance to today's artists as his drawings themselves. "You must portray the human being in a movement that truly represents his character, otherwise your art is not worthy of praise. A figure whose heart's passion cannot be discerned in his movements is of no interest. Highest praise to those who can communicate through a man's gesture his innermost passion."

As Leonardo realized, there are two aspects to movement: the actual mechanics of motion and the characteristic movement of individuals – the way they hold themselves. Portrait painters know that timid or frightened feelings are expressed with the whole body, not just the face, so that a pose determines both the mood of the composition and to some extent the identity of the subject.

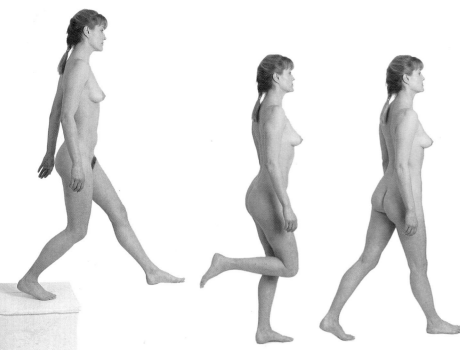

In both walking and running the shoulders swing in opposition to the hips to stabilize the body. In practice, if you want to draw a figure walking, ask the model to take a quick pose with the weight on the leading leg as though he or she were really walking. In the drawing, extend the body slightly forward so that the balance point at the pit of the neck is just ahead of the body by a few inches. The model should then appear to be walking across the page.

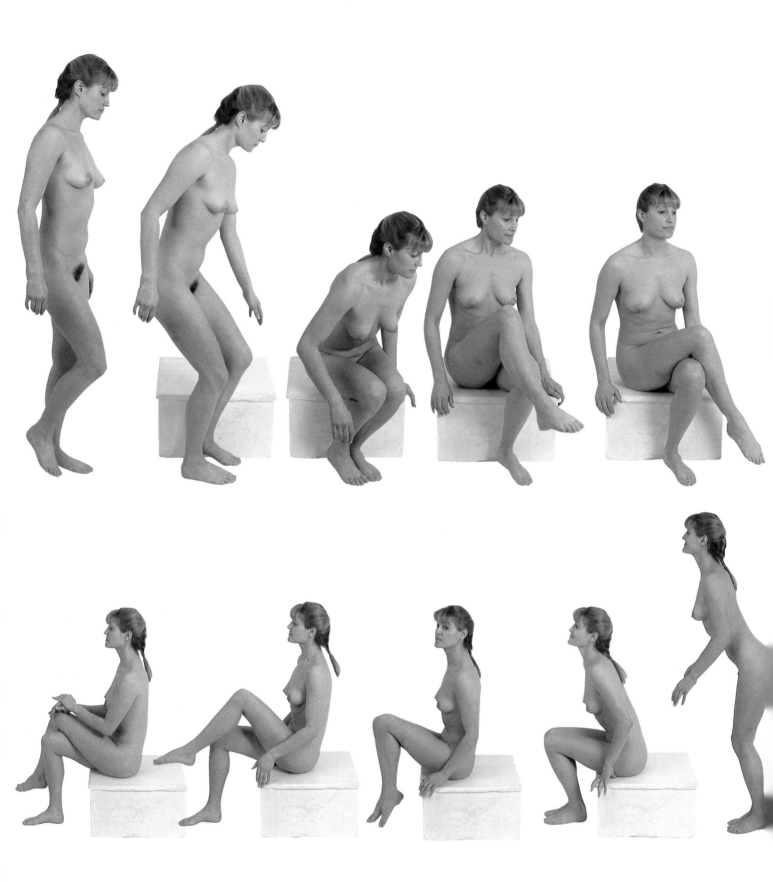

The rule of the displacement of balance in movement holds true for any movement of the body. With the figure truly in motion the whole thrust of the body is following

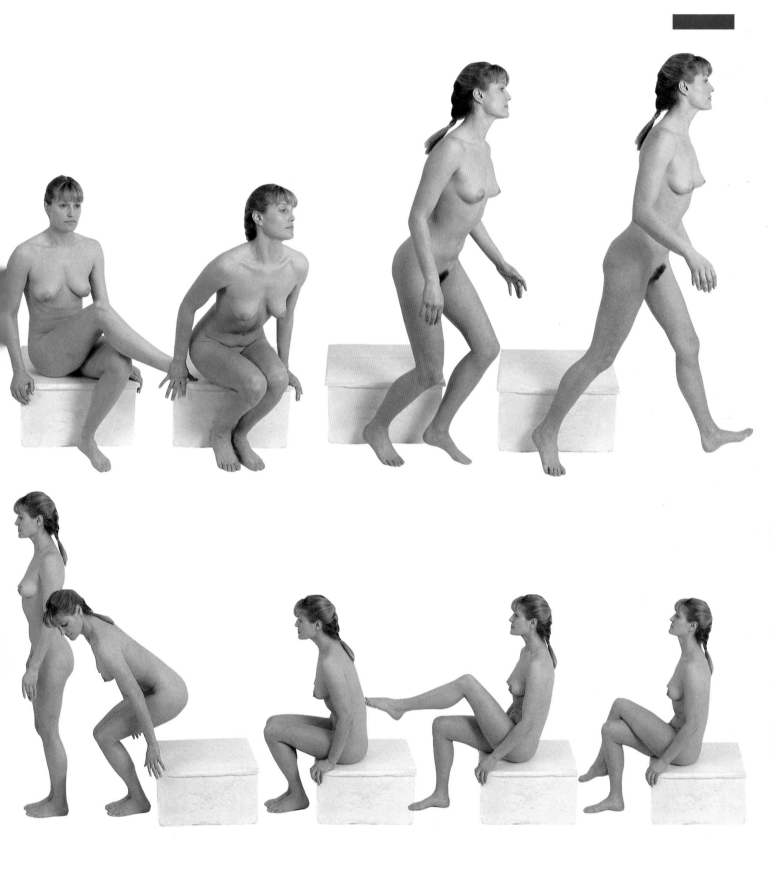

the balance point. When a person is
running there is a moment when both
feet are off the ground and the balance
point is thrust even further forward than
in walking. When we sit on a chair or bend
down to sit on the ground we extend the
balance point and the body executes a
controlled fall, in the latter case with the
arm reaching out to catch the weight.

STARTING TO DRAW

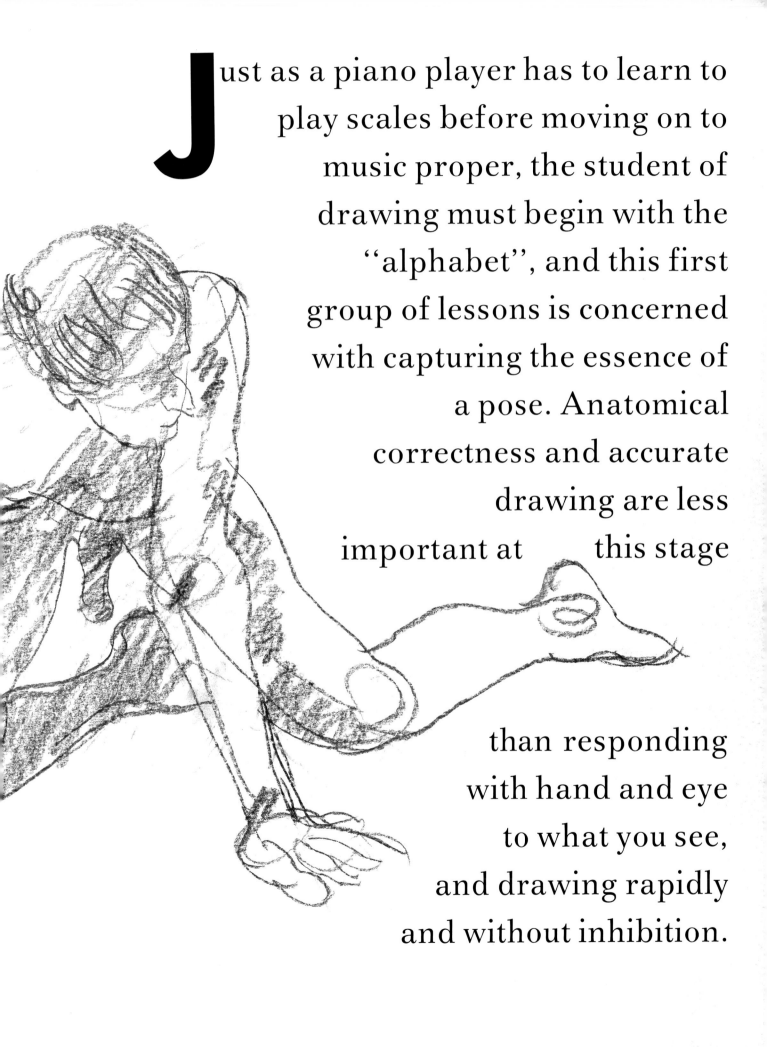

Just as a piano player has to learn to play scales before moving on to music proper, the student of drawing must begin with the ''alphabet'', and this first group of lessons is concerned with capturing the essence of a pose. Anatomical correctness and accurate drawing are less important at this stage

than responding with hand and eye to what you see, and drawing rapidly and without inhibition.

Pencils are graded H (hard), and B (soft); thus a 2H will give a very sharp, light line and a 6B a darker, broad line.

Graphite sticks are essentially the same as pencils, but without the wood casing. They are solid pieces of soft graphite, which can be used on the point like a pencil, or on their side for broad areas. Another way of working is to sharpen them with a craft knife to form a wedge-shaped point, which will enable you to go from a thin line to a broad one by slightly turning the stick. A disadvantage is that they are fragile, so care must be taken not to drop them. Erase with putty eraser or soap eraser.

Coloured pencils are an attractive medium for small works. There are several brands on the market, varying in both softness and brilliance. Before buying a box, try a pencil out to find the type you prefer. Erase with putty eraser or soap eraser.

Willow charcoal consists of soft, fine sticks, ideal for quick sketches.

Compressed charcoal, which comes in different grades and is heavier and darker than willow, can be used over large areas for very strong effects. Both can be erased with putty eraser or fresh bread, which will not damage the surface of the paper. Drawings should be sprayed with fixative when finished.

Conté crayons are sticks made of natural pigments bound by gum arabic, and they come in three colours, sienna, umber and black. They can be sharpened with a sandpaper block and used on the point or on the side. They are less easily smudged than charcoal, but more difficult to erase. This can be done, however, with fresh bread.

Fibre-tip pens have now virtually replaced the traditional metal-tip pen used with Indian ink. There are several brands on the market so be sure to ask for one with Lightfast, or pigmented ink. The colour from cheaper felt-tips is fugitive and will fade within months.

Quill pens are still valued by artists for their fine, lyrical line. They can be obtained from some shops, or you can sometimes buy a quill at a butcher's and cut it into a point yourself. To do this, first soak it overnight in water. Then take a sharp craft knife and cut the point, holding the quill firmly with one hand and cutting away from the body downwards to the point. Finally make a small cut in the end so that the point can flex and open to give a broad line when pressure is applied.

Bamboo pens have been used for many centuries in the East and give a dry line with considerable character. They are best used on watercolour paper with Indian ink. Before use the tip must be lightly scraped to remove some of the dried ink. Both ends of the pen can be drawn with, so keep the top end slightly blunted for a broader line.

Materials

PASTELS AND CRAYONS

Pastels are sticks of pure pigment lightly bound with gum arabic. They are sold in two grades, soft and hard, the latter being rather similar to conté crayon, and thus more suitable for linear effects.

Oil pastels, also sold in sticks, are rather like paint in solid form. They can be used dry as a drawing medium or spread over the paper with a brush and turpentine to create painterly effects.

Watercolour pastels can also be used both as a dry and wet medium. A light wash of clear water over drawn lines will spread the colour while still retaining some of the line.

Wax crayons are very hard and not suitable for the normal type of drawing. They come into their own, however, for the wax resist technique explained on pages 168-9

Pastel pencils, simply pastels encased in wood, are ideal for use with watercolour. They can pick out detail and give an attractive effect on slightly damp paper. They are very fragile, and must be sharpened carefully with a craft knife.

To a large extent the choice of materials is a personal one. I dislike pencils, but many artists use nothing else, and feel unhappy with the broader effects produced by charcoal or pastel. With experience you will find out your own preferences, but this brief introduction to the subject may be helpful in the early stages.

PAPER

Newsprint paper is useful for quick sketches, but will turn brown and crumble after a few years.

Sugar paper has a good texture and pleasant colour, but like newsprint, will not last long.

Cartridge paper is the standard drawing paper, good for pencil work and charcoal sketches.

Ingres is a lightweight quality paper with a fine texture and pattern suitable for charcoal, conté and pastels.

Pastel paper comes in different colours. Conté as well as pastel can also be used to good effect on this paper, with white chalk for highlighting.

Watercolour paper comes in different weights and textures and can be used with all mediums including pen and brush. Since it is designed for watercolour it is the best paper to use with wash.

1

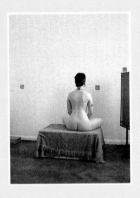

BRIEF

● **Exercise**

Following the lines of the body to capture the essentials of a pose.

● **Objectives**

Loosens up drawing. Concentrates the mind. Helps the student to convey movement.

● **Suggested mediums**

Charcoal, conté crayon, felt-tipped pen

● **Time**

Each pose 3–5 minutes.

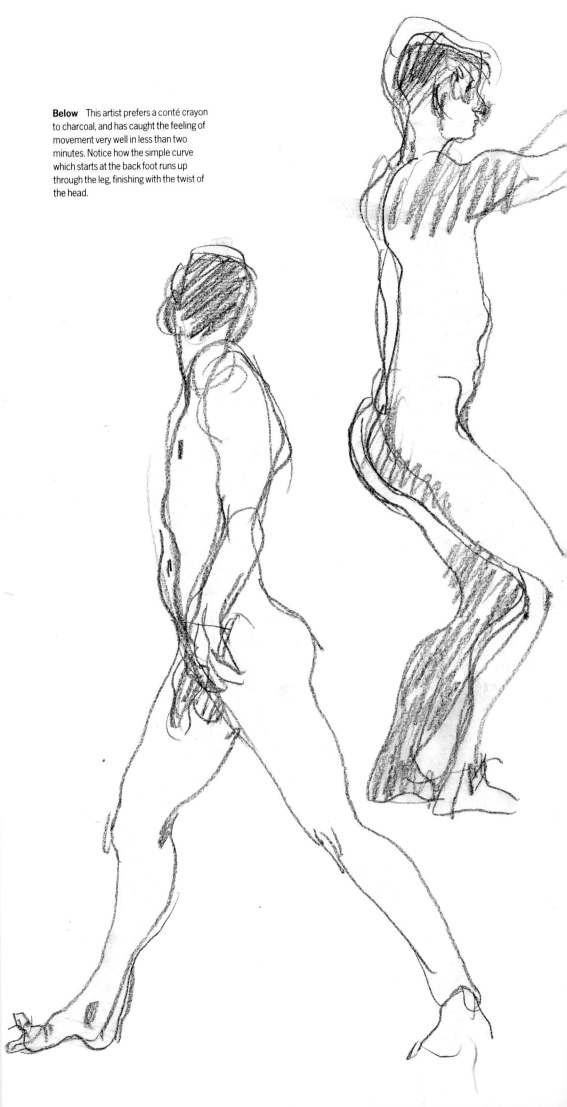

Below This artist prefers a conté crayon to charcoal, and has caught the feeling of movement very well in less than two minutes. Notice how the simple curve which starts at the back foot runs up through the leg, finishing with the twist of the head.

Quick poses

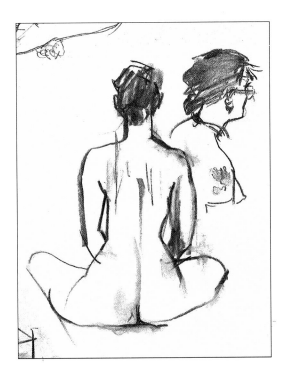

Right Every artist has a different way of approaching a drawing, even when the same medium is used. Here we see a more linear treatment with a fine stick of willow charcoal.

The short pose is as essential to the figure artist as scales and finger exercises to the musician, and they never lose their value. One of Matisse's students described how the master would work from the model for three hours in the morning, after which the floor around him would be covered with sketches. From these he would choose no more than one or two at the end of the sitting.

There are two main reasons for doing quick poses. One is to overcome the tyranny of the empty page which inhibits both novices and professional artists. The necessity of plunging in quickly removes, at least for the time being, the fear of making mistakes. The other reason is to put you in tune with the body. As the drawing implement rapidly follows the lines of the figure a certain rhythm is built up. The movements become fluid, and the non-essential details are disregarded in the rush to catch the pose.

Any medium can be used that will give you a quick, fluid line, for example charcoal sticks, conté crayon or felt-tip pen, and several poses can be put on a page, as they should not be too large. Look first for the direction of the body and the balance line, and try and capture the essentials in one swift line. If you get it wrong don't worry – go over the line again and use as many lines as you need to describe the movement. Ignore the details of the body at this stage.

After you have done a few drawings of this kind you might try out another interesting way of working. For this method you keep your drawing implement continuously on the page for the whole pose. Without lifting it off, move it over the whole body to show the rounder parts and the flat planes, going from one part of the form to the other to build up the mass of the figure.

Above These charcoal drawings were all done in one minute. A few swift lines are all that is needed to catch the movement of the body, and for studies like these you only need to indicate the position of the head and hands in the broadest terms.

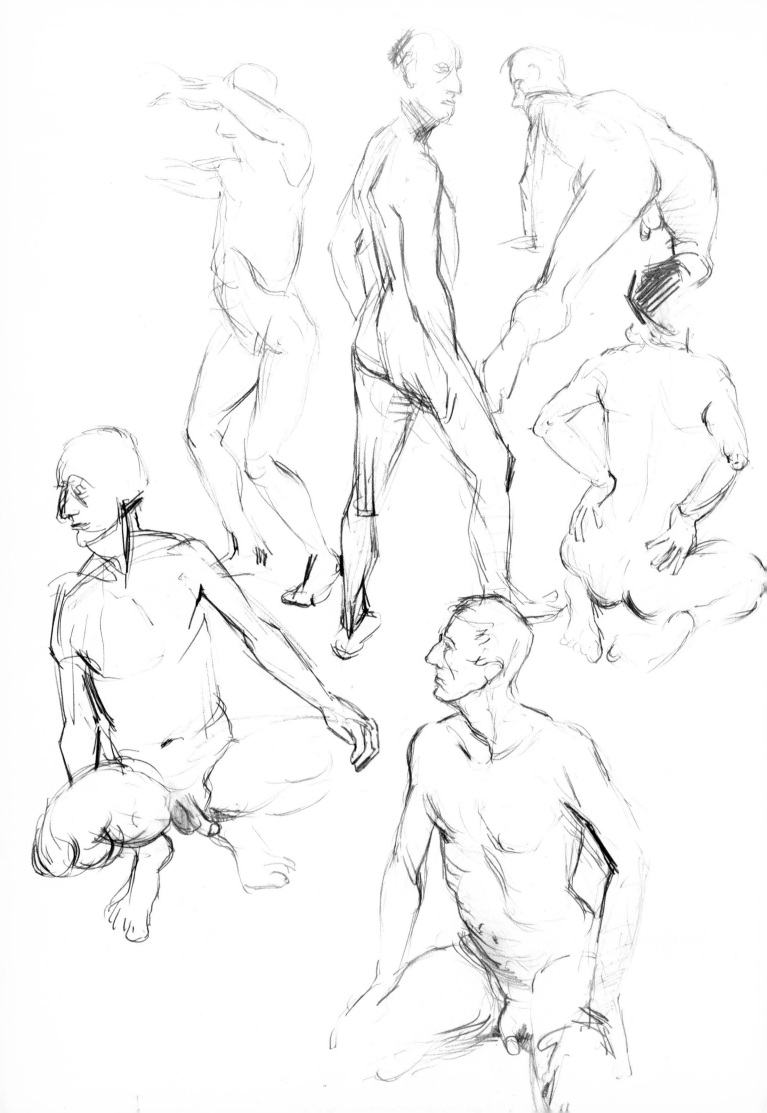

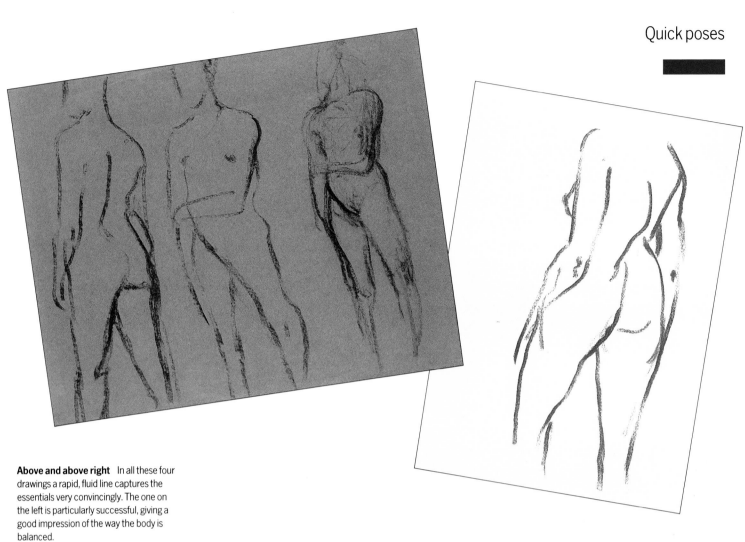

Above and above right In all these four drawings a rapid, fluid line captures the essentials very convincingly. The one on the left is particularly successful, giving a good impression of the way the body is balanced.

Opposite The model was in almost constant movement for these poses, and the artist has stressed this by placing several drawings on one page (this also saves valuable time). It is a successful page: the line has been kept loose, moving quickly to express the complicated planes and forms of the figure.

MASTER WORK

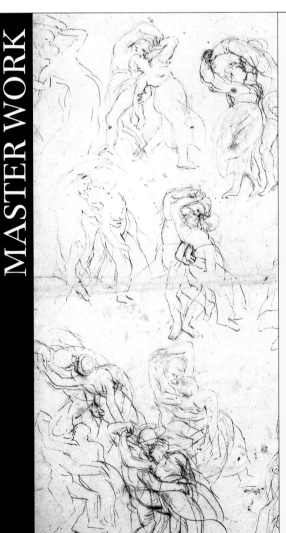

Sir Peter Paul Rubens
1577–1640
Studies for a Kermesse
Pen and brown ink over
black chalk

Rubens was not only a master of painting, he also had a considerable talent for life itself, and enjoyed a happy family life as well as a successful dual career as artist and diplomat. The subject of this lively page of quick sketches is a Flemish festival (*kermesse*), and may have been made on the spot. Rubens painted every possible subject, as well as designing tapestries and festival decorations.

41

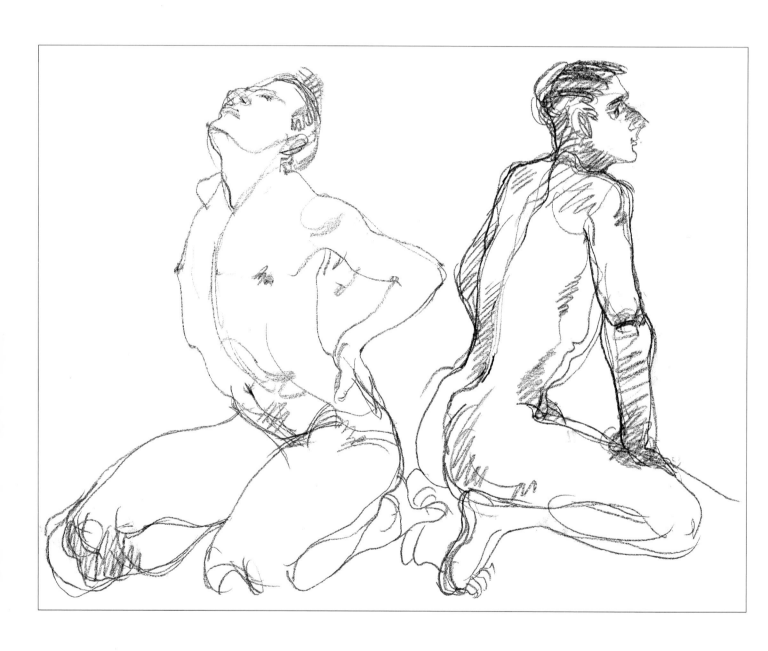

Above The loose line and rough scribbling technique give an energy and dynamism to the drawings. The left-hand example is particularly expressive: notice the way the curve of the chest sweeps up to the back of the head, suggesting the tension of the neck muscles with only a few lines. These poses both took about three minutes, allowing the artist enough time to sketch in the head and hands.

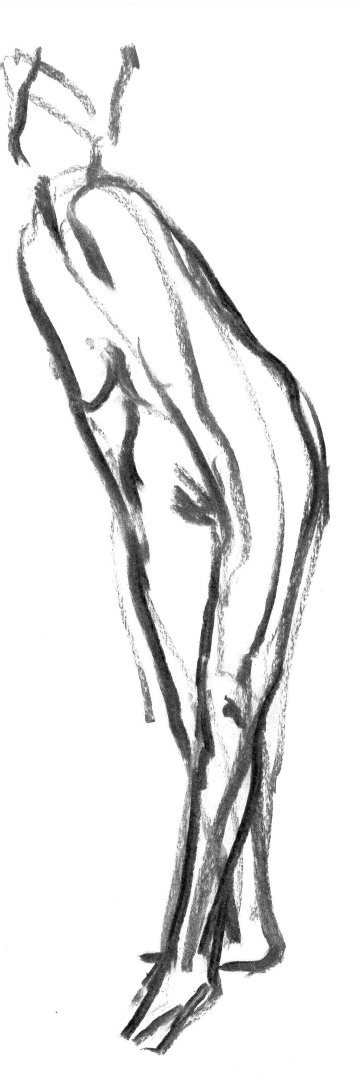

Quick poses

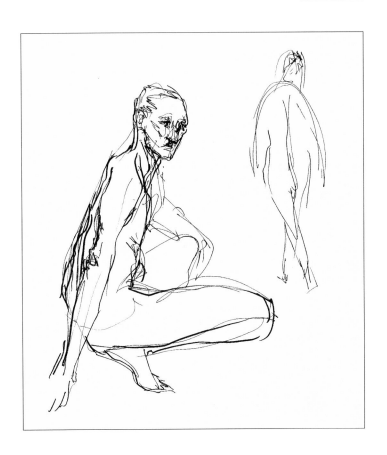

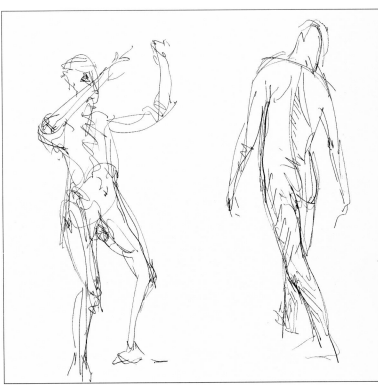

Left The model was slowly moving as this charcoal sketch was made.

Above and top Pen and ink (or fine fibre-tip in this case) is also a good medium for quick poses. Since it is impossible to erase, wrong lines must be corrected by overdrawing, which can convey movement very effectively.

43

BRIEF

● **Exercise**

Identify the balance
points for standing
figure; mark in balance
line.

● **Objectives**

Helps to produce a
realistic portrayal.
Balance line provides a
framework for the
drawing.

● **Suggested
mediums**

Charcoal, felt-tipped
pen, pencil.

● **Time**

Quick poses, each 5–10
minutes.

Cross-check

Refer back to pages
28–9 for extra help.

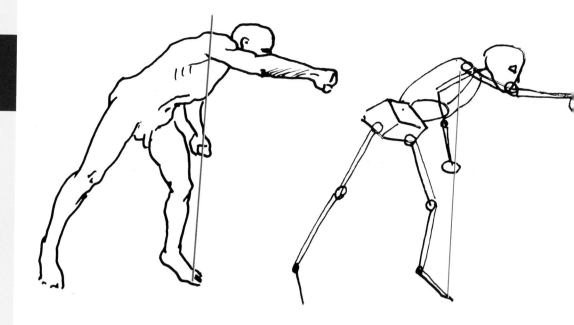

Above Even in an action pose like this
the balance is maintained, and the balance
line is measured from the pit of the neck
down to the leading foot.

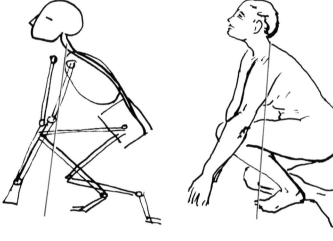

Right The weight of the body is being
supported by the foot, knee and hands, so
the balance line falls between them.

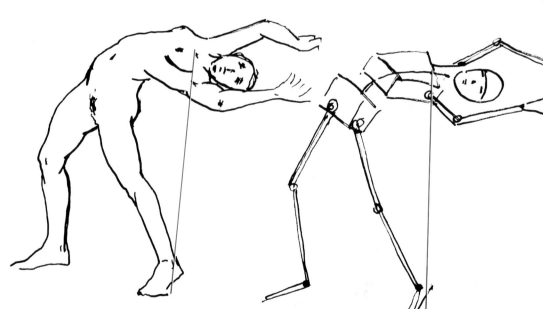

Above As the body bends back it bows
out to keep the balance under the pit of
the neck. To find the balance line, hold up a
pencil vertically in front of you, aligning the
tip with this balance point.

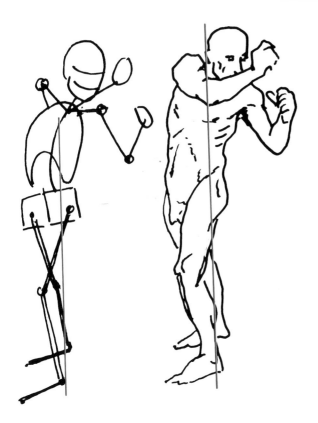

Balancing the figure

Above The model's weight is being carried on the front foot as the movement of arms and shoulders brings the torso forward. The balance point from the neck is completely over that foot.

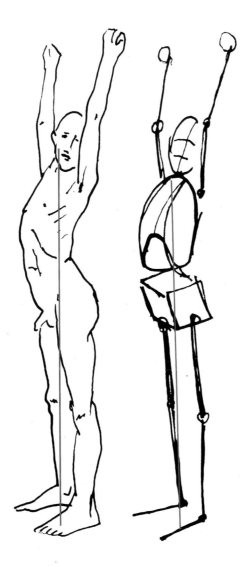

Right The boy is standing with his weight evenly divided so the balance line falls between his two feet.

There is no way to make a drawing look convincing if the figure is out of balance and appearing to topple over even slightly. The question of balance is also of importance in creating the illusion of the three-dimensional mass and weight of the body. One of the many great achievements of Rembrandt in his figure drawings is the perfect balance, so convincing that we can almost guess the weight of each individual model.

To begin the study of balance I find it helpful to try to imagine what is happening under the confusing blanket of flesh and to draw a simplified skeleton. This need be no more than a stick figure with simple geometric shapes for skull, ribcage and pelvis. You might try out this approach, or you can draw the model as he or she really is. In either case start with easy standing poses, and ask the model to take a pose first with most of the weight on one foot and then with the weight on two feet. Give about ten minutes to each pose, and then do the same ones from the back view. The drawings do not have to be large – you can put four to a page if you wish.

As soon as the model takes the pose look for the balance point, which will be at the pit of the neck for a front view, the middle of the ear for a side view and the middle of the root of the neck for a back view. Hold your pencil up vertically with your arm outstretched, aligning the tip with the balance point, and then look down it. The pencil intersects the ground at the point where the weight falls, so the next step is to mark in the balance line lightly, and then indicate the position of the weight-bearing foot (or feet).

You can now begin to place the different parts of the body, starting with the head. You can draw this as a simplified egg shape, but make sure you show it at the correct angle – it may be tilting. Next draw a line showing the curve of the spine down to the pelvis and hip, and put in a simple shape for the ribcage. If the model's weight is mostly on one foot you

will see that the hip above the weight-bearing leg has been thrust upwards, tilting the pelvis, while if the weight is evenly distributed the pelvis will be level. You can draw the pelvis and hips as a rectangle, but make sure the tilt is correct. Now you can begin to draw the legs, starting with the main weight-bearing one, and making a note of the direction of the feet.

I like to show how the balance affects the angle of the hips before positioning the shoulders and arms, because to counterbalance the body, the shoulders tilt downwards over the leg and hip carrying the main weight. Thus once the correct position of the hips is established it is easy to find the direction of the shoulders. The arms should always be drawn after the shoulders since their movements are interdependent.

Once you have mastered the simple poses try a few five-minute action ones, in particular asking the model to take poses bending forwards and backwards. If you draw these poses from the side view, use the ear as the point of balance. It is fascinating to see how the body bows to keep the balance point over the feet no matter how far the top is bent forward or back.

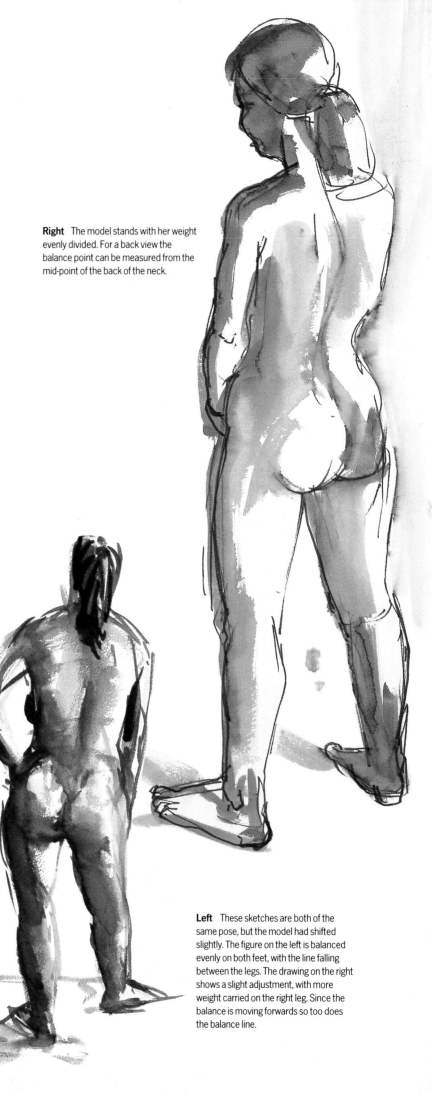

Right The model stands with her weight evenly divided. For a back view the balance point can be measured from the mid-point of the back of the neck.

Left These sketches are both of the same pose, but the model had shifted slightly. The figure on the left is balanced evenly on both feet, with the line falling between the legs. The drawing on the right shows a slight adjustment, with more weight carried on the right leg. Since the balance is moving forwards so too does the balance line.

...line is
...he
...d artists
...nce line,
...rs as it
...est of the

Left The weight is almost entirely on one foot, so the balance line runs from the pit of the neck to a point between the feet. Notice how the hip carrying the weight is pushed up, while the shoulder over that hip drops down.

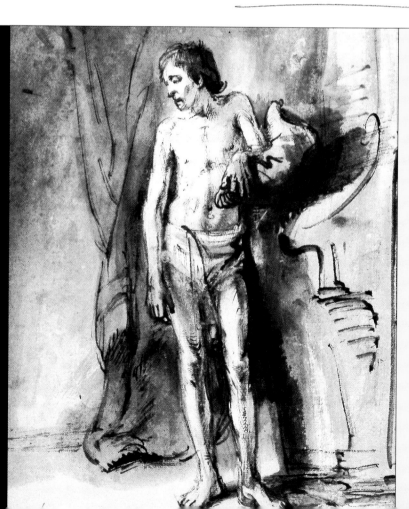

MASTER WORK

Rembrandt
1606–1669
Study of a Man Standing
Pen, brush and wash

Rembrandt, one of the greatest painters in the whole of art history, was also a superb etcher and draughtsman, and the man in this drawing looks as alive today as he did 300 years ago. Generations of artists and students have looked to Rembrandt's work for inspiration, and it still has much to teach us.

PLACING THE FIGURE

3

BRIEF

● Exercise

Planning placement
points for standing
figure.
Making simple divisions
for seated figure.

● Objectives

Ensuring that the
drawing fits within the
page.
Relating the drawing to
the page.

● Suggested mediums

Pencil, charcoal, conté
crayon.

● Time

30 minutes to one hour.

Cross-check

Refer back to pages
10–13 for extra help.

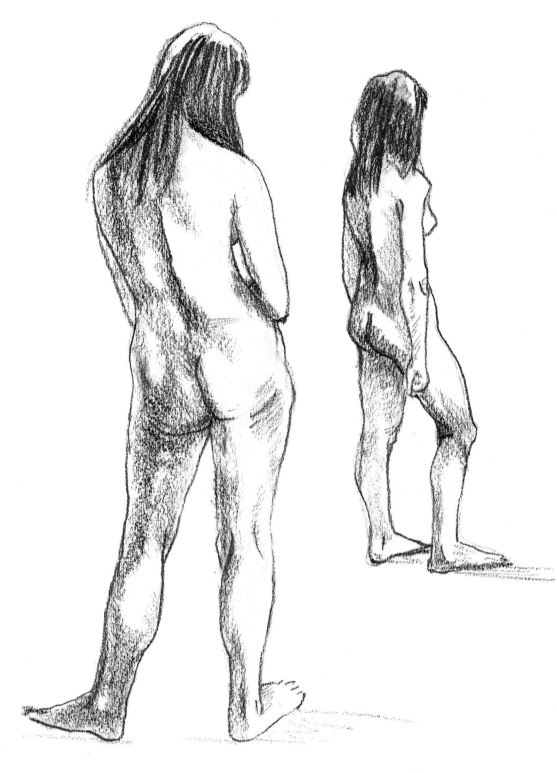

Above Two pencil drawings were made
of the same model in different poses. The
second figure was placed higher up on the
page to suggest a distance between the
two, thus creating a feeling of space.

Right The diagram shows how the figures
were mapped out on the page. The hips
were placed first, then simple lines were
drawn indicating the positions of the head
and feet. The half-way point of the legs and
the elbow were then placed. When the
drawings were completed the light
guidelines were erased.

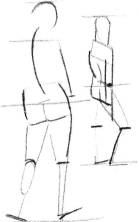

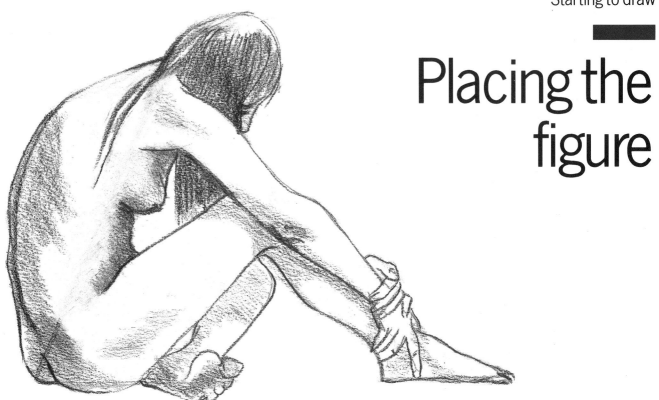

Placing the figure

Top and above A standing pose is quite easy to measure and place, but with a pose like this, or a seated one, a different approach is needed. The general rule is to look at the simple shape of the pose and then measure and lightly draw it. This pose was basically triangular, and measurements showed that the distance from shoulder to foot was the same as that from foot to hips. Once the triangle was drawn, it was quite easy to place the figure in and around the triangle.

Being able to place the figure properly on the page seems both simple and obvious, but beginners have a tendency to plunge ahead without considering this aspect of their drawings, only to bewail decapitated or footless nudes standing forlornly on the bottom or top of the paper. This is easily avoided if you bear in mind the basic proportions of the figure and make some preliminary "mapping" marks before beginning the drawing proper.

First find the middle of your paper and mark it lightly. To place the figure itself some quite simple divisions of the body can be used, taking the pubis as mid-point and the nipples and knees as the two quarter-points. These may not be completely accurate in all cases, as figures vary, but they are adequate at this stage. The rule is simply to place the middle of the figure in the centre of the position you want the whole figure to occupy, so for a standing pose showing the full figure place the pubis near the middle of the page. Then, going outwards, mark the placement for the feet and head, and then the breasts and knees, which will be the quarter-points between. To find these measurements, hold up a pencil at arm's length straight in front of you and slide your thumb up and down it.

If you want your drawing to be as large as possible and fill the page, place the feet near the bottom, and for a smaller figure place them higher up. Since you know that the distance from pubis to head will be equal to the one you have just laid out from pubis to foot, you should be able to position the whole figure quite easily with this method.

However, the middle of the page should be used only as a rough guide to help vertical placement; you should try to off-centre the figure slightly. One of the basic rules in composition is never to put a subject directly in the centre of a page, as this creates a static symmetry which is extremely boring to the eye. This will be discussed in more detail in the "Picture making" section later in the book.

There is, of course, no reason why you should have just one figure on a page – with quick poses you will want several, perhaps varying the size. In such a case try placing the large figures in the foreground and the smaller figures either partially behind them or higher on the page, so that they will appear in correct perspective.

If you wish to draw only part of the figure, for instance from waist upwards, then measure the area to be drawn by the pencil and thumb method. When you find the mid-point, mark it in the appropriate place on your paper and proceed in the same way as for the complete figure. After a little practice you should be able to judge the size of the figure in relationship to the page without much trouble, and will be able to dispense with the need to mark it out each time. However, for standing figures I advise retaining the practice of starting the drawing around the pelvic area. Not only does this help to place the figure; it is also here that you must also look for the balance line, explained in the next lesson.

CONTOUR DRAWING

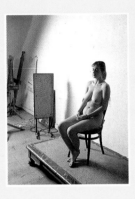

BRIEF

● **Exercise**

Drawing without looking at the paper.

● **Objectives**

Concentrates attention on the subject. Avoids stereotyped images.

● **Suggested mediums**

Felt-tipped pen, soft pencil, sharpened conté crayon.

● **Time**

30 minutes minimum.

Left Contour drawing is essentially a linear exercise, so avoid an easily smudged medium such as charcoal. In this case crayon was used to give a soft, responsive line. The artist has had experience with this kind of drawing, so there is very little distortion.

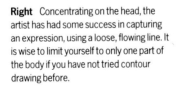

Right Concentrating on the head, the artist has had some success in capturing an expression, using a loose, flowing line. It is wise to limit yourself to only one part of the body if you have not tried contour drawing before.

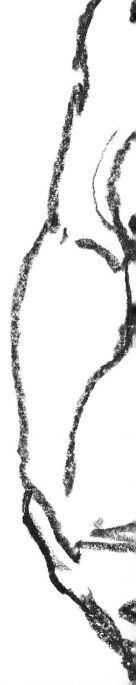

Left This is the first time the artist has attempted the method, but it is a good rendering of the soft, ample body, although the figure is distorted.

Contour drawing

This is a drawing exercise; it is not intended as a method for finished drawings since it is impossible to do a contour drawing without mistakes and distortion. As an exercise, however, it is one of the most useful that I know. We all believe that we look carefully at the model, and certainly intend to do so. But I have often watched a group of students working busily away and been struck by the fact that for most of the time their eyes are fixed on the paper, and they give only an occasional quick glance at the model. This results in many preconceived stereotypes being drawn again and again at the expense of direct observation. In a contour drawing you look at the model all the time, and the paper not at all.

The method is quite simple. Choose a soft pencil or felt-tip pen – a drawing pen can also be used, but avoid the type that has to be repeatedly dipped in ink. Look at the model and decide where you want to begin drawing. I find it is best to make a drawing of part of the model first rather than the whole body because you want to put in as much detail as possible.

Use the entire page and give yourself plenty of time. Place your pen or pencil at the edge of the form and follow around the contour very slowly. Keep your eyes on the model and do not look down at the page except when you need to reposition the pen or pencil. For example, if you are drawing the head, and have completed the outside contour, you should look down to reposition the pencil for the eyes. When drawing the eyes, however, continue looking at the model until they are complete, and then reposition for the nose, and so on. After you have done several of these drawings try repositioning without looking down at all. The drawings will probably look strange but you should have improved your powers of observation considerably.

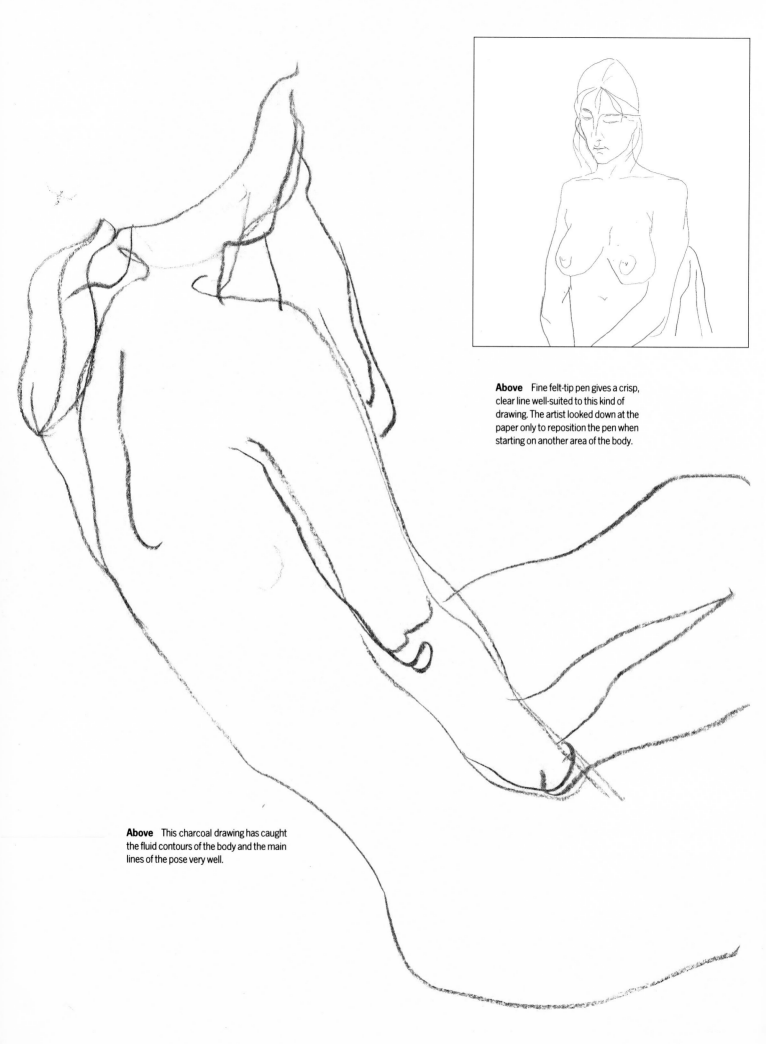

Above Fine felt-tip pen gives a crisp, clear line well-suited to this kind of drawing. The artist looked down at the paper only to reposition the pen when starting on another area of the body.

Above This charcoal drawing has caught the fluid contours of the body and the main lines of the pose very well.

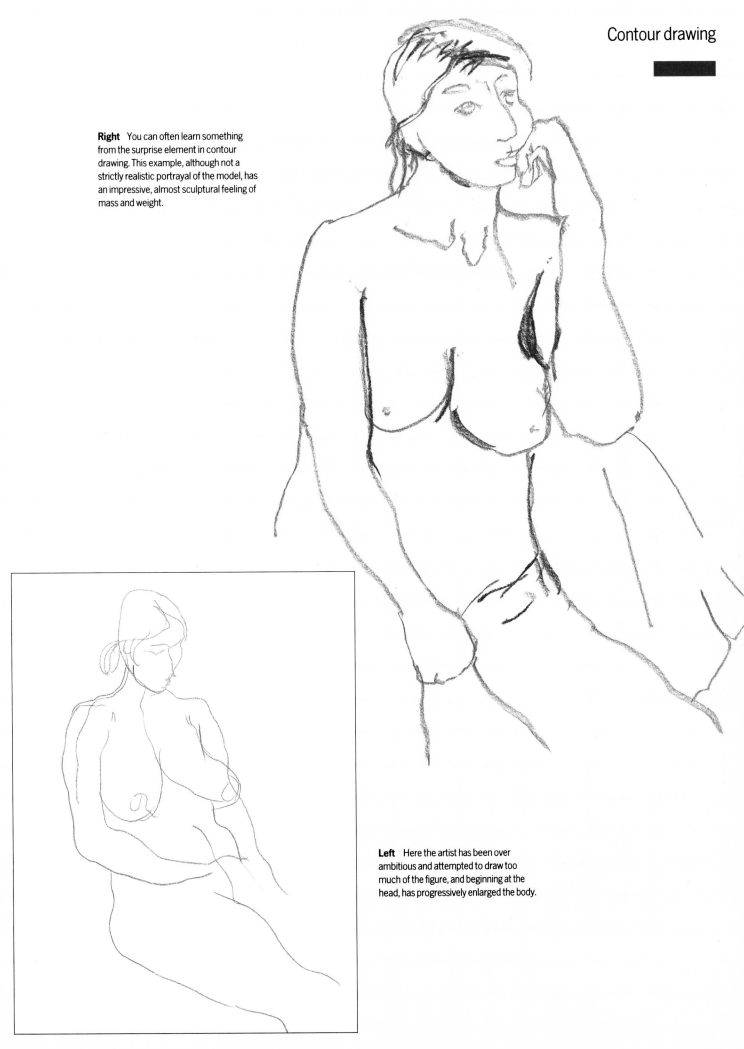

Right You can often learn something from the surprise element in contour drawing. This example, although not a strictly realistic portrayal of the model, has an impressive, almost sculptural feeling of mass and weight.

Left Here the artist has been over ambitious and attempted to draw too much of the figure, and beginning at the head, has progressively enlarged the body.

BRIEF

● **Exercise**

Quick poses drawn as
broad areas of tone.

● **Objectives**

Learning to express
mass, weight and
movement.

● **Suggested
mediums**

Charcoal sticks,
compressed charcoal,
black conté crayon
used on its side.

● **Time**

Each pose 3-5 minutes.

Above and left This exercise, like
Lesson 1, is based on quick poses, but in
this case line is secondary to the overall
"feel" of the body's shape. These charcoal
sketches were both done from one-minute
poses; the shorter the pose the more the
artist has to concentrate on the essentials.

Opposite The pose was slightly longer
for this drawing – between two and three
minutes, and the artist has captured the
swing of the body very successfully.

Seeing the mass

However lyrical and charming a line drawing may be, there is always the danger it may become weak and insipid. "We are not composed of little wires" said Oskar Kokoschka when criticizing an unfortunate student's rather tentative drawing. The disaster of war – Kokoschka had fled to London in 1938 – at least benefited the art students of London, who were able to work with one of the great masters of German Expressionism. Kokoschka's "troubled heart and his apocalyptic vision" made him not the easiest of teachers – one student remembers her palette being compared to over-cooked boiled cabbage – but those who could withstand the sharp edge of his tongue learned a great deal.

Students were encouraged to turn charcoal sticks on their sides and make bold marks that expressed the movement, mass and feeling of the model. Sometimes the model posed normally, but often was drawn in movement, with the students trying to keep up and see "as if for the first time". Kokoschka's ideal was to achieve the vision of a child who sees without the limitations of traditional taste.

These exercises can be recreated by choosing a medium that can be used quickly, like charcoal sticks, compressed charcoal or conté. These are all extremely sensitive to the slightest change in pressure, varying from the faintest tone to the darkest black in a second, and allowing a poetic translation of feeling from the subject to the paper. Before starting work with the model I advise practising with these media for a few minutes so that you will be able to use them freely. Hold the charcoal at an angle to the paper so that you get a broad line. Then try drawing a circle in this way; you will find you have a dark tone around the outer edge of the circular form. Then bring the stick down flat onto the paper, which will give you a broad, flat plane of tone. Then change your pressure from the

55

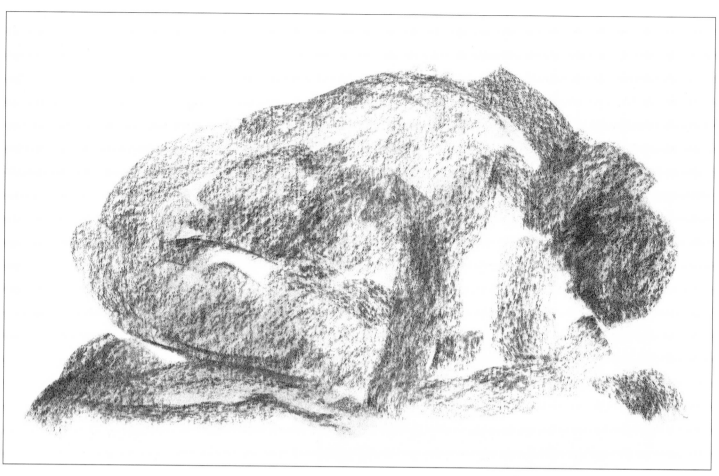

The best mediums for this kind of drawing are block charcoal or conté crayon, but you should not use either as you would a pencil. Instead, break them into pieces so that you can use the side of the stick. If you try to draw with the side of a long stick, particularly of willow charcoal, it will simply break.

palest tone to the darkest and just see how many different types of line and tone you can achieve. This is a good loosening-up exercise before beginning serious work.

When the model takes up the pose, use the charcoal on its side or at an angle and follow the main form around, varying the pressure from dark to light to express weight and lightness. Put down only what you see without adding anything because you think it should be there. Above all, don't bother with details; the object is to express mass and weight, together with a feeling for the individual person being drawn.

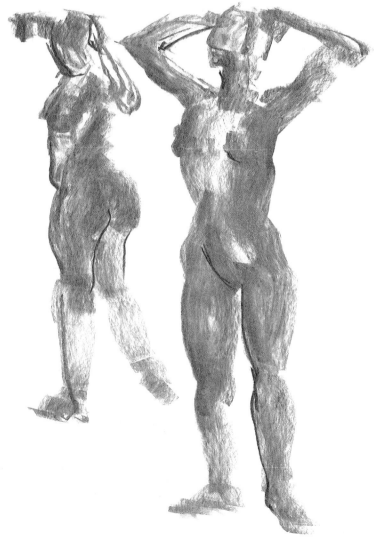

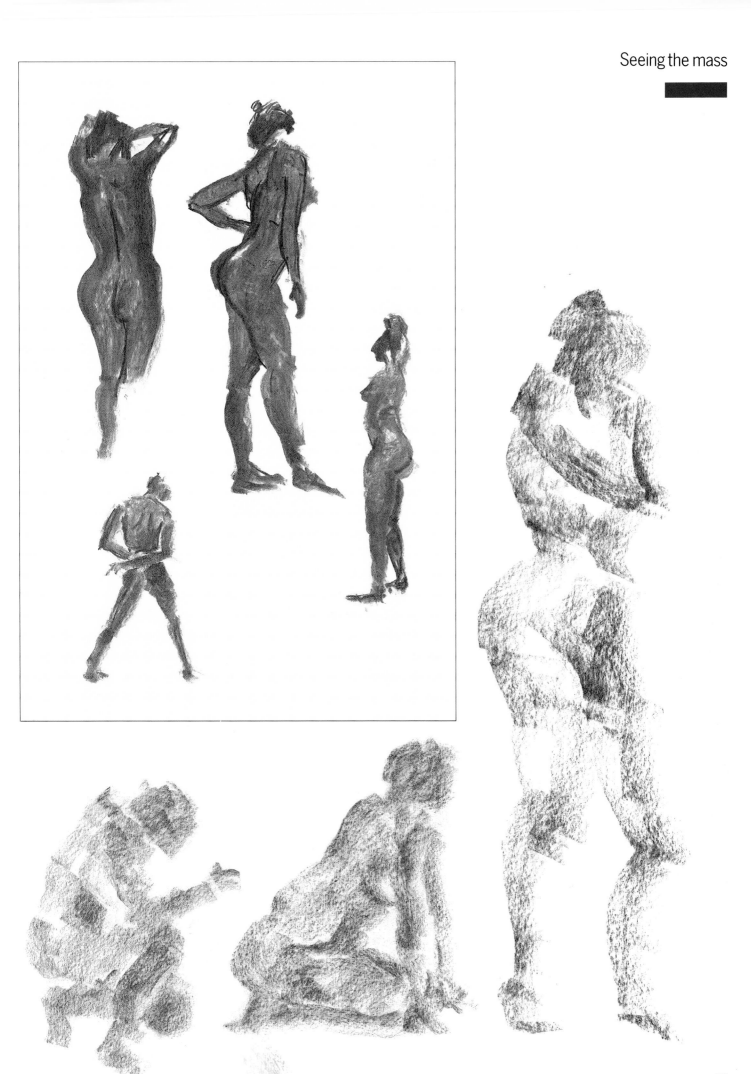

Exercise

Constructing a drawing
without using curves.

Objectives

Focuses attention on
the subject.
Gives a new awareness
of body's contours.
Gives an opportunity to
explore the dynamics of
straight lines.

Suggested
mediums

Pencil, bamboo pen,
felt-tipped pen.

Time

30 minutes minimum.

Above However experienced an artist is,
trying out a new kind of drawing exercise is
instructive – and sometimes daunting. In
this case the planes of the body have been
well understood, but the size of the head
has not been measured, and it is too small.

Drawing with straight lines

The purpose of this exercise is two-fold. The primary concern, as in the preceding lessons, is to increase and sharpen our observation of the body. Using straight lines exclusively for drawing the body is, of course, unnatural, since the figure is composed of a very subtle mix of line and curve. In order to translate the curves into line you will have to look very carefully at the direction of the planes and contours so that you can decide precisely where a change of direction occurs. It is not necessary to use sharp angles, indeed it would be quite impossible in certain areas of the body. You will find that you become more conscious of the dynamics of the body's contours, for example the way the ear protrudes from the plane of the skull, which may make a greater impression drawn with angles.

Since this is a linear exercise pen or pencil are advisable, or you might like to try out a bamboo pen, a lovely, sensitive drawing implement. It must be used with Indian ink, and gives a strong black, dry line. When you buy the pen the point will have already been cut, but if you want a finer point you

Left Here the approach is simpler, with fewer lines used. The method gives a nice feeling of energy to a drawing.

can sharpen it with a craft knife. The main problem with a bamboo pen is obtaining a smooth flow of ink, so each day, before you begin work with it, scrape off the dried ink from the point, otherwise the ink will keep drying up or blotching. The line will differ considerably depending on the type of paper used. I like to use a lightly textured paper from a sketching pad, but the pen will draw equally well on smooth paper.

The pose should last at least half an hour to give sufficient time to put in as much detail as possible. The finished drawing will look a bit odd, which is to be expected, but this brings us to the second purpose of the exercise, which is that of examining the dynamics of straight lines and angles as opposed to curves. Most people know the old rule that curves give a harmonious, flowing and restful appearance, while lines and angles suggest energy, tension and strength. This holds true for all areas of art and design, and understanding and making use of the knowledge is just as important to the artist as it is to the textile designer or the architect. If you compare your straight-line drawing with a conventional sketch you will probably find it a bit more vigorous.

Left In this quick sketch, the main characteristics of the pose have been well observed. This method can be useful in designing compositions.

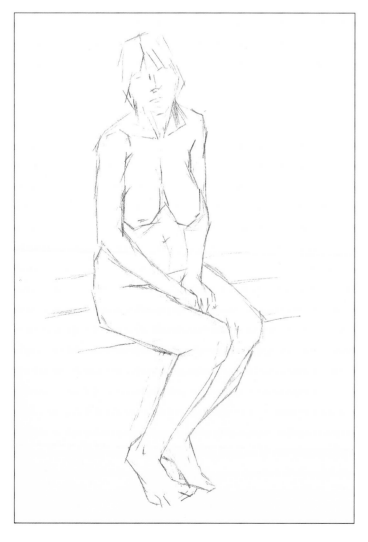

Drawing with straight lines

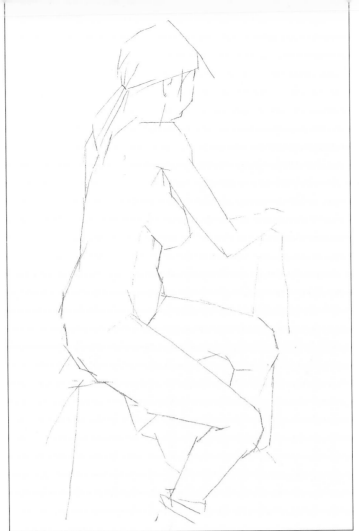

Left Here the artist has created an exciting effect with white pastel pencil on toned paper. Head and body are not in correct proportion, but the drawing is lively and full of movement.

Right In this case the straight-line method has produced a fairly conventional drawing, while in those below the artist has taken the linear approach considerably further.

Below In these studies of the same pose the artist has simplified the forms to make a semi-abstract design. In the second drawing (below) the figure has become a strong, linear design, suitable for a linocut.

Above A rather different technique was used for this drawing. It was done slowly with the pen kept on the paper, the line making very subtle changes in direction as it followed the form.

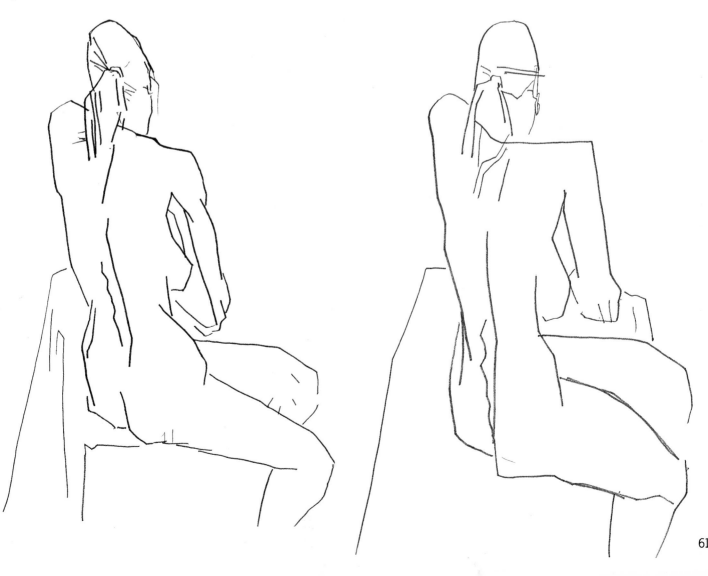

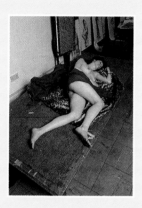

BRIEF

● **Exercise**

Drawing the reclining or seated figure in perspective.

● **Objectives**

Acquiring familiarity with a difficult aspect of drawing.
Learning to take measurements.
Using "reference" points for checking drawings.

● **Suggested mediums**

Pencil, charcoal (you may need to erase).

● **Time**

One hour minimum.

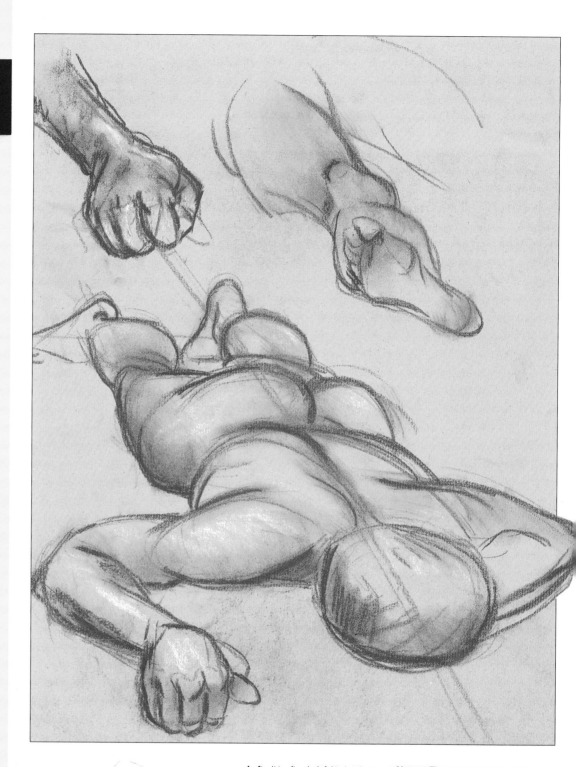

Left It is often helpful to treat the foreshortened figure in a diagrammatic way. The body, as here, can be drawn as a series of three-dimensional shapes such as cylinders and boxes, arranged one in front of the other.

Above The same technique has been used for this conté drawing; notice how the lines of the shoulders and ribcage have been drawn over the shape behind them. A guideline has been drawn the length of the body to ensure that it looks as though it is lying on a flat surface.

Opposite In this conté crayon drawing the exaggerated foreshortening of the hand leads in the eye and creates a strong sense of depth on the picture plane. An experienced artist can use such effects to advantage, though the beginner is advised to take careful measurements.

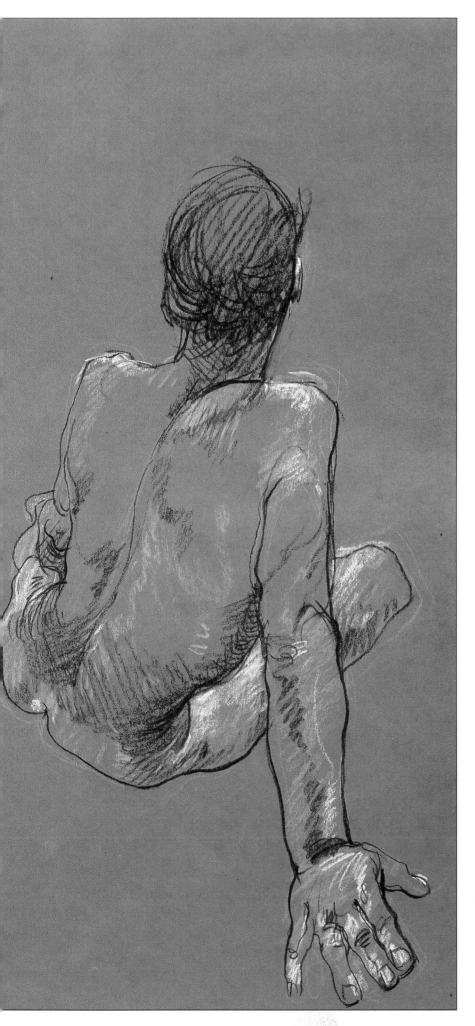

Fore-shortening

Foreshortening is the *bête noire* of the novice figure artist. A study of perspective is of limited use, since unlike the elements in architecture the form of the human body changes within itself as it moves, and these changes affect its outer shape. We can, however, start with the few basic rules of perspective that are applicable. Imagine a piece of vertical glass directly in front of you and then imagine a model with arm stretched out towards you. If you drew the outline on the glass and then moved much closer, you would see not only that the figure was bigger, but that the outstretched arm and hand appeared much larger in relation to the rest of the body than before. The closer you come the greater the distortion. The change in size is of course an optical illusion, but so is all perspective.

To catch and fix these images on paper, careful measurements are needed. To start with make a note of where you are standing or sitting in relation to the model so that you can keep the viewing angle constant. When faced with a difficult subject there is a temptation to bob about, looking at the model first from one side of the easel then from the other. This can be disastrous when you attempt to draw a foreshortened figure, because the slightest shift of angle changes your view of the pose and makes measurements very misleading. It is also necessary to note the model's position in relation to your own eye level, as this is of great importance with a foreshortened figure. A reclining pose, for instance, will be below eye level, but if you were planning a painting as a ceiling decoration you would have to draw the model from a low angle so that he or she would appear to be above eye level.

When you begin to draw, I suggest separating the various parts of the body into easy geometric shapes to begin with, as this enables you to clearly show one part of the body in front of the other. The chest and

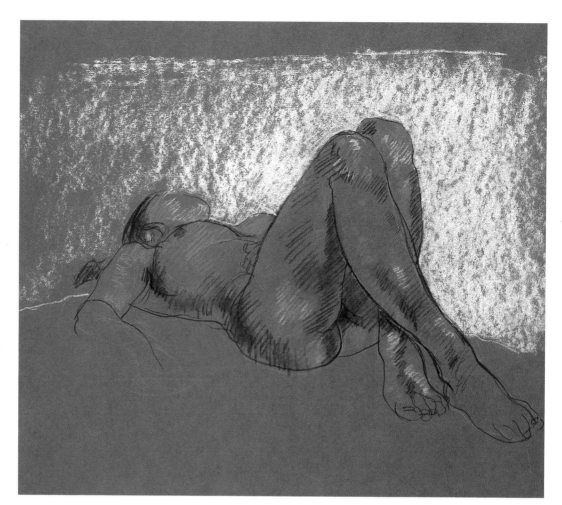

Right The artist has used white pastel effectively to bring out the drawing of the legs, creating depth and compositional interest. Note how the drawing of the torso and head fades into the background.

Below A simple diagram was drawn first as a guide to the finished drawing. Note how the cast shadow under the back places the figure on a flat surface and emphasizes the curve of the back.

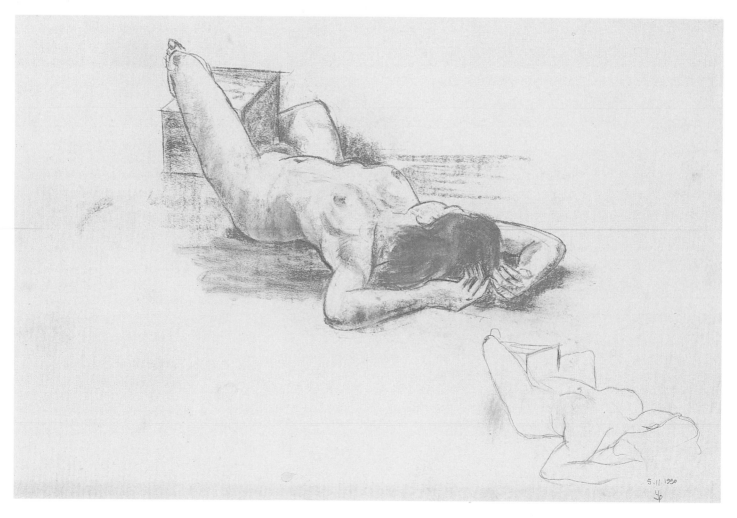

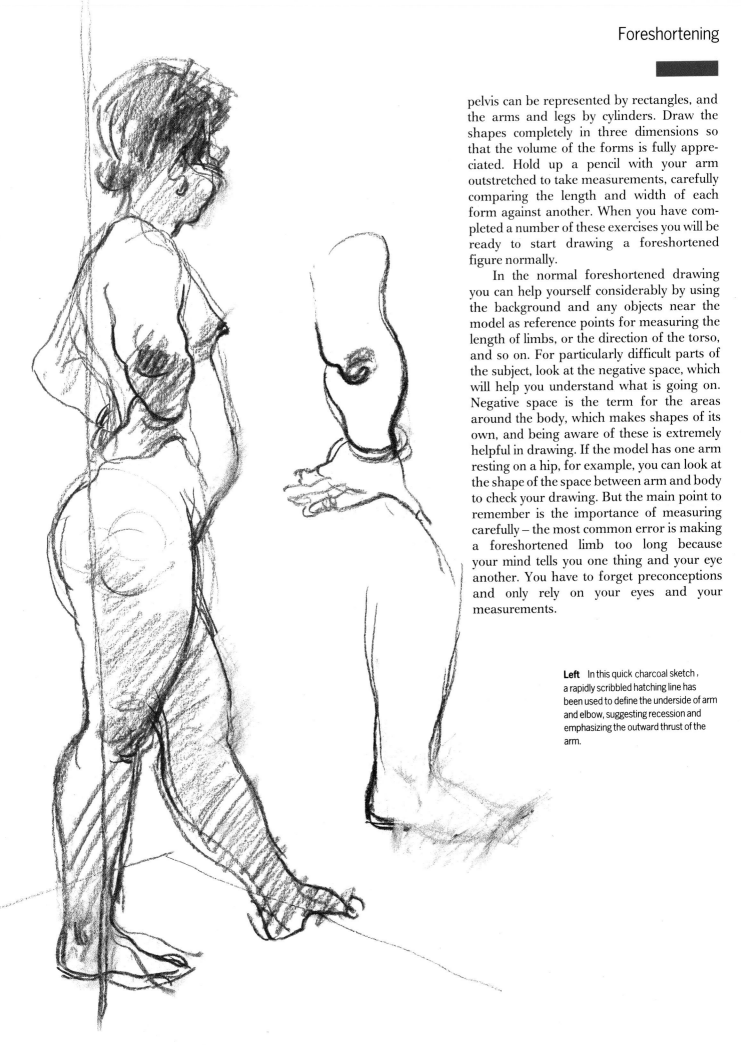

pelvis can be represented by rectangles, and the arms and legs by cylinders. Draw the shapes completely in three dimensions so that the volume of the forms is fully appreciated. Hold up a pencil with your arm outstretched to take measurements, carefully comparing the length and width of each form against another. When you have completed a number of these exercises you will be ready to start drawing a foreshortened figure normally.

In the normal foreshortened drawing you can help yourself considerably by using the background and any objects near the model as reference points for measuring the length of limbs, or the direction of the torso, and so on. For particularly difficult parts of the subject, look at the negative space, which will help you understand what is going on. Negative space is the term for the areas around the body, which makes shapes of its own, and being aware of these is extremely helpful in drawing. If the model has one arm resting on a hip, for example, you can look at the shape of the space between arm and body to check your drawing. But the main point to remember is the importance of measuring carefully – the most common error is making a foreshortened limb too long because your mind tells you one thing and your eye another. You have to forget preconceptions and only rely on your eyes and your measurements.

Left In this quick charcoal sketch , a rapidly scribbled hatching line has been used to define the underside of arm and elbow, suggesting recession and emphasizing the outward thrust of the arm.

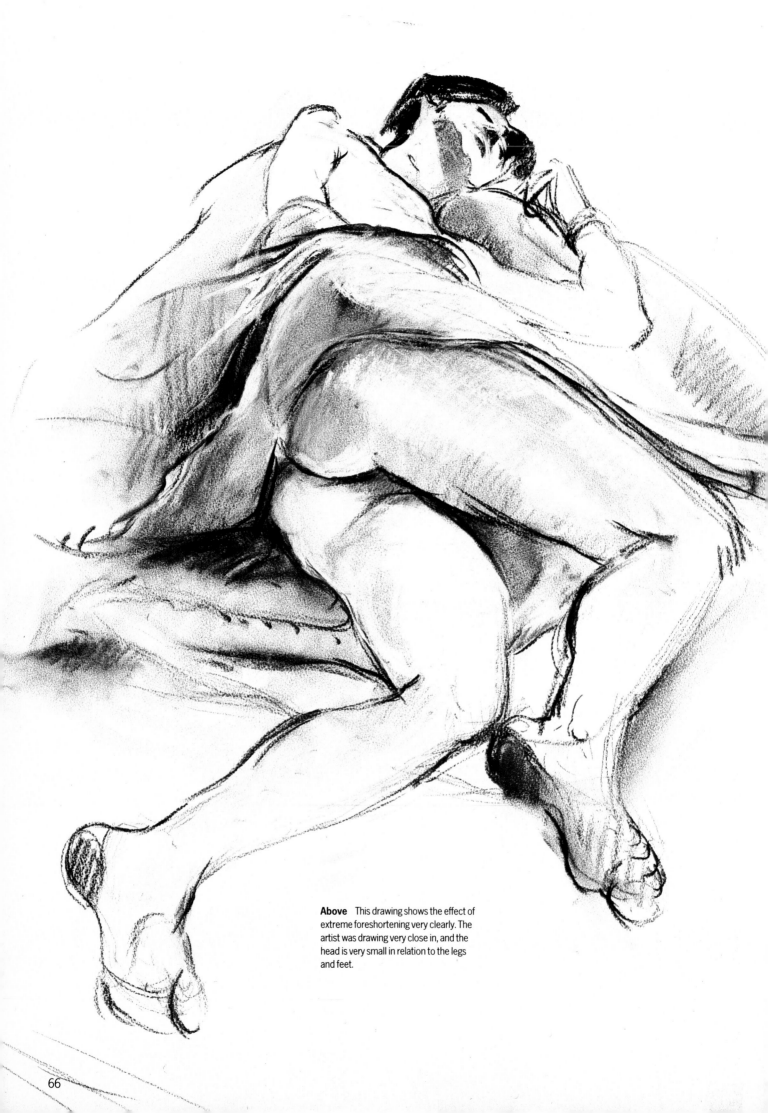

Above This drawing shows the effect of extreme foreshortening very clearly. The artist was drawing very close in, and the head is very small in relation to the legs and feet.

Right In the diagrammatic drawing (top) the artist has made an analysis of the pose, using a series of straight lines to establish the direction of the various planes of the body. Linear guidelines like these are always helpful to work out the relationship of one part of the body to another.

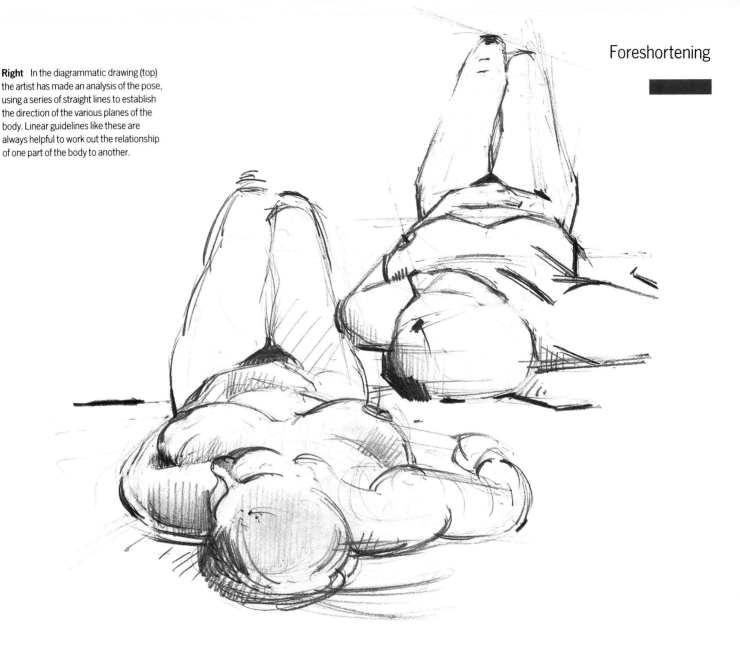

MASTER WORK

Luca Signorelli
1441–1523
Sketchbook page
Silverpoint

Luca Signorelli was born in Cortona, and worked in several towns of central Italy. His finest work was a series of six frescoes of the Last Judgement done for the cathedral in Orvieto, much admired by Michelangelo, who was to use the same theme years later in the Sistine Chapel. Like other artists of the time, Signorelli was interested in figures in movement – as can be seen from these drawings – and the frescoes show the nude figure in a wide variety of poses.

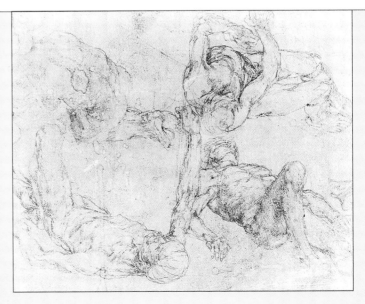

BRIEF

● **Exercise**

Making a separate study of the most complex forms. Using guidelines to draw them.

● **Objectives**

Learning to understand the basic structures. Enables you to draw the whole figure with confidence.

● **Suggested mediums**

Charcoal, pencil, conté crayon, pastel.

● **Cross-check**

Refer back to page 14-21 for extra help.

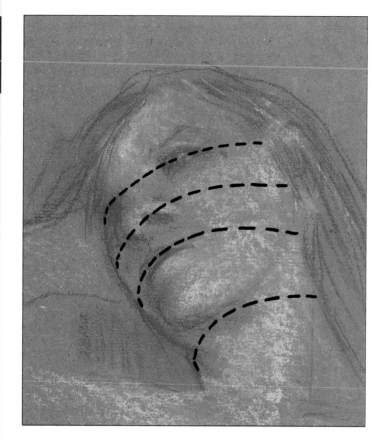

Left The easiest way to draw a head, especially when tilted, is to mark in simple guidelines that wrap around the head, as shown here. These are a great help in placing the features, and can be erased when the drawing is finished. A point to remember is that, although there are individual differences, the eyes and mouth generally line up with the top and bottom of the ear.

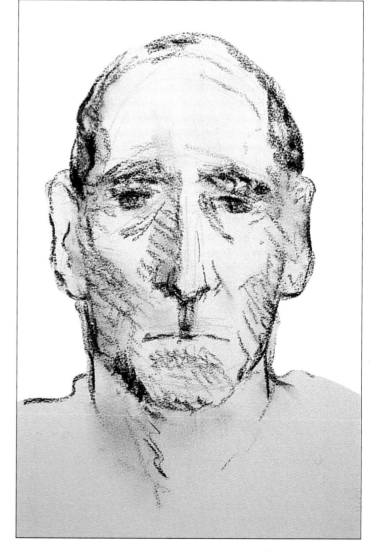

Right This charcoal drawing conveys a clear impression of an individual face. One of the "tricks" used by portrait painters is to measure the distance between the eyes and tip of the nose, as this triangle differs a great deal from one person to another. Also look for any slight curve of the features down the middle seam of the face – a face is rarely symmetrical – and for such points as the size of ears and the set of a mouth.

Heads, hands and feet

Above A drawing is more convincing when the slight difference between the two sides of the face is well observed, as in this delicate pencil sketch.

Right and below These profiles show the depth of the skull in relationship to the size of the face.

Until now I have almost disregarded the extremities of the figure, but this was a deliberate neglect. The aim of a life drawing is to express the person by making a portrait of the whole body, and if too much attention is focused on one part the whole suffers. Because the shapes of the head, hands and feet are complex there is a tendency to worry and linger over them far too long, and if one part of a drawing looks laboured the rhythm and immediacy is lost.

I believe that the solution is to make a thorough study of these parts separately so that they are well understood and can be drawn confidently. Since time before the model may be limited, you could try drawing your own non-working hand and use a mirror to draw your foot.

The head

The head and the neck should always be drawn together, as the angle of the head on the neck is crucial in suggesting the natural flow of movement from one to another. There is a great deal of variation in people's heads, and the overall shape is more important than the details of the features. Since the skull has only a thin covering of muscle and fat the planes of the bones are more easily seen than on other parts of the body. When drawing try to emphasize this structure – the roundness of the forehead; the two depressions at the side of the temples, the eye sockets and ridge of cheekbones giving way to the jawbone. You may find it helpful to refer back to the chapter on the skeleton in the earlier part of the book.

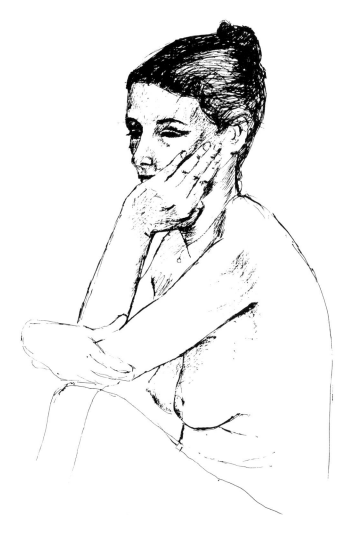

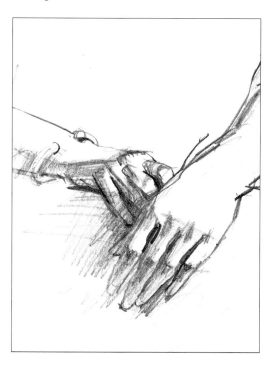

Left and below Since the hand is wrapped around the face in this biro drawing (left), it becomes an important part of the composition. The artist also made several pencil sketches of the model's hands (below) during a morning's drawing session.

MASTER WORK

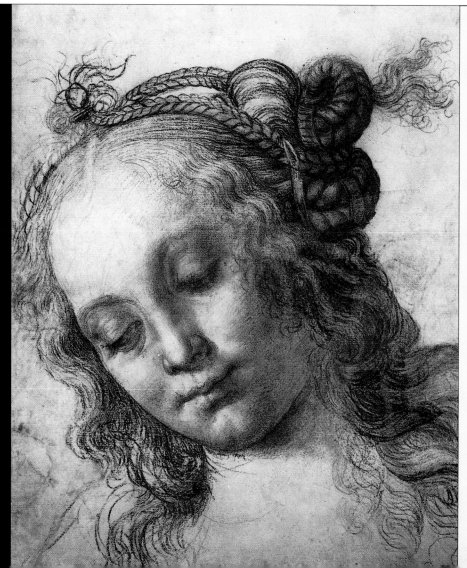

Andrea del Verrocchio
1435–1488
Head of a Woman
Black chalk heightened with white

Verrocchio was a sculptor, painter and goldsmith, whose workshop was the most prestigious in Florence. Among the students working there was a youth called Leonardo from the village of Vinci, whose fame was to eclipse that of his master, at any rate in the realm of painting – as a sculptor Verrocchio was supreme. The soft modelling and expression of this lovely portrait of a young woman shows something of the skills he passed on to his pupils, and is a clear forerunner of Leonardo's later work.

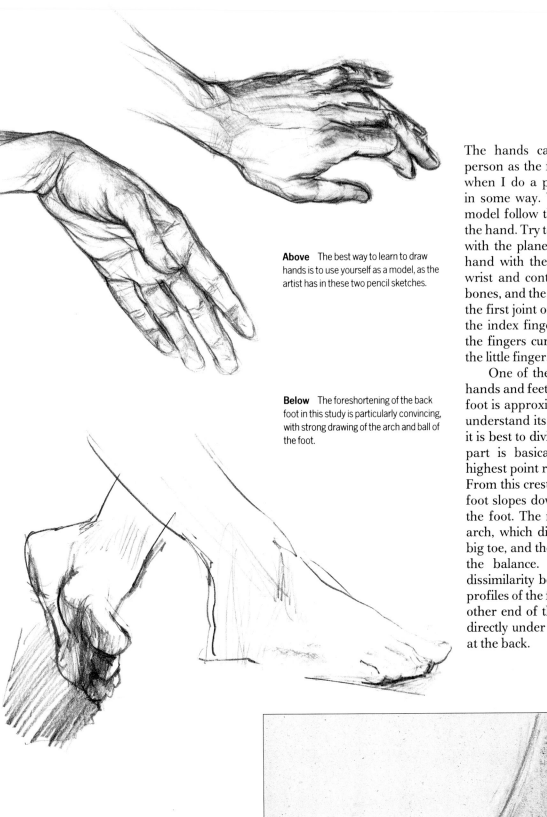

Hands and feet

Above The best way to learn to draw hands is to use yourself as a model, as the artist has in these two pencil sketches.

Below The foreshortening of the back foot in this study is particularly convincing, with strong drawing of the arch and ball of the foot.

The hands can betray as much about a person as the face, and sometimes more, so when I do a portrait I like to include them in some way. When you are drawing a life model follow the movement of the arm into the hand. Try to simplify the shape and begin with the planes of the hand: the flat of the hand with the bones fanning out from the wrist and continuing on to form the finger bones, and the triangular plane of the thumb, the first joint of which reaches the knuckle of the index finger. When the hand is relaxed the fingers curve inwards and around from the little finger.

One of the common mistakes with both hands and feet is making them too small. The foot is approximately one head in length. To understand its complex structure and planes it is best to divide it into two parts. The front part is basically wedge shaped, with the highest point running in line with the big toe. From this crest of the wedge the plane of the foot slopes down to the flat at the outside of the foot. The main weight is carried by the arch, which disperses it mainly through the big toe, and the other toes fan out, stabilizing the balance. This is the reason for the dissimilarity between the inside and outside profiles of the foot. The heel, which forms the other end of the weight-bearing arch, is not directly under the ankle but projects slightly at the back.

Right A red conté drawing of the artist's own foot showing the basic triangular form of the inside profile. The drawing was made using a mirror.

Without light, nothing can exist – it is this that creates both colour and form. The planes of the body are described by the way the light falls on them, and the second group of lessons shows the student how to exploit the effects of light and shadow to

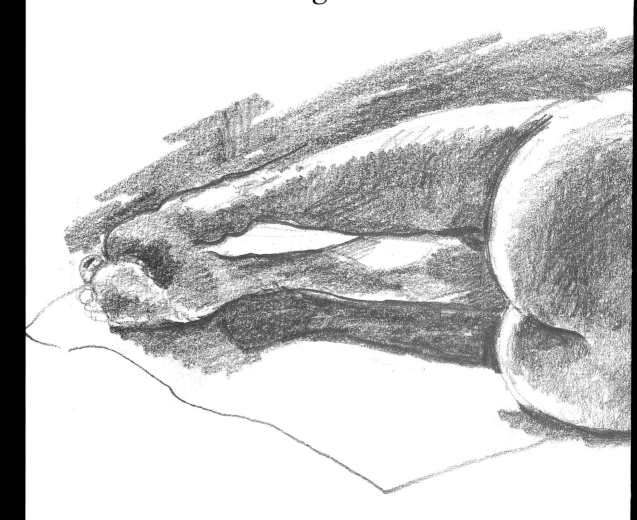

build up solid, three dimensional images. Individual lessons explore different media and approaches, such as using charcoal and erasers to work from dark to light, building up form by modelling with coloured pastels, and drawing with pen and wash.

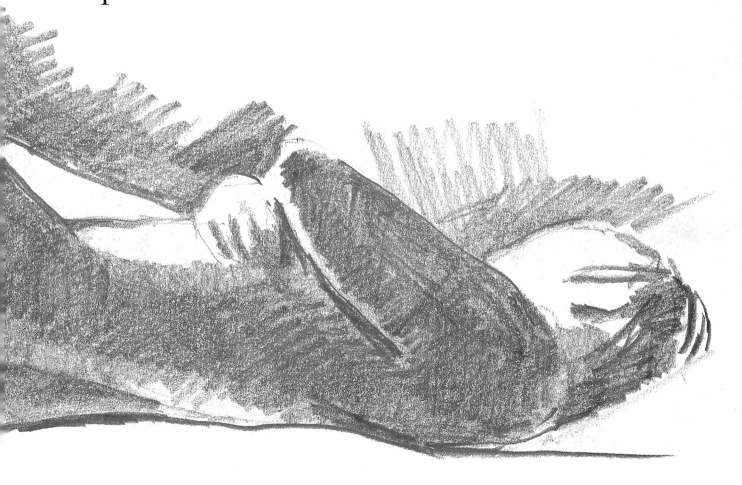

BRIEF

● **Exercise**

Using three basic tones to model form.

● **Objectives**

Building up a three-dimensional image. Learning to analyse the fall of light.

● **Suggested mediums**

Conté crayon and white chalk on toned paper.

● **Time**

One hour minimum.

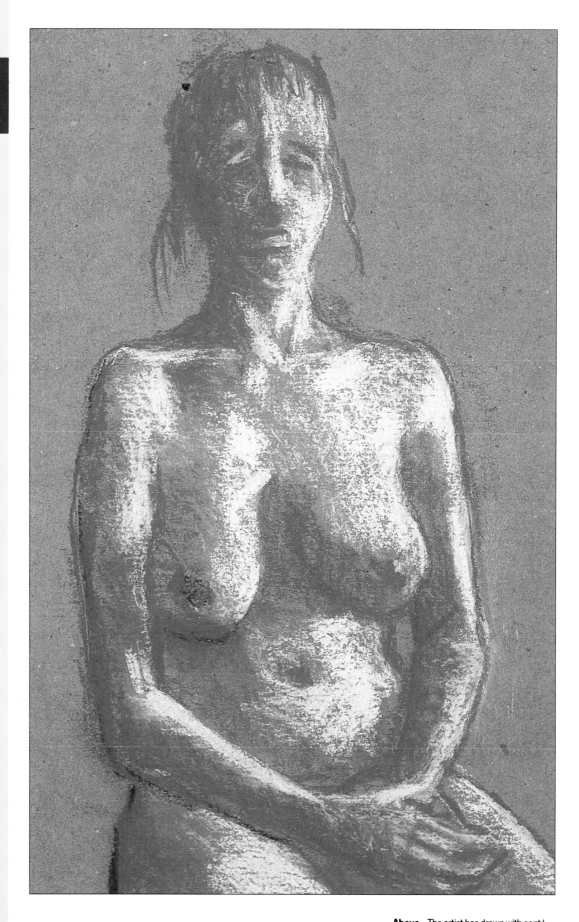

Above The artist has drawn with conté crayon and chalk on recycled paper, the rough texture of which encourages a very simple, direct approach. The emphasis is on form, and the detail kept to a minimum, giving a strong, sculptural effect.

Tonal drawing

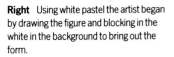

Above This drawing combines tonal modelling with the linear hatching technique shown in lesson 10. It shows the potential of a simple black and white line on toned paper.

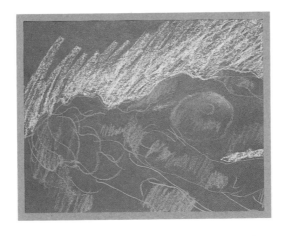

Right Using white pastel the artist began by drawing the figure and blocking in the white in the background to bring out the form.

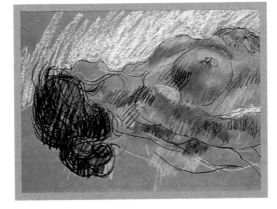

Right Black hatching lines were used for the shadows, and the colour of the paper stands as the basic flesh tone.

This lesson is concerned with modelling the figure with conté crayon or pastel on toned paper, a traditional way of working, as is the cross-hatching technique shown in the next lesson. Three basic tones are used, white chalk for the highlights, conté (or pastel) for the shadows, and the paper's own tone as the mid-tone.

Before going further it is important to define the word tone, which is sometimes believed to refer only to the shades of grey between black and white. This is a misconception; it also refers to the lightness or darkness of colours themselves. Choose a tinted paper of the same colour as the crayon, but a much lighter tone. For example, if you are going to use a sepia conté crayon, choose a beige paper, but if you prefer black conté, choose a grey paper.

Begin with a very simple, light drawing, either of the whole figure or part of it. Then look carefully at the model to see how the light is falling on the form. This may be difficult to see if there is strong overall light, so if possible turn off a few lights so the shadows are more clearly defined. Using the conté stick almost flat, start at the head, gently laying in the shadow you see – perhaps the side of the head or nose, the eye sockets, under the chin and so forth – all the way down the body. What you want to try for is a pattern of connected shadow running the length of the figure, so avoid small, scattered shadows. As you draw, imagine the shadows delineating a curved surface, and let the crayon follow the direction of the form almost as though you were sculpting it.

Once you are satisfied with the shadow areas, look for the highlights. I prefer white pastel to white conté for the highlights. Pick out just the strongest ones and use them to define the important parts of the body to give a roundness to the form. Once the darks and lights have been composed you can make any additions necessary.

Below Here the artist has used pastel on grey paper, and the first step (bottom) shows how he defines the body by simply putting in a few shadows and then working around the figure with white. In the final stage more detailed modelling and drawing has been added without losing the freshness of the drawing.

Right Two pastel colours were used for this drawing: earth green and a light flesh colour. The green was used for the basic drawing, with the differences of tone achieved by varying the pressure, and final flesh-toned highlights were put in last.

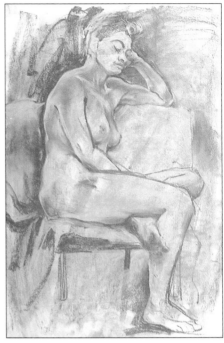

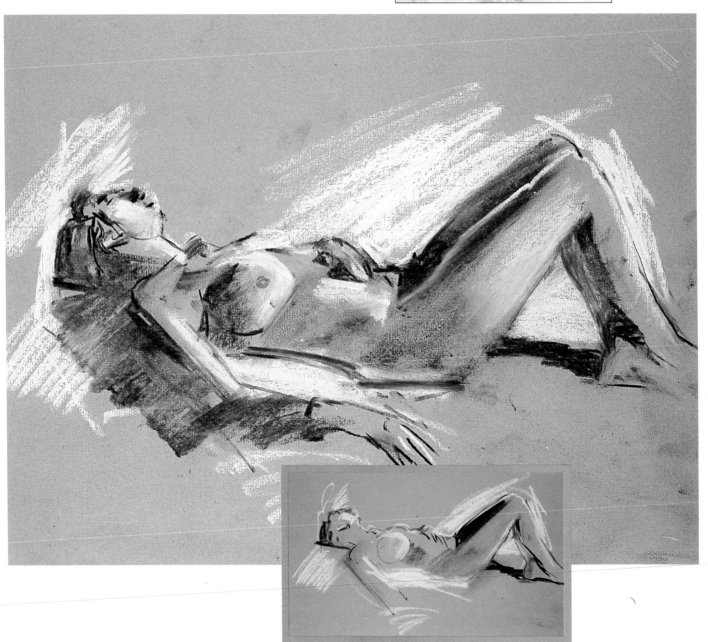

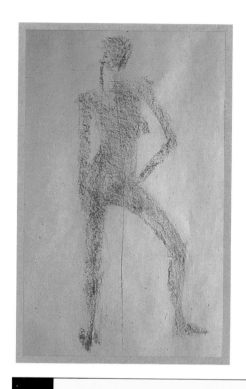

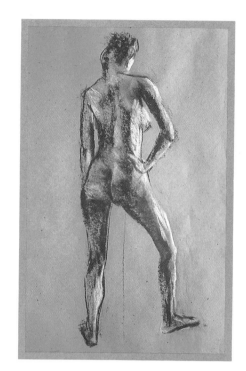

Right In the first stage of the drawing, done in pastel on rough (recycled) paper, the mass of the body has been blocked in very rapidly.

Left White pastel highlights were then laid over the first colour so that the two mixed slightly. This has produced a strong, sculptural effect.

MASTER WORK

Sir Peter Paul Rubens
1577–1640
*Study for the figure of Christ
on the Cross*
Black chalk and conté crayon

Rubens was the greatest master of Northern European Baroque art, with a prodigious output. Although most of his work was done in Antwerp, it was the eight years he spent in Italy from 1600 to 1608 that had the most decisive effect on his style. In this study of the crucified Christ we can see the influence of Michelangelo in the figure, while the head is pure Baroque, expressing the confidence and energy of the prosperous Reformation period.

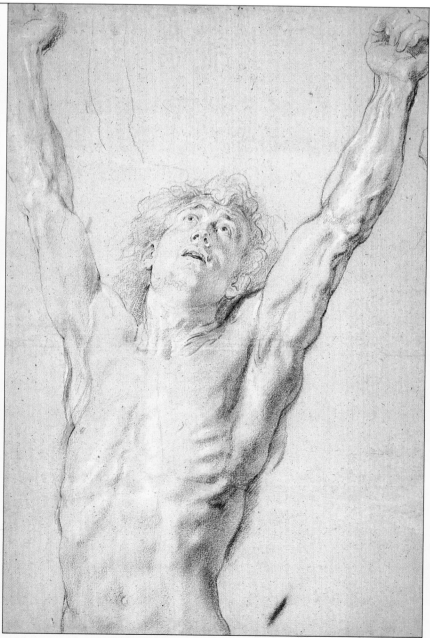

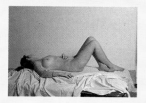

BRIEF

● **Exercise**

Building up tones by hatching and cross-hatching.

● **Objectives**

Encourages the student to explore a traditional method.
Provides a "shorthand" method of describing tone.

● **Suggested mediums**

Pen and ink, pencil, ball-point pen.

● **Time**

One hour minimum.

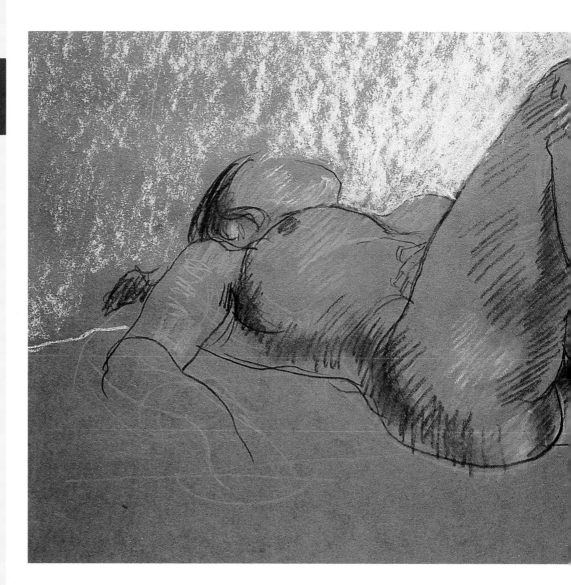

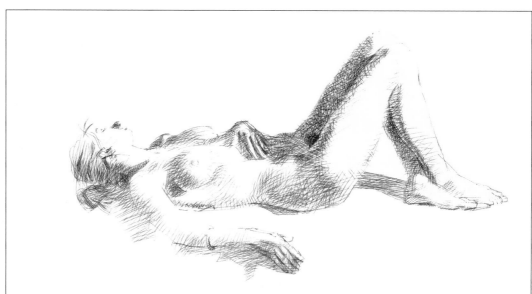

Above In this biro drawing the figure has been defined by using a light, feathery line to model the form. Where the light is strongest on the arm, the artist has omitted the top contour line, which gives the interesting effect of light bleaching out an edge.

Left Here the artist has used pastel pencil on coloured paper. The hatching lines follow the form around, emphasizing the three-dimensionality of the figure, and the line has a loose, lively quality. For consistency, the highlights have been added with a similar type of line.

Line into tone

It is important to have a method of defining tones (the light and dark areas) using nothing but line. You may find yourself on a train or bus with time to spare, interesting subjects to sketch and only a biro to do it with. A simple line drawing will probably not make a sufficiently comprehensive note of the subject. This lesson demonstrates some methods of turning a pen or pencil line into a variety of tones.

Hatching and cross-hatching

Artists have developed various methods, which serve as a shorthand, enabling a composition with depth and volume to be built up with line alone. The best known

Below This pencil sketch uses the traditional method of cross-hatching, with the lines kept parallel and straight. Where a deep tone is needed the lines have been doubled up by crossing over with a new layer, hence the name of this technique.

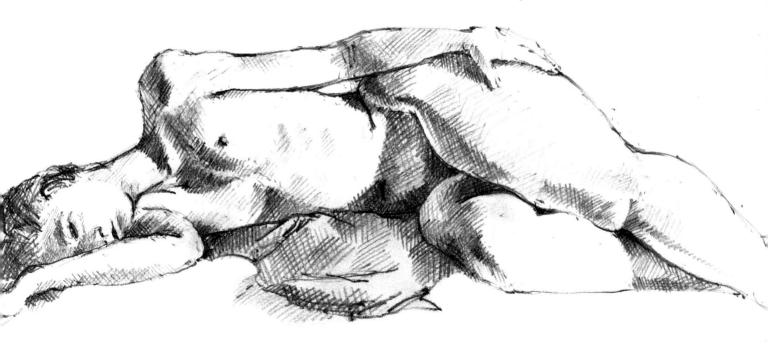

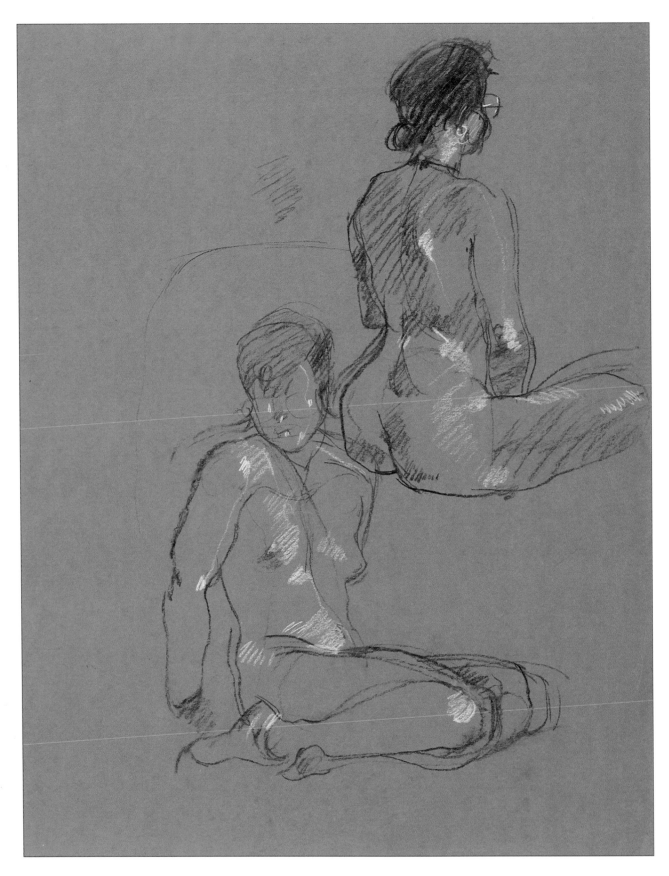

Above These quick drawings done in less than ten minutes, using firm bold hatching lines with charcoal and pastel on coloured paper, show how the artist can make a comprehensive note of the essentials of a pose with a few lines.

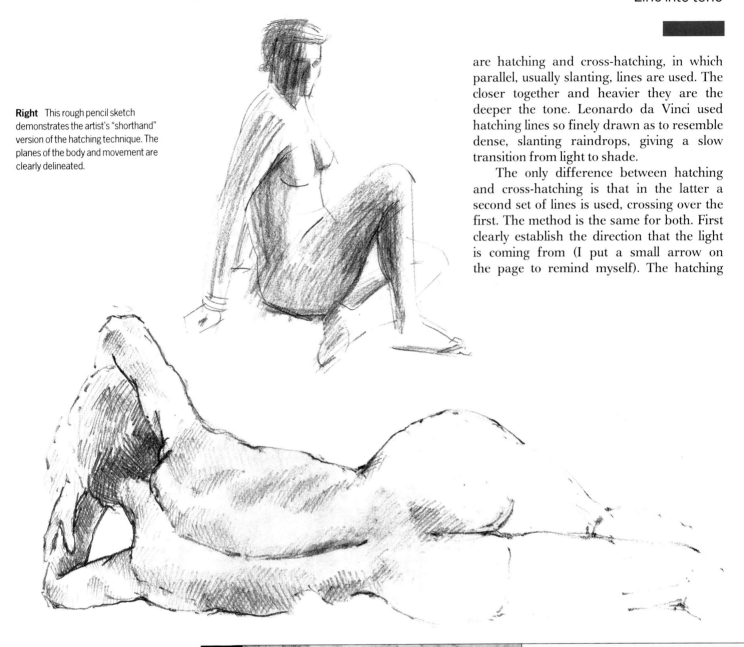

Right This rough pencil sketch demonstrates the artist's "shorthand" version of the hatching technique. The planes of the body and movement are clearly delineated.

are hatching and cross-hatching, in which parallel, usually slanting, lines are used. The closer together and heavier they are the deeper the tone. Leonardo da Vinci used hatching lines so finely drawn as to resemble dense, slanting raindrops, giving a slow transition from light to shade.

The only difference between hatching and cross-hatching is that in the latter a second set of lines is used, crossing over the first. The method is the same for both. First clearly establish the direction that the light is coming from (I put a small arrow on the page to remind myself). The hatching

Above Any linear medium can be used for cross-hatching, but this artist favours pencil, which she finds more controllable than pen and ink.

MASTER WORK

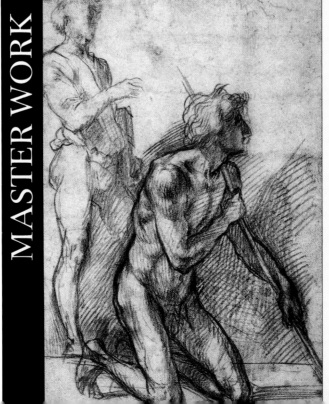

Andrea del Sarto
1486–1530
Study of a Kneeling Figure
Red chalk

Andrea del Sarto, whose name was derived from his father's profession (*del sarto* – "of the tailor"), was a Florentine Renaissance painter. He has tended to be slightly overlooked, as he was a near-contemporary of the two giants, Michelangelo and Raphael, but his exquisite and graceful draughtsmanship shows a rare talent. The busy lines of the cross-hatching in this study not only model the figure – probably a study for Christ carrying the cross – but also seem to give it life, so that it appears about to move.

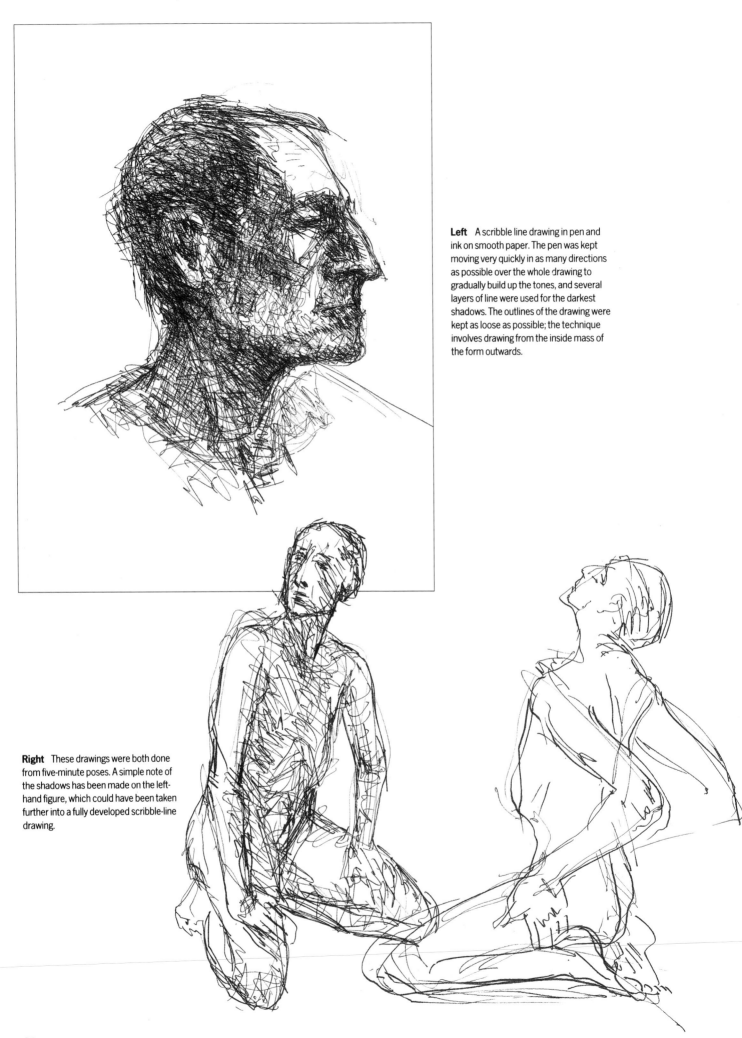

Left A scribble line drawing in pen and ink on smooth paper. The pen was kept moving very quickly in as many directions as possible over the whole drawing to gradually build up the tones, and several layers of line were used for the darkest shadows. The outlines of the drawing were kept as loose as possible; the technique involves drawing from the inside mass of the form outwards.

Right These drawings were both done from five-minute poses. A simple note of the shadows has been made on the left-hand figure, which could have been taken further into a fully developed scribble-line drawing.

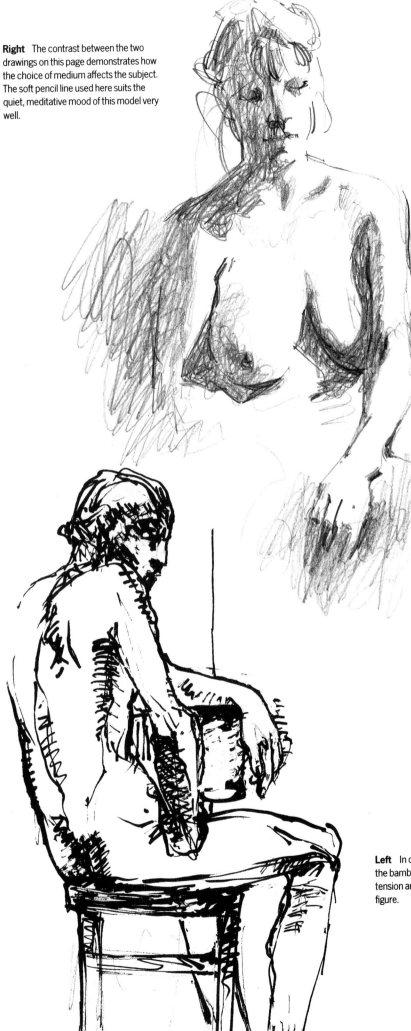

Right The contrast between the two drawings on this page demonstrates how the choice of medium affects the subject. The soft pencil line used here suits the quiet, meditative mood of this model very well.

lines can be straight or curved, following around the shape of the form, but in order to make a clear pattern of light and shadow they must be close, evenly drawn and parallel. I usually put them at an angle of approximately 45 degrees to the side of the page, adding crossing lines later and only in the darker areas. The alternative method, of curving the lines around to follow the form of the body, will give a more of a three-dimensional look than straight lines, which establish a pattern of flat shadow.

The quality of the line will depend upon the type of pen or pencil chosen. For an even, fine texture and soft transition from shadow to light choose a pencil, conté, fine pen or felt-tip. If you want a vigorous texture use a bamboo pen on watercolour paper. Rembrandt developed the technique using a quill pen, which gave him a very loose, flowing line. The density changed quickly with the slightest alteration of pressure to give vitality and a sense of immediacy never before achieved with cross-hatching.

Scribble line

In this century the technique was brought up to date by Picasso, who used a meandering or scribbled line which abandoned the concept of parallel hatching. This is an equally effective method of defining tone, though it takes some skill and experience to master the method. The pen or pencil makes a loose line backwards and forwards in areas of shadow, and the artist works over the drawing until he has built up the desired depth of tone. The lines are not kept parallel, but random and closely knit. The effect of an etching or engraving can be achieved with a steel tip pen and Indian ink or a fine drawing pen.

Left In contrast, the strong, rough line of the bamboo pen expresses the greater tension and sharper angles of the male figure.

BRIEF

● **Exercise**

Building up lights and darks with torn paper.

● **Objectives**

Teaches the student to analyse and simplify tone.

● **Materials and equipment**

Method 1: Pencil, paper in dark grey, light grey and white. Glue.
Method 2: Tracing paper, pencils in various grades. Glue.

● **Time**

One and a half hours minimum.

Right The first method, that of using manufactured coloured paper, has been used in this case. Having made a preliminary drawing, the artist begins with small pieces of dark paper to establish a framework for the drawing.

Below This is a detail of the drawing built up by the alternative technique, that of "toning" pieces of tracing paper with various grades of pencil.

"Drawing" with torn paper

Below If you compare this detail with that shown opposite you will see that the two methods create very different effects. The artists' styles also vary, and here the individual pieces are smaller, creating a slightly mosaic-like impression.

Left The artist prepares a sheet of tracing paper, using fine pencil lines to create a grey mid-tone. Softer pencils and a denser line are used for the darker tones.

There are two great obsessions in art: one is the flat design of the work, of which drawing is the essential part, and the other is light. It is frequently difficult to combine these two elements successfully. However, with an understanding of the way light illuminates form you will be able to plan how to use the pattern of light and shadow as part of the total composition, thus avoiding the pitfall of un-coordinated random light destroying the design element of the work.

There are, of course, a great many different ways to represent light in a figure drawing, several of which will be explored in later lessons. The technique shown here has a strong element of graphic design. It involves using three tones of paper (dark grey, mid-grey and white), which are torn and then stuck down onto a "base" drawing of the model. The value of the method is that it focuses your attention on light and shadow alone. You will have to observe the model carefully to see the planes of the body, so that you can separate them into different tones.

You can either buy sheets of paper in grey or make your own by rubbing tracing paper with pencil. If you choose the latter method, which gives a softer, sketchier effect, make up several tones by varying the density and pressure of the line in different areas.

For both methods, begin by making a simple drawing as a guide. Then look for the darkest shadows, and try to tear the paper to fit the shape – it is not nearly as difficult as it sounds. Identify the lightest tone next and proceed in the same way, leaving the middle tones – there will be at least two or three – until last. Continue until the entire figure is covered with the torn paper; it is a slow process so allow yourself plenty of time – at least an hour and a half.

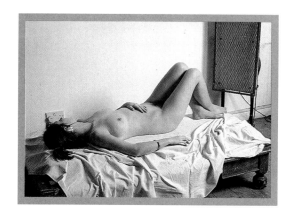

Below A light pencil drawing was made of the pose. The artist must be prepared to take time at this stage, as the drawing acts as a guide for the placing of the torn paper.

Above The model was asked to take a long pose, which would be held for an hour and a half, so she chose a relaxed, reclining one. Before rests, her position was marked with strips of masking tape.

Below Although the figure is complete, the artist did not have sufficient time to fill in the stand – this is a slow process. Because of the concentration on light and shadow, the drawing has a semi-abstract quality.

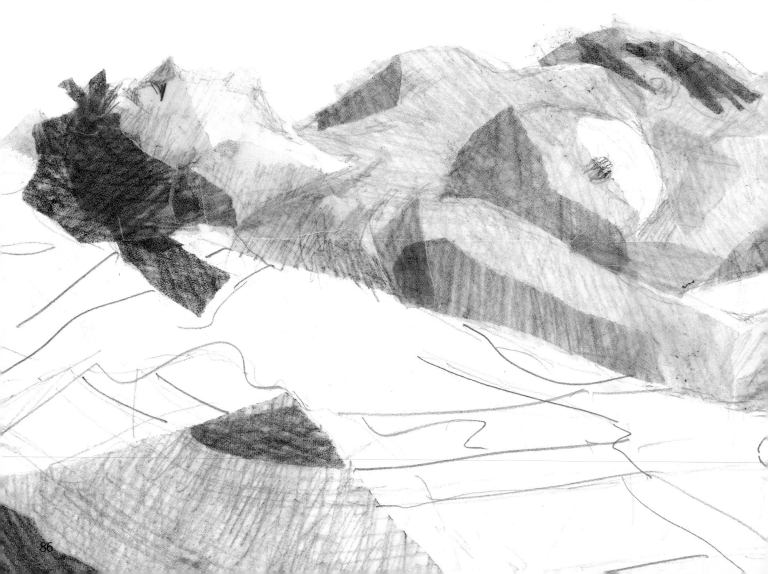

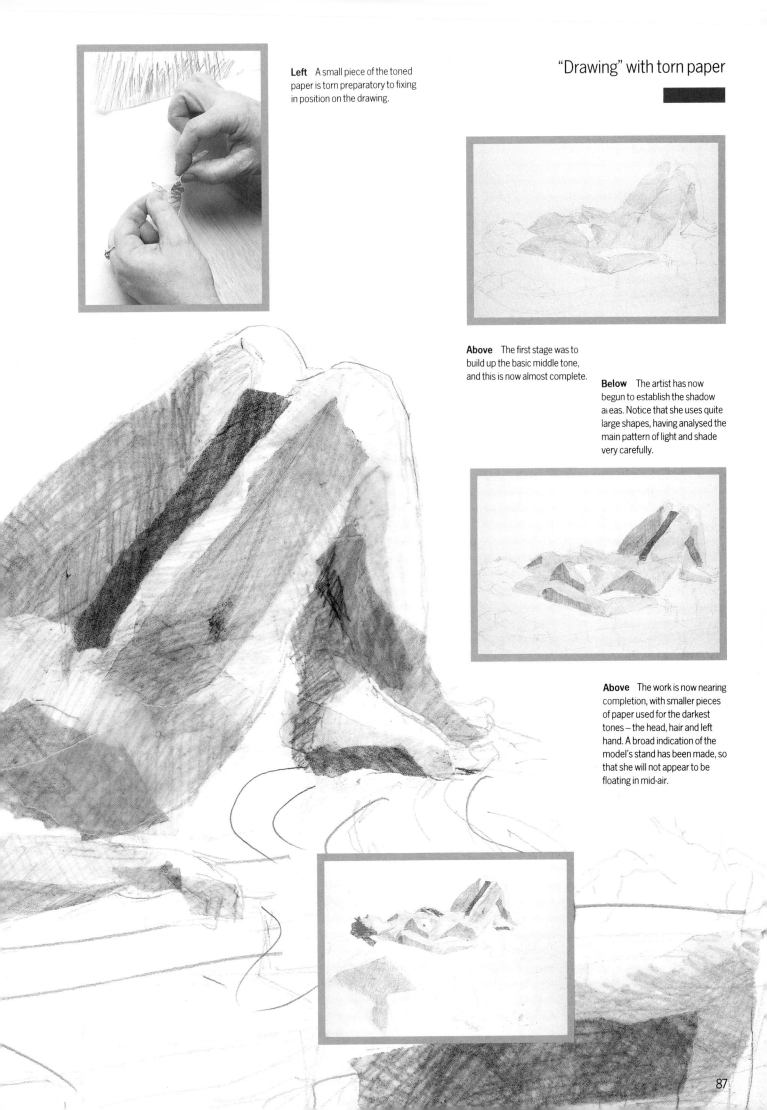

Left A small piece of the toned paper is torn preparatory to fixing in position on the drawing.

"Drawing" with torn paper

Above The first stage was to build up the basic middle tone, and this is now almost complete.

Below The artist has now begun to establish the shadow areas. Notice that she uses quite large shapes, having analysed the main pattern of light and shade very carefully.

Above The work is now nearing completion, with smaller pieces of paper used for the darkest tones – the head, hair and left hand. A broad indication of the model's stand has been made, so that she will not appear to be floating in mid-air.

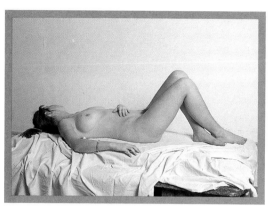

Above Both artists worked from the same pose, but from different viewpoints.

Above As in the work shown on the previous pages, the artist began with a light drawing, in outline only since the tones will be provided by the paper.

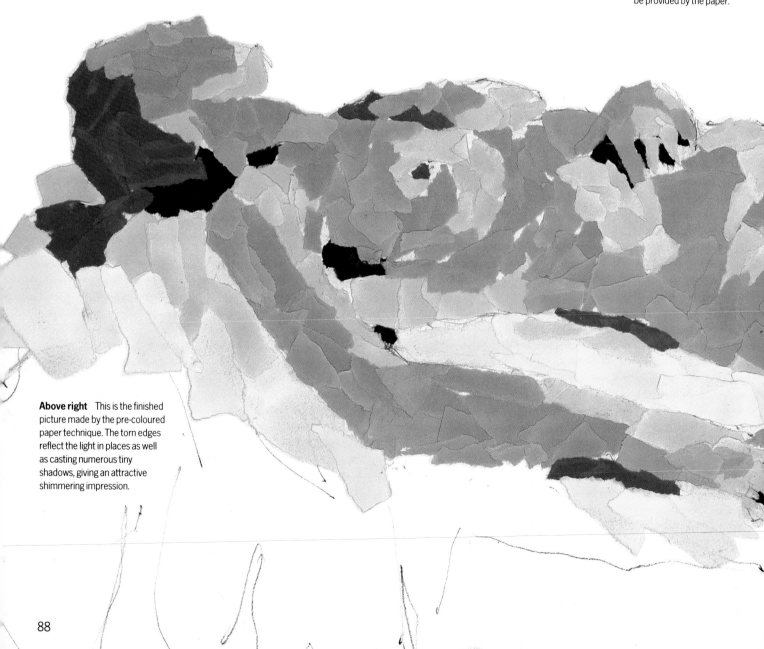

Above right This is the finished picture made by the pre-coloured paper technique. The torn edges reflect the light in places as well as casting numerous tiny shadows, giving an attractive shimmering impression.

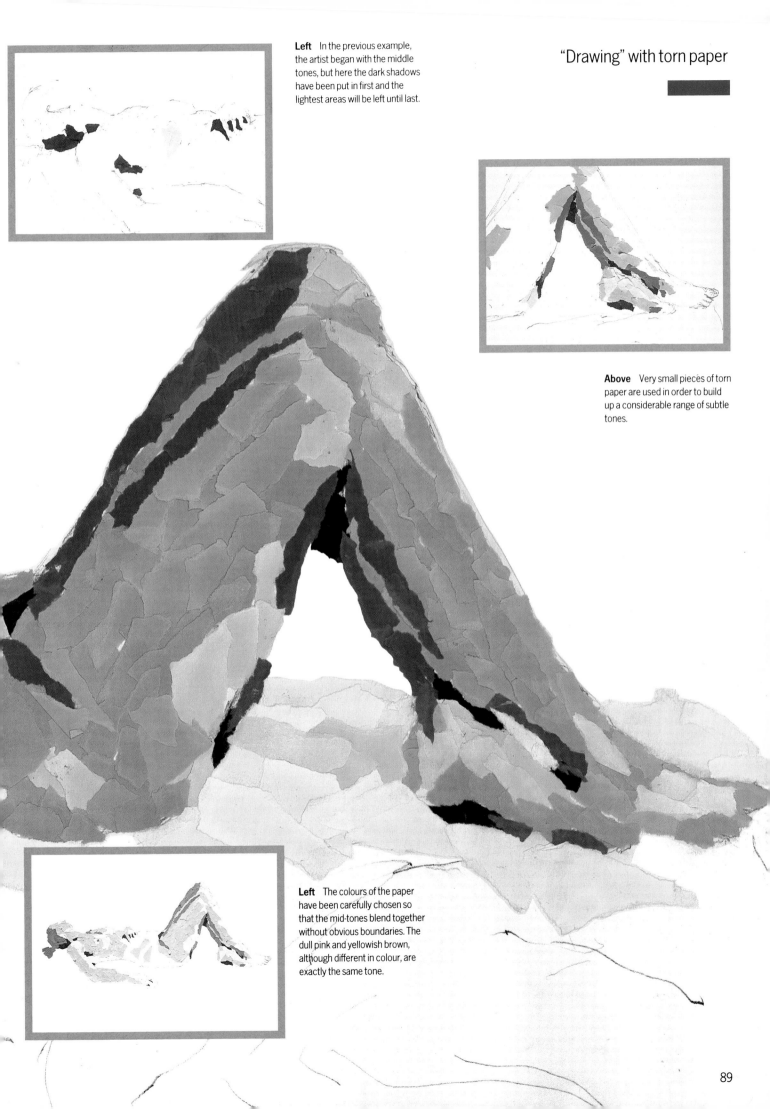

Left In the previous example, the artist began with the middle tones, but here the dark shadows have been put in first and the lightest areas will be left until last.

Above Very small pieces of torn paper are used in order to build up a considerable range of subtle tones.

Left The colours of the paper have been carefully chosen so that the mid-tones blend together without obvious boundaries. The dull pink and yellowish brown, although different in colour, are exactly the same tone.

BRIEF

● **Exercise**

Subtracting highlights.

● **Objectives**

Analysing form through
light and shadow.
Creating drama by high
contrast.

● **Medium and
equipment**

Charcoal, putty eraser.

● **Time**

One hour minimum.

Right The first stage is to cover
the whole of the paper with
charcoal so that it is evenly dark
but not black.

Below This detail of the finished
drawing shows the effect of the
method.

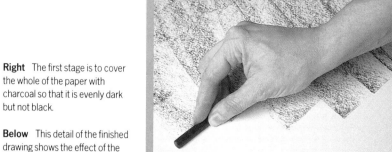

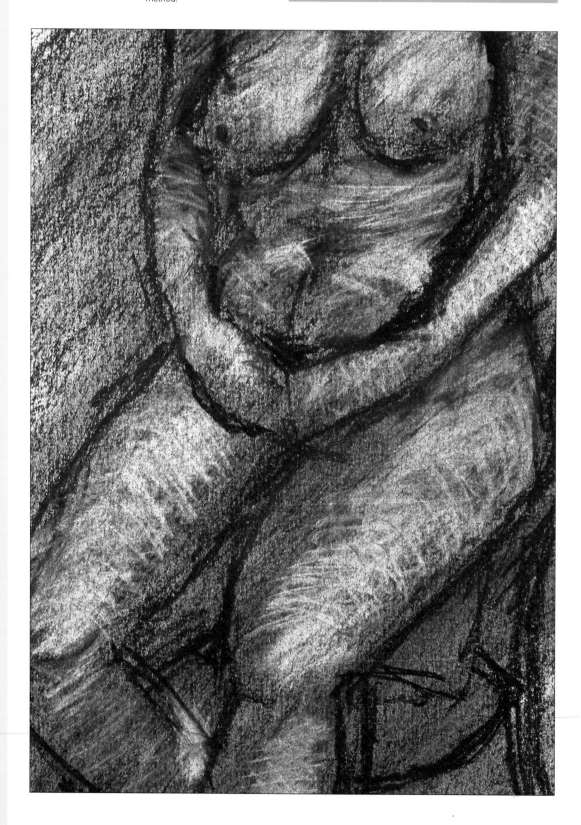

Working from dark to light

Left Now make a simple, strong drawing with willow charcoal.

Right Lightly rub the paper with soft tissue to blend the drawing into the background. Aim at softening the lines but take care not to obscure them completely.

Left Begin to pick out the strongest highlights with putty eraser. As can be seen from the detail of the finished drawing (far left), the eraser can be used very much as a drawing implement to give a delicate, linear effect.

This lesson explores a quite different approach to any used up to now. Instead of building up tone, this method involves laying in the dark areas first and "subtracting" the highlights. For anyone who becomes over-worried about line, drawing in this way can be a liberating exercise, as it forces you to abandon preconceptions.

You will need good-quality cartridge paper and a soft, thick stick of charcoal. Start by rubbing the paper all over as evenly as you can, using the side of the charcoal. Make the paper quite dark, but not completely black. Then, using the same charcoal or a stick of willow charcoal, make a drawing of the model. It is important to make a very strong, dense drawing, so if you make a mistake do not erase it but draw over the lines. When you bring in the light patterns they will impart organization to what may now look like chaos. When the drawing is finished carefully rub over the whole page with a small pad of soft tissue to slightly merge the charcoal without obliterating the drawing.

Now look for the way the light is falling on the figure. If the studio is too well lit it will be difficult to see a pattern of light and shadow, so if possible turn off some of the lights. Take a kneaded putty eraser and pick out the strongest highlights on the figure, moving it over the form to give the impression of roundness. A putty eraser can be pulled or torn to give a point or flat edge, and you can draw with it just as you would with a stick of chalk. After you have put in the strongest highlights work down to the less important ones, taking care not to go too far or you will sacrifice the strength of the drawing.

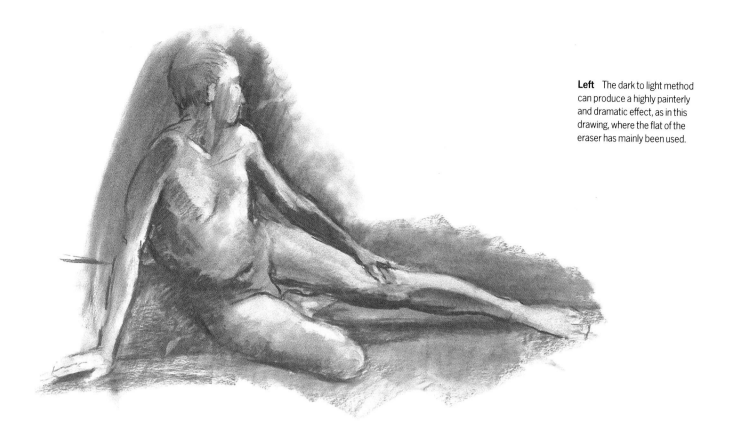

Left The dark to light method can produce a highly painterly and dramatic effect, as in this drawing, where the flat of the eraser has mainly been used.

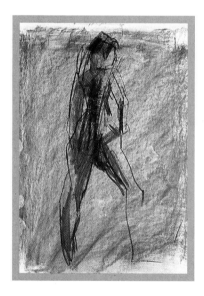

Left Whatever the medium and method, every artist has a different approach. This drawing is much more linear, and dark tones have been added for the shadow areas on the figure.

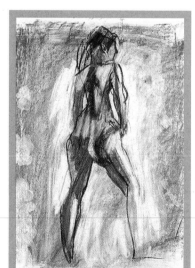

Left The taut linearity has been retained by using sweeping strokes of the eraser on both figure and background.

Right A few incisive lines with willow charcoal have defined the form and separated the figure from the background.

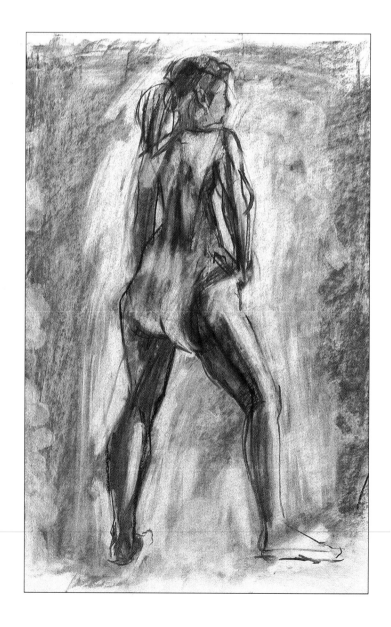

Working from dark to light

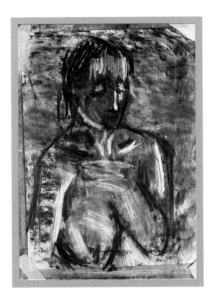

Far left A block of scene-painter's charcoal has been used to make this ground. The strong texture is the result of drawing with the paper held on a rough board.

Left The most pronounced highlights were removed first, with a piece of putty eraser pulled into a point.

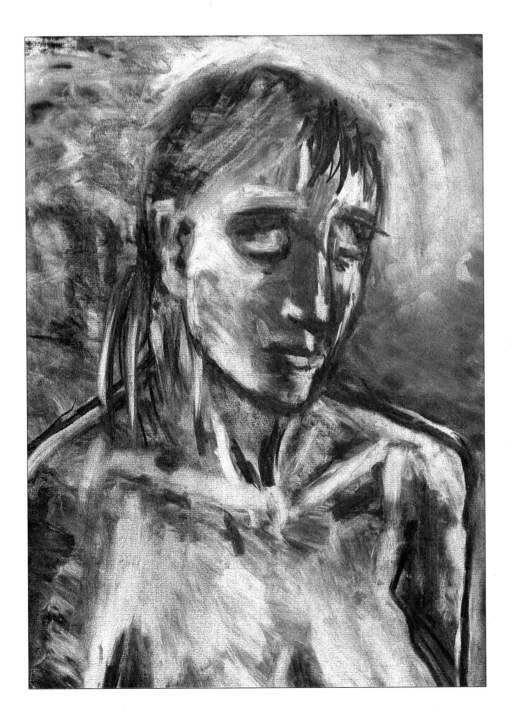

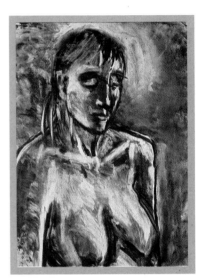

Above More of the figure begins to emerge as broader areas of mid-tone are established.

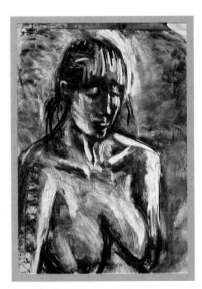

Above and left Face and body are now well-defined. A surprising degree of precision is possible with this technique.

THE PATTERN OF SHADOW

13

BRIEF

● **Exercises**

Drawing with pen and wash.
Drawing with brush and wash.

● **Objectives**

Helps the student to examine form rather than outline.

● **Mediums and equipment**

Method 1: Metal-nib pen or felt-tip, watered ink.
Method 2: Brushes, ink.
Watercolour paper (optional).

● **Time**

One hour minimum.

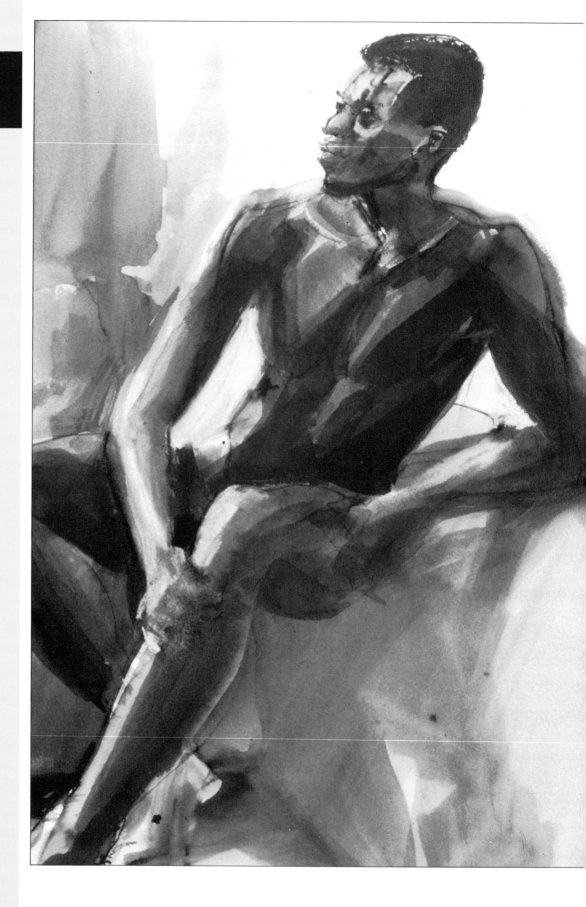

Above This pen and wash drawing has been built up in stages, beginning with the pen lines. A light wash was then laid over the shadows and mid-tone areas, leaving the highlights as white paper.

The pattern of shadow

Among the most delightful ways of rendering the nude are pen and wash or brush and wash. Poussin was a great master of the former technique, creating figures which possess both delicacy and substance. The pen line is light and lyrical and the wash gives a transparency to the flesh.

Pen and wash

The best pens are bamboo pens or quills; felt-tips or drawing pens can be used also, but the line is less sensitive and the ink tends to run when the wash is applied. The wash can be diluted Indian ink or watercolour. Use a light watercolour paper for the best effect; the pen line will be drier and more sensitive and the wash will not buckle or ripple watercolour paper as easily as cartridge paper. If you plan to use a great deal of wash you may need to stretch the watercolour paper first.

It is best to draw directly with the pen, but if you feel uneasy about this put in a very light placement sketch with a pencil first. Whatever type of pen you are using try to draw with long, fluid lines. Avoid a jerky start/stop effect, and above all lift the pen off the paper when you are at the end of a line or it will blot. When you have completed the line drawing and it has dried, erase any pencil guidelines with a soft eraser that will not damage the surface of the paper – any roughness will show when you apply the wash. Dust off the paper thoroughly before the next step.

Mix up a large quantity of wash in a dish before you begin so the colour and tone remain consistent throughout. A good watercolour brush or a (less expensive) Chinese brush can be used, either in large, sweeping

Above Some washes were laid on a still-wet layer below, giving a soft blurring, while others were worked "wet on dry" to create a crisp edge. The artist has used a flat-ended brush, which can give broad bands and sharp angles.

Above In this detail you can see how the artist uses the shadow pattern to describe the structure of the head.

Left A small natural sponge was used to take up some of the wash in places, leaving a lighter tone.

Right This is a relatively quick drawing of the pose shown above, done with a round brush and ink wash; the emphasis was on catching the movement with a few strokes. This type of brush gives quite a different effect to the flat one used for the drawing on the previous page.

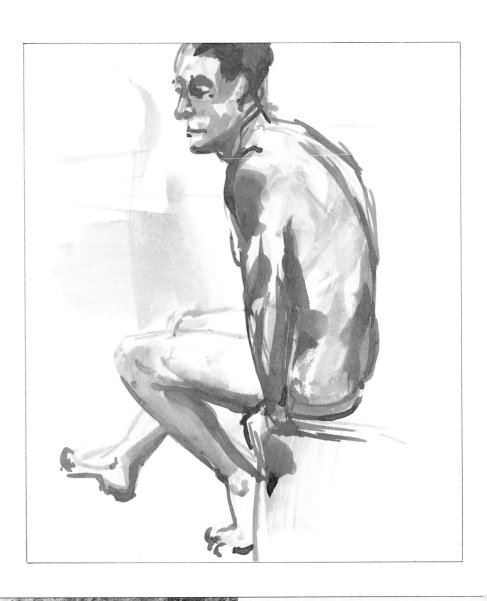

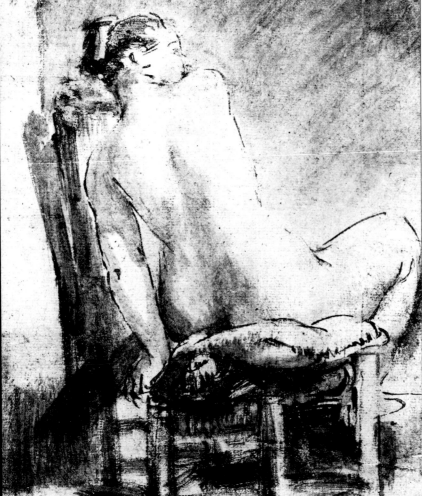

Rembrandt
1606–69
Seated Nude
Pen and wash

Rembrandt could create a complete image and a strong feeling of presence with the lightest pen line and wash. He has given the impression of light and shadow in this drawing by delicate modelling with the light concentrated on one side of the figure. Notice that the line has been used only where needed; there has been no attempt to make a complete outline of the figure, and in the hip area the body blends into the background.

movements down the body or more lightly controlled for sharp detail of smaller shadows. In the latter case, hold it at a right angle to the side of the paper, using the tip to make a crisp edge.

Brush and wash

This can be seen as the first stage in painting the figure. The approach is similar to the quick sketches in Lesson 2 in that the idea is to grasp the essential movement of the figure in a concise and economic manner. The same brushes can be used as for pen and wash, but in this case it is not desirable to mix up the wash in advance since a variation of tone helps to define weight, mass and light.

Begin directly with the brush, with no pencil drawing, and concentrate on capturing the general movement of the figure. Dilute the ink or watercolour to make a lighter line when called for and use the deeper tone for weight and shadow.

An alternative method is working on dampened paper, which creates a softer and looser type of drawing. This enables you to put in very large areas of wash quickly, as it spreads out on the dampened surface. More than one colour can be used. Brush clear water over the paper and allow the water to sink in slightly, until the surface is no longer shiny. The success of this method depends a great deal upon controlling the spread of the ink or paint on the wet surface, so a few

Above and right The same technique was used by both artists for this standing pose. A simple pen sketch was made and allowed to dry. Then a wash was put in with a round brush, and water was added to some parts of the drawing wash to dilute the wash for a lighter tone.

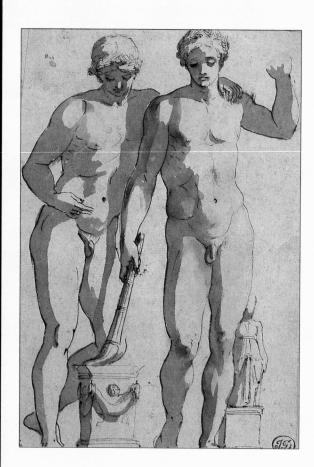

Nicolas Poussin
1593/4–1665
Marble Group of Two Athletes
Pen and brown wash

Poussin, generally thought to be the greatest French painter of the 17th century, found his real home in Italy. He spent most of his working life there, and the sculpture and antiquity of Rome were the main inspiration for his Classical style. This wash drawing of a marble sculpture of Castor and Pollux is very typical, and could have been drawn in the sunlit gardens of the Villa Ludovisi in Rome.

Right In this case a drawing was first made with a bamboo pen. This was allowed to dry, after which a wash of clear water was put on the shadow areas, and washes were laid on the still-damp paper. This technique gives a slightly softer shadow and allows greater control, because the shadow is "drawn" first with water. If mistakes are made with the initial water wash, this can simply be left to dry and you can start again.

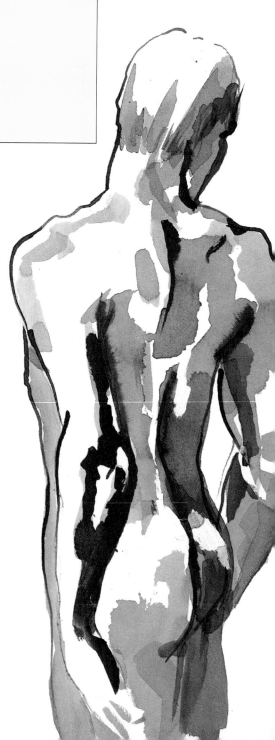

Left Watercolour paper was the base for this brush and ink wash drawing. Before the ink wash was put in, the shadows were laid out with areas of clear water; a very light pencil sketch having been made first to give some guidelines. After the water had sunk in slightly, the ink wash was carefully floated into the damp areas. A high degree of control is possible with this method because the ink is confined to the areas you have dampened; it will not run over the dry parts of the paper. Adjustments can easily be made by adding darker ink in some areas or lifting out with a small sponge to lighten the wash.

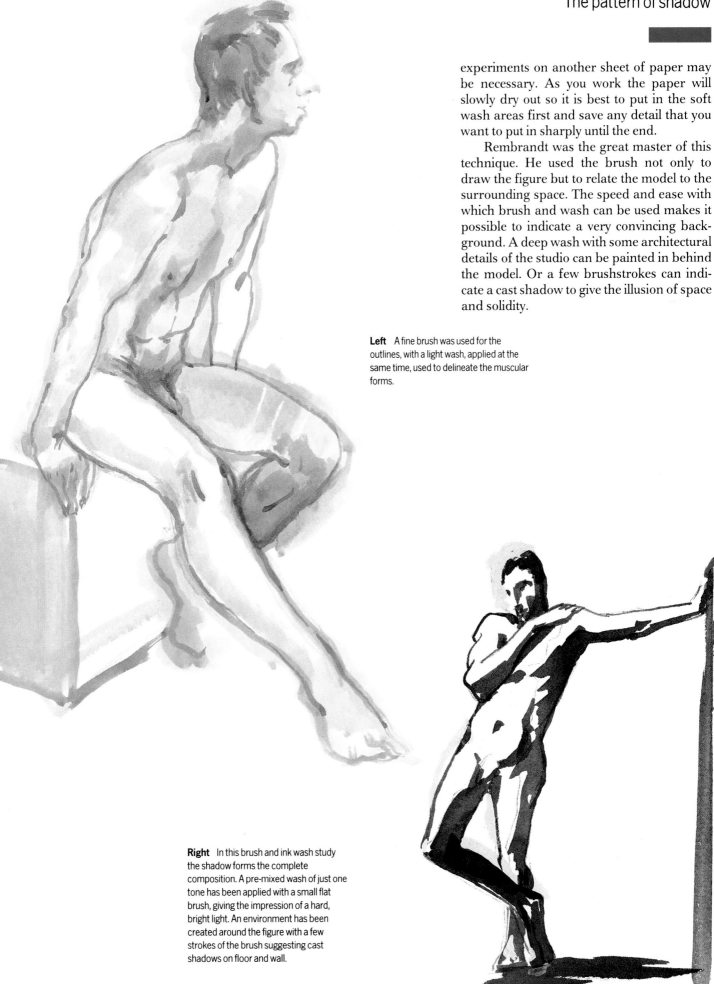

experiments on another sheet of paper may be necessary. As you work the paper will slowly dry out so it is best to put in the soft wash areas first and save any detail that you want to put in sharply until the end.

Rembrandt was the great master of this technique. He used the brush not only to draw the figure but to relate the model to the surrounding space. The speed and ease with which brush and wash can be used makes it possible to indicate a very convincing background. A deep wash with some architectural details of the studio can be painted in behind the model. Or a few brushstrokes can indicate a cast shadow to give the illusion of space and solidity.

Left A fine brush was used for the outlines, with a light wash, applied at the same time, used to delineate the muscular forms.

Right In this brush and ink wash study the shadow forms the complete composition. A pre-mixed wash of just one tone has been applied with a small flat brush, giving the impression of a hard, bright light. An environment has been created around the figure with a few strokes of the brush suggesting cast shadows on floor and wall.

BRIEF

● **Exercise**

Building up form with

warm and cool colours.

● **Objective**

Taking the first step

towards painting.

● **Suggested**
mediums

Soft pastel, coloured

pencils.

● **Time**

Two hours minimum.

Right This is a pastel done on rough watercolour paper, which provides an attractive, broken texture. The pastel sticks were used on the tip to give a loose, scribble-line effect. The cool tones were put in first and the warm flesh colours built up gradually.

Above This artist has also worked in pastel, but in this case on brown cardboard. The light flesh tones were built up over this base colour, which appears bluish in the shadow areas by contrast with warmer flesh tones. The main figure is in fact a reflection in a mirror; the model is in the foreground, and her shoulder and hip can be seen below.

Modelling with colour

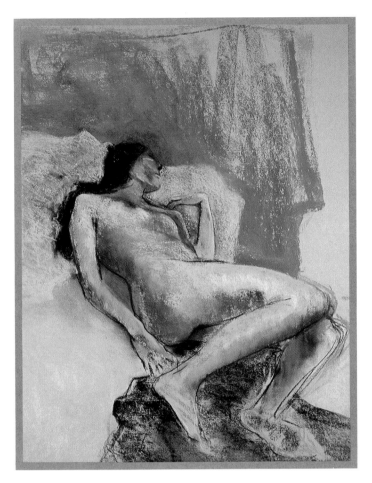

Above A drawing was first done in charcoal, with the colour of the beige paper used as the basic flesh tone. The charcoal was blended for the shadows, and a light flesh tone added for the highlights. Other colours were also blocked in at this stage.

Painting proper is outside the scope of this book, but the drawing media do not exclude colour, and pastel in particular can create a very painterly effect. The texture of the paper is very important for pastel work. The sticks are made from almost pure artist's pigment, and have marvellous colour but poor adhesive quality, so a paper with texture is needed to hold the pigment. For a quick sketch, pastel paper is satisfactory and convenient, but if you want to layer the pastel and work heavily on it I advise a light watercolour paper. You can give it a preparatory wash of watercolour if you like, but make sure the paper is thoroughly dry before using the pastel.

There are a number of ways to model the figure with colour, but the basis for all of them is the fact that cool colours recede and warm colours come forward. In the past, artists often began their oil paintings with a light underlay of terre verte (green), which was allowed to dry before the warm flesh tones of a portrait or figure were applied. In Velázquez' later portraits this underpainting is still visible, particularly in the hands of the sitters.

To begin the pastel drawing make a light placement sketch of the model with a neutral-coloured pastel. Do not use pencil, as it is impossible to either cover or erase with

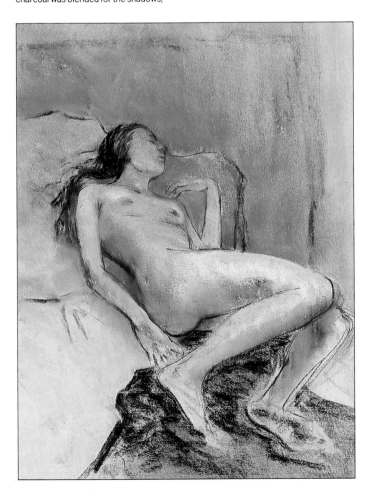

Left Adjustments were then made to the colours of both figure and background, giving both a rich glow. The blue cloth was blended slightly with the fingers to soften it.

101

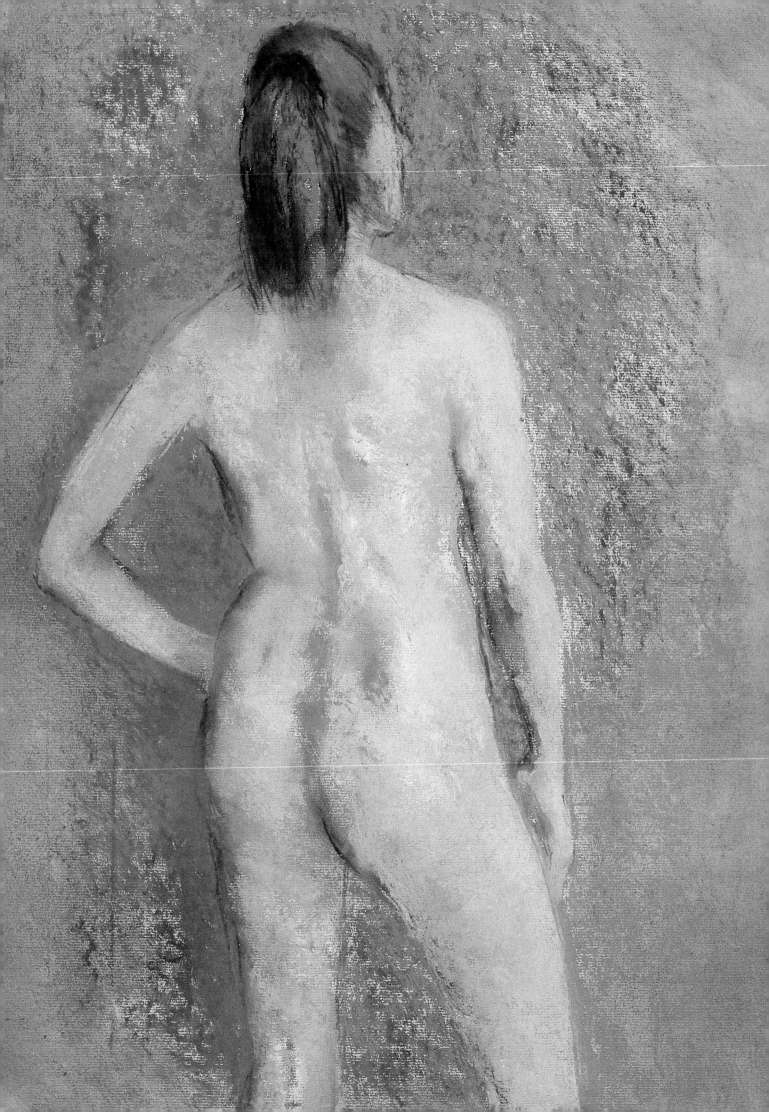

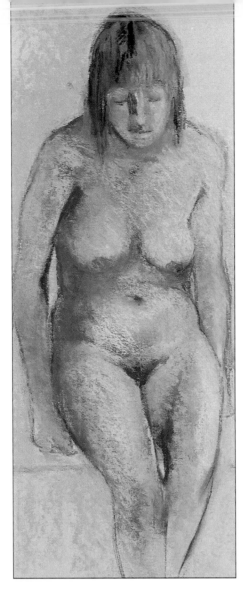

pastel. Once you are satisfied with the placement, begin putting in the shadow areas with a cool shade of blue or green. You can do this with the side of the pastel or you can use a scribble line or short strokes to build up the pattern of shadow and light.

Next look for the strongest highlights on the figure and, using a very light tone, put them in provisionally. Once the lights and darks are drawn, you can begin putting in the more subtle middle tones. Some pastellists spray the drawing with fixative at this stage to prevent the colours from mixing too much. This is ideal if you want a layered effect. If, on the other hand, you want the middle tones to softly blend into the shadow area, save the fixative spraying to the end. Many adjustments can be made at this stage, and the colours can be built up like a painting. If you want the final highlights to stand out, spray before putting them in.

Opposite White paper was the base for this pastel and the background texture was obtained by taping it to a rough wall. The flesh colours were built up gradually from cool green shadows, and slightly blended in some areas, leaving others with a harder edge. The background colours were sprayed between layers to keep them from mixing.

Above This almost monochromatic pastel was worked on pink paper. This is the simplest method of modelling with colour: a dark tone of the same colour as the paper is used for the shadows, and white for the highlights.

MASTER WORK

Edgar Degas
1834–1917
After the Bath
Pastel

Although a painter of genius, Degas always saw drawing as his prime concern, and criticized other artists for following colour rather than line. He particularly liked pastel because it offered the perfect synthesis between the two, and in all his pastels the drawing element is very evident. Here he has built up the form by means of diagonal hatching strokes, using warm colours for the light side of the body and cool blues and mauves for the shadows.

BRIEF

● **Exercise**

Drawing a back-lit
figure.

● **Objective**

Introduces a new way of
treating shape and
form.

● **Suggested
mediums**

Charcoal, graphite
stick, conté crayon,
pastel.

● **Time**

One hour minimum.

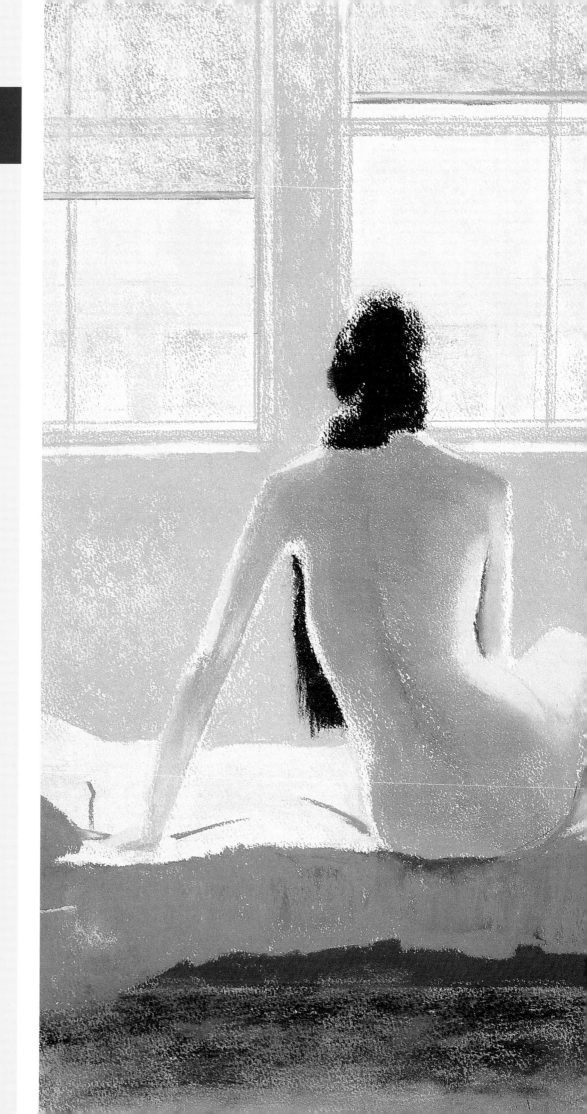

Against the light

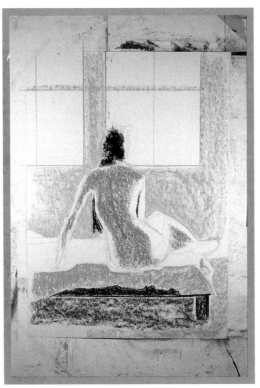

Above In a pastel composition, the tones and colours of the basic shapes are planned at the first stage, and here they have been blocked in broadly. When you are working against the light, the light source itself and the dark shadow areas will form the basic structure, and if the dark tones are not both strong enough and consistent throughout, the picture will not work. It is helpful to make small thumbnail sketches in advance so that you can work out how dark the shadows must be in order to convey the impression of backlighting. Here the dark, warm tone used for the model's back is balanced by the cool blue shadow on the sheet – a bit of artistic licence.

Left Although the plan of the picture has not changed, many adjustments were made between the first stage and the finished picture. Cool blue, for example, now overlays the warm shadow of the back, linking up with the blue of the bed. The view has been drawn in with pale colours to give the bleached-out effect of strong sunlight, and all the tones of the interior have been deepened for greater contrast. The window shades were an invention, necessary to balance and "top out" the composition.

Drawing against the light, or *contre jour*, is one of the most intriguing and attractive ways of using light (it is used a great deal with still-lifes). It may appear a bit daunting at first, but the principles are quite simple and the effect fascinating; it can transform what might otherwise be a very pedestrian composition. In many works the light source is taken for granted, whereas with *contre jour* it is all-important.

There are two main factors to consider. The first is the amount of light behind the model, for instance is she seated in front of a very sunny window or illuminated by the softer light of late afternoon? The second point is the way the model is posed: she may be completely against the light or at a slight angle to it. If the light behind the model is very strong the contrast between it and the figure will be enormous, and any cast shadow on a chair or the floor will be a very dark tone. In such a case, the background of the window can be drawn in with pale colour to simulate the bleached-out effect of strong light. The flesh tones of the model will be darker than normal since the body is almost completely in its own shadow.

This brings us to the most interesting part of the drawing. Since the figure is a curved surface, not a two-dimensional cut-out, the light not only illuminates the edge of the form but moves around to envelop the outside of it too. Thus we have the reverse of the usual kind of modelling, with the darkness in the middle and the light tone on the outside. If the model is slightly turned towards the light you will be able to pick out the highlights on the body and create a very three-dimensional effect. When the light is softer the contrast between the figure and light source is much less, and any shadows are more diffuse.

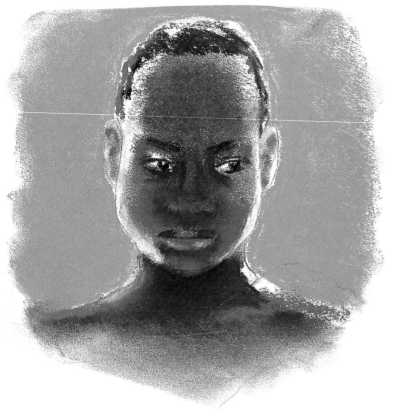

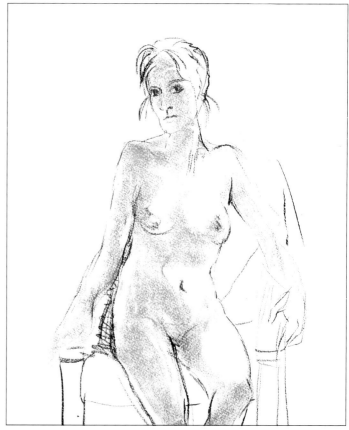

Above A small piece of pastel, held flat, was used to model the head very smoothly. A heavy pressure down the middle of the face ensured a deep tone, and then the pressure was eased so that the pastel glided lightly to make a soft edge, giving the effect of the halo of light. The eyes and mouth were left largely as areas of uncovered paper.

Above This is the first stage of the pastel composition seen opposite. The basic drawing has been done, and the pattern of shadow across the figure established.

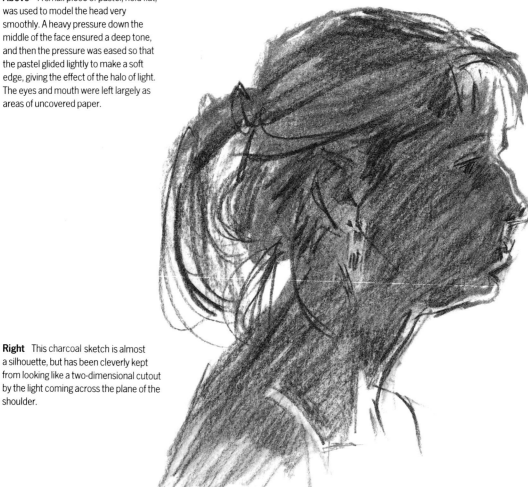

Right This charcoal sketch is almost a silhouette, but has been cleverly kept from looking like a two-dimensional cutout by the light coming across the plane of the shoulder.

Opposite The next stage is to create the environment, as this will make the idea work. Since the heavy shadows on the model tell us that there is a great deal of light coming from somewhere, it is helpful as well as logical to show the source, so pale yellow, the most effective colour for sunlight, was added to the background. The cover on the chair was darkened to contrast with the figure, balance the dark hair colour and give the weight to the composition. This sunny picture was actually done on a dull afternoon, with the natural light effects on the model observed but the differences in light and dark tones greatly enhanced.

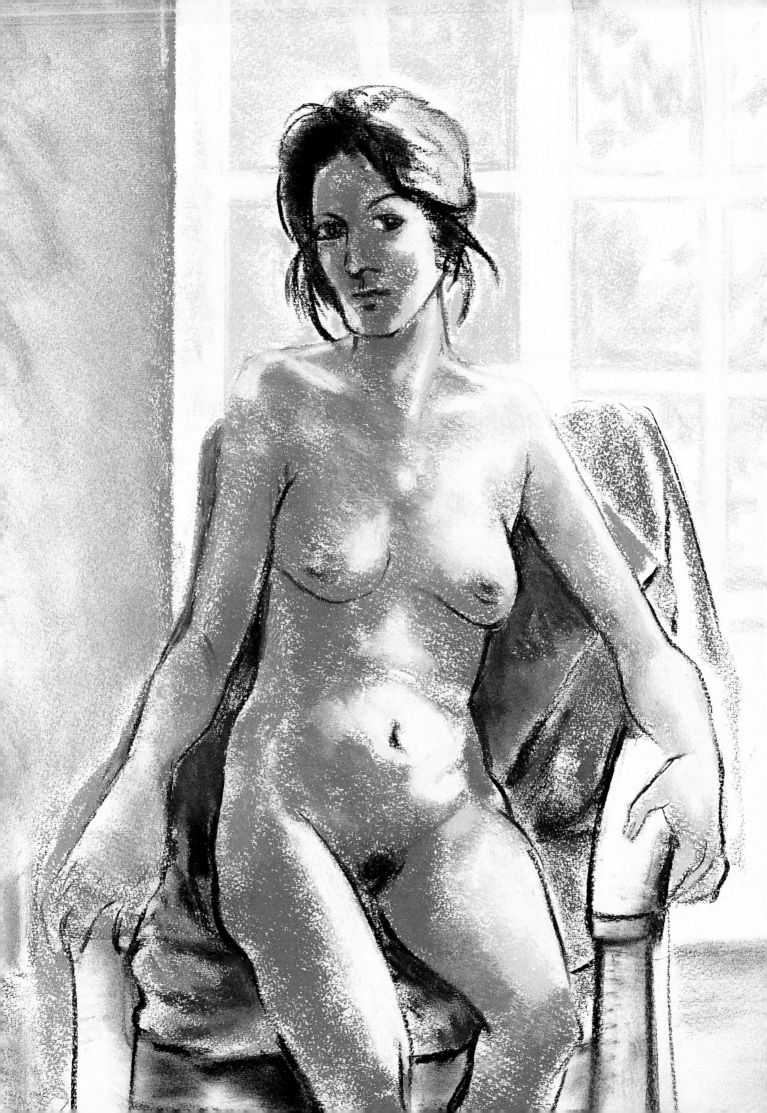

BRIEF

● **Exercise**

Using shadow to break up and describe form.

● **Objectives**

Enlivening an otherwise dull pose.
Learning a method of creating mood.

● **Suggested mediums**

Charcoal, graphite stick, pastel, pen and ink.

● **Time**

One hour minimum.

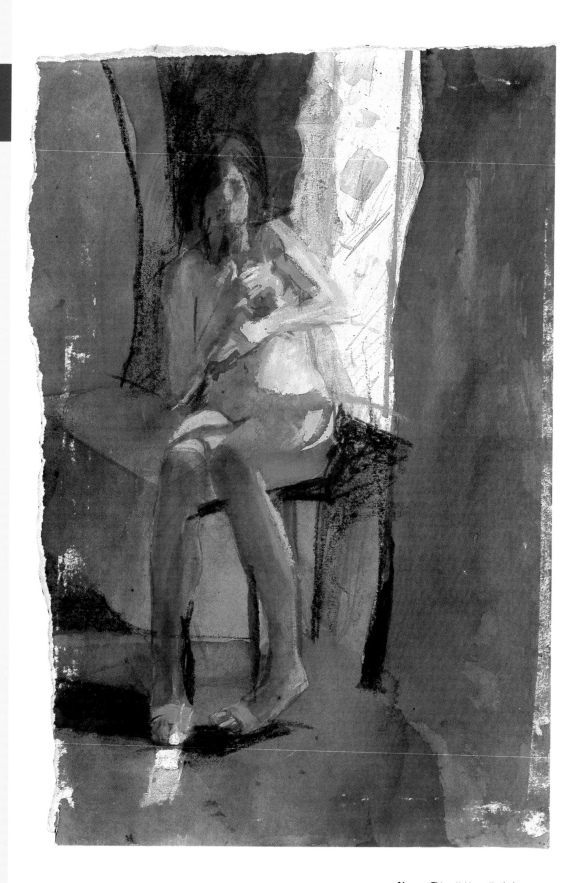

Above This artist is particularly interested in the play of light on forms, and has explored the idea in this sketch and those opposite. Here the strong sunlight from the window and the window itself have been used almost as abstract shapes. The curved bars of shadow on the hip and right thigh break up the main forms into a series of small, tonally distinct areas, giving a dynamic quality to the composition.

Using cast shadows

In these four pencil drawings in a sketchbook, the artist analyses the effects of light and cast shadow on the figure.

1 The converging lines of the Venetian blind behind the model are balanced by the opposing, stronger bands of shadow that follow the form of her body, creating an energetic composition.

2 In this drawing the mood has changed. The slow, downwards curve of the pattern of light and shadow is barely interrupted as it moves over the slumped form.

3 In this sketch the whole room appears flooded with light, the busy lines of shadow increasing the sunlit feeling.

4 Here the angular bands of cast shadows form a strong pattern, adding movement to a basically tranquil pose.

1

Used successfully, shadows thrown on a form give the figure a very three-dimensional appearance. For example, the pattern of light and shadow thrown over the body by a Venetian blind describes all the planes and curves. The patterns give an exciting graphic quality to a drawing, which can enhance an otherwise boring composition, and they also give depth, weight and solidity to the figure.

The stronger the light the darker the shadow that will be cast. A cast shadow is both darker and better defined close in; it diffuses and enlarges as it stretches out from its source. When you are drawing a shadow, start at the root and slowly fan out, lightening the shadow as you go. You can work either with tone or with line. In the latter case the shadows can be put in with hatching and cross-hatching (see Lesson 10).

Shadow is a very strong element in creating a mood. The drawings and paintings of the great Norwegian painter Edvard Munch rely heavily on the long, eerie shadows of the Northern sun to create stark graphic images.

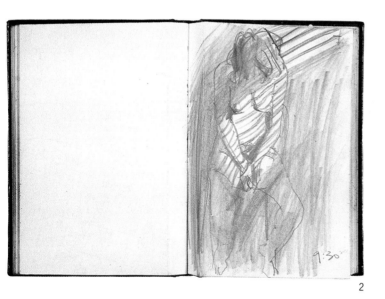

2

3 4

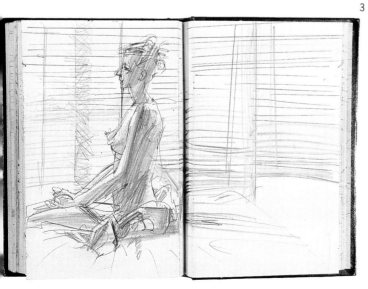

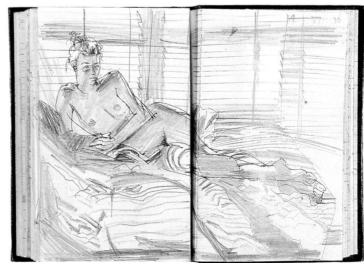

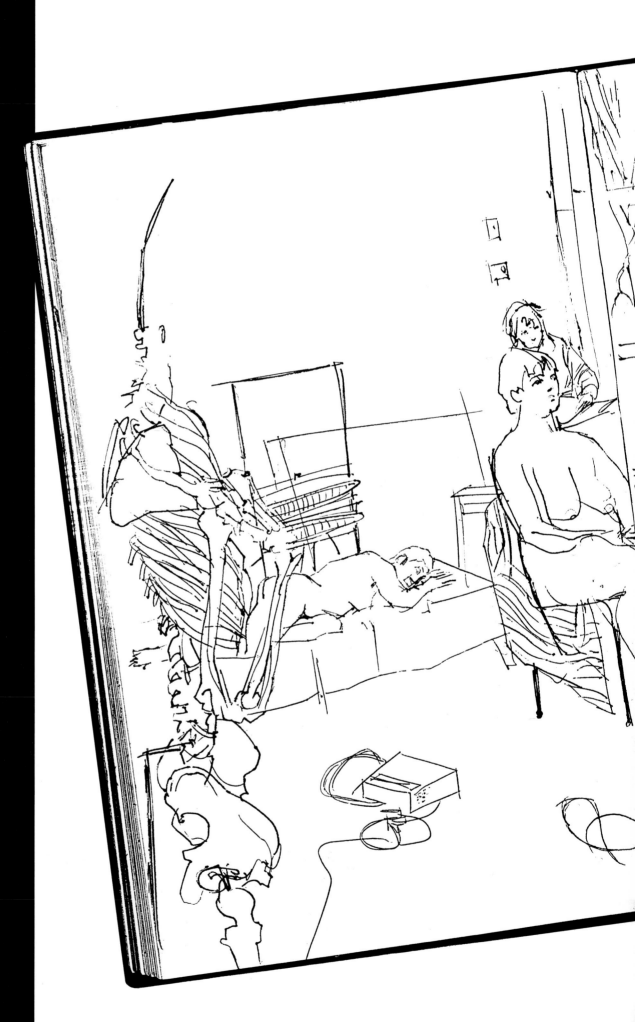

Drawing a life model is a valuable discipline, but there comes a time when you will want to say more about a person by placing the figure in a specific context. The following lessons show how a drawing can be composed, or orchestrated, so that you are creating something more ambitious than a sketch.

BRIEF

● Exercise

Using the figure as a cutout pattern.

● Objectives

Learning to use negative space. Seeing the figure in relation to the background.

● Suggested mediums

Indian ink, charcoal, graphite stick.

● Time

One hour minimum.

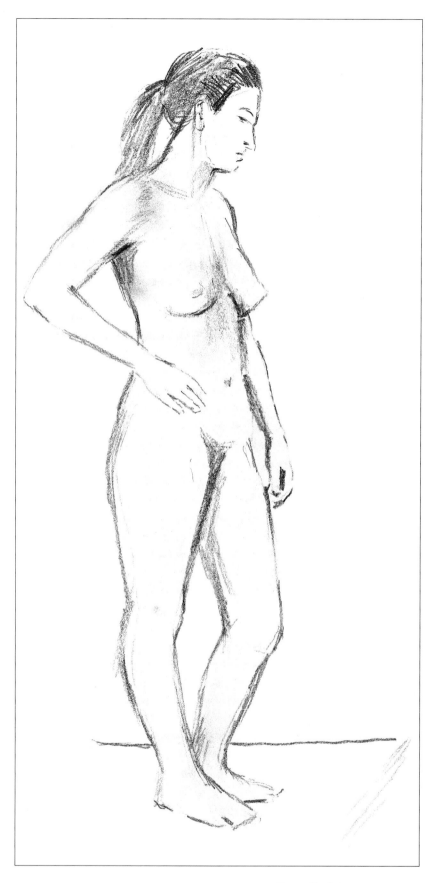

Above The first stage is to make an accurate pencil drawing, giving careful consideration to the way the figure is placed on the page.

Silhouetting

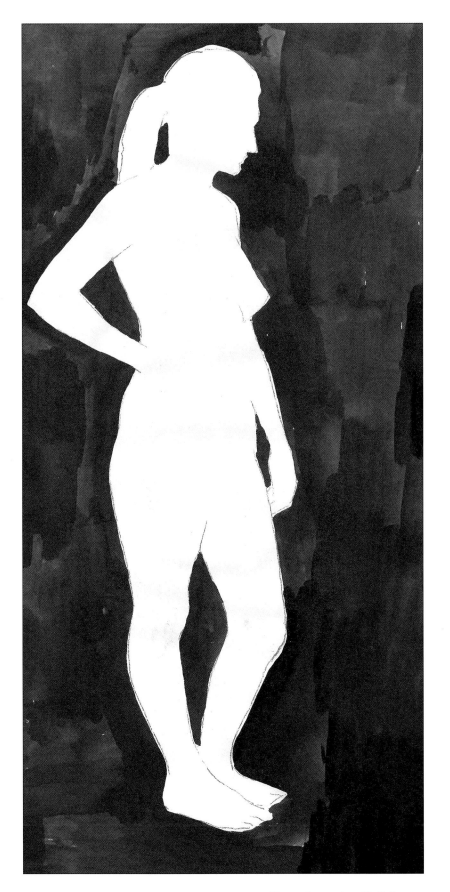

Above Once you have filled in the background with ink you can see how well the drawing works in terms of design, and whether the distribution of positive and negative space is satisfactory. In this case the overlapping feet are a little unfortunate, and the gap between the body and left arm might be enlarged.

Silhouetting is the first step towards placing the figure in a composition, as it introduces the concept of negative space. The subject of any picture, be it a bowl of fruit in a still life or a figure, occupies what is called the positive space on the page, while the area around it is referred to as the negative space. This comprises the background, foreground and other areas that are a part of the composition but are not the focal point, or central subject of it. In order to achieve a strong composition it is necessary to give as much consideration to negative shapes as to the subject; the more interesting the shapes the more effective the finished work.

This exercise falls into two parts, and for the first one it is best to use a soft pencil which will give a strong, dark line but can be erased later. Choose a seated or reclining pose that will give you an interesting and dynamic overall shape on the page. Avoid a compressed pose, where the limbs are held against or across the body. The pose will have to be held for at least thirty minutes to give you time to make a careful line drawing, the object being to make the figure into a design on the page. Whether you are doing a sketch in a notebook or a large painting, the shape of the paper or canvas contributes to the overall design of that composition.

Before you begin to draw, think carefully about the placement of the figure on the page. Are you making it large enough, need it be squarely in the centre or would it be better a bit off-centre? As you draw the contours imagine your pencil is a pair of scissors cutting and dividing the page into different interesting shapes.

When you have completed the line drawing you are ready for the next stage. Using compressed charcoal or Indian ink applied with a brush, go right round the outside contour of the figure to silhouette it, filling in the whole page to the edges. Then erase the pencil lines inside the figure and you will be left with a simple flat design of white on black.

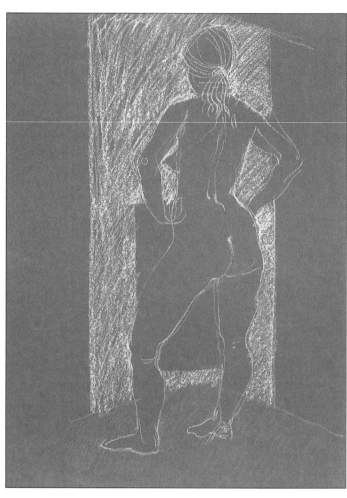

Above Here graphite stick has been used to fill in the negative space. This is a quicker method than ink, and thus suitable for rapid sketches to work out a composition.

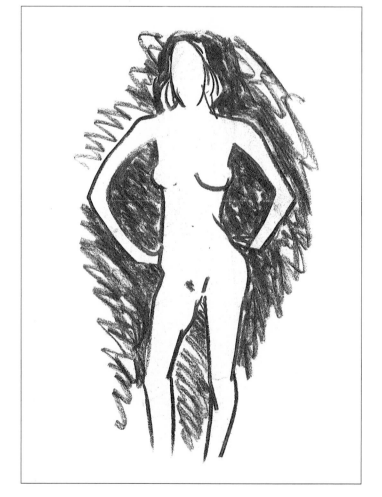

Above The artist has made an interesting composition by reversing the procedure, using light pastel for the background and the brown tone of the paper for the figure. The dark rectangle behind the figure focuses the eye on the twist of the back and hips.

Left This quick drawing with graphite stick emphasizes the strong design potential of the pose. The figure has been deliberately distorted to make a more exciting composition.

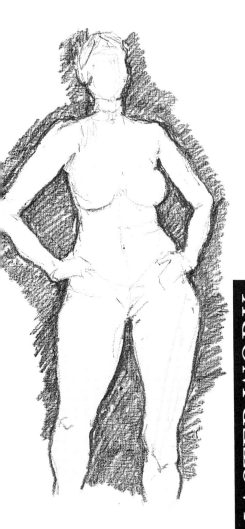

Left In this rapid charcoal sketch the width of the hips has been slightly exaggerated to give a feeling of mass and weight. The silhouetting method has a freeing effect, allowing the artist to depart from a literal representation of the pose.

MASTER WORK

Albrecht Dürer
1471–1528
Study of Eve (recto and verso)
Pen and ink with brown wash

Dürer, both a painter and supreme graphic artist, was the greatest figure in Northern European art during the Renaissance. He summed up his own work as being the study of the ideal human figure and the expression of a deeply felt religious message. This graceful figure of Eve shows us Dürer the draughtsman and designer at

work. The simple drawing on the left was copied on the back of the sheet (the verso). The addition of the brown wash in the background enhances the total design effect by making the negative shapes surrounding the figure interesting in their own right, thus transforming the sketch into a beautifully designed composition. This was probably intended for later use in an engraving.

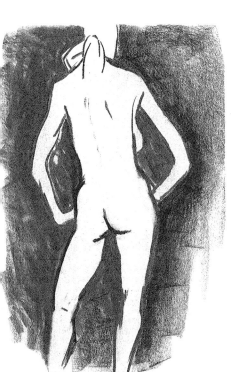

Above Elongation of the figure in this case has given a good sense of sweeping movement, and the distribution of shapes is pleasing.

COMPOSITION

BRIEF

● **Exercise**

Planning the figure in the context of the room.

● **Objectives**

Moving from drawing towards picture-making.
Making a fuller pictorial statement.

● **Mediums**

Any.

● **Time**

One to three hours (depends on level of experience and number of elements in composition).

Left and below The artist has made his own interpretation of the scene in the life class, tipping the angle of perspective to open up the composition and allow the viewer to look down and into the picture more easily. The easel and chair have been removed and the other artist moved in as a counter-balance.

Left This composition has been simplified by removing the middle figure and the easel, while retaining the cast shadow behind the drawing board. The triangular nature of the composition is stressed by the legs of the drawing box.

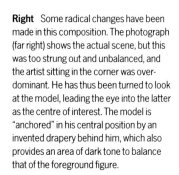

Right Some radical changes have been made in this composition. The photograph (far right) shows the actual scene, but this was too strung out and unbalanced, and the artist sitting in the corner was over-dominant. He has thus been turned to look at the model, leading the eye into the latter as the centre of interest. The model is "anchored" in his central position by an invented drapery behind him, which also provides an area of dark tone to balance that of the foreground figure.

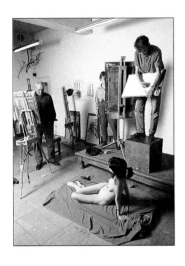

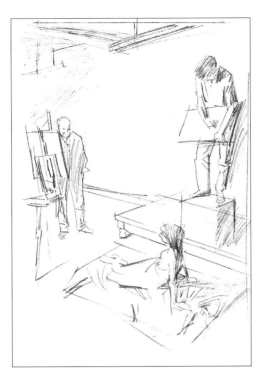

Right and above This simplification of the composition clarifies its triangular nature and focuses our attention on the model. The strip lighting, which might have been overlooked, has been used effectively to give scale and structure to the room as well as reinforcing the downward thrust represented by the artist standing on the box.

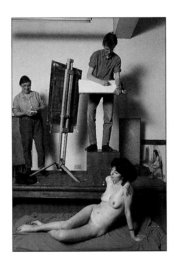

Left and above The drawing is a great improvement on the "found" composition represented by the photograph. The figure on the left, with her easel, has been turned to a profile view so that she faces the other artist. He, in turn, looks down to draw the model, making a circular movement.

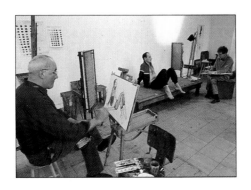

Composition

A composition should never be simply a random selection of props which fill in the space around the figure. The arrangement of the various elements in a drawing or painting should always work together to create a mood or express a feeling about the model. The life studio is, of course, an artificial environment, which can make a model look rather like part of a still life. This is a difficult problem to overcome, but a life class does at least provide an opportunity for learning the mechanics of composition and exploring ideas which can be put into practice later on when drawing in a more natural setting.

Classical composition

Before going further into the subject of composition, it is helpful, as with every such subject, to examine the norm, which in this case is traditional "classical" composition. The arrangement of forms and the ordering of the picture area are common to all types of composition. Classical composition creates works based on harmony and balance. Paintings by Vermeer and Cézanne are perfect examples of this type of composition, which produces a still, self-sufficient image within clear boundaries. It incorporates a rule called the golden section, which the Greeks originally developed to find the perfect proportions in architecture. The formula was rediscovered in the Renaissance and first used by Piero della Francesca.

It states that when a line is divided, the smaller section of it is in the same proportion to the larger section as the larger section is to the whole line. It is not easy to apply when you are doing a quick composition in the art class, but some of the basic tenets can be kept in

Right You do not always have to draw the whole figure, indeed a composition is often stronger when deliberately cropped. In this pen and ink sketch the artist has extended the drawing over two pages of a sketch book, allowing the head and legs to go out of the "frame" so that the model seems to be contained within the book. This impression is heightened by the high angle of perspective, which causes us to look down into the book.

Below This pastel composition is a study of curve and angle. The two rhythmic lines of the thigh and arm contrast with the angle of the stand at the top of the page. The centre of interest is formed by the acute angle where the inside of the leg joins the body. The blue of the drapery makes a diagonal shape which modifies the difficult head-on perspective of the model's stand.

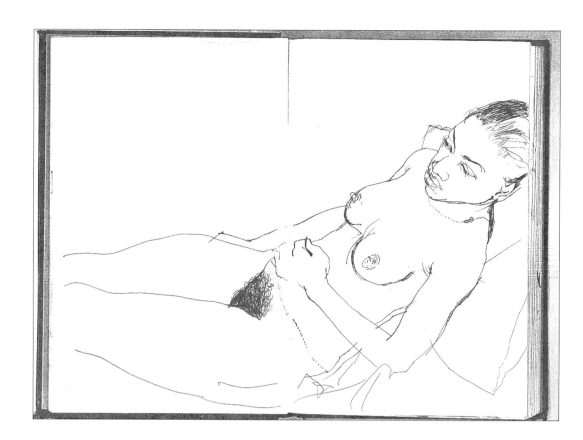

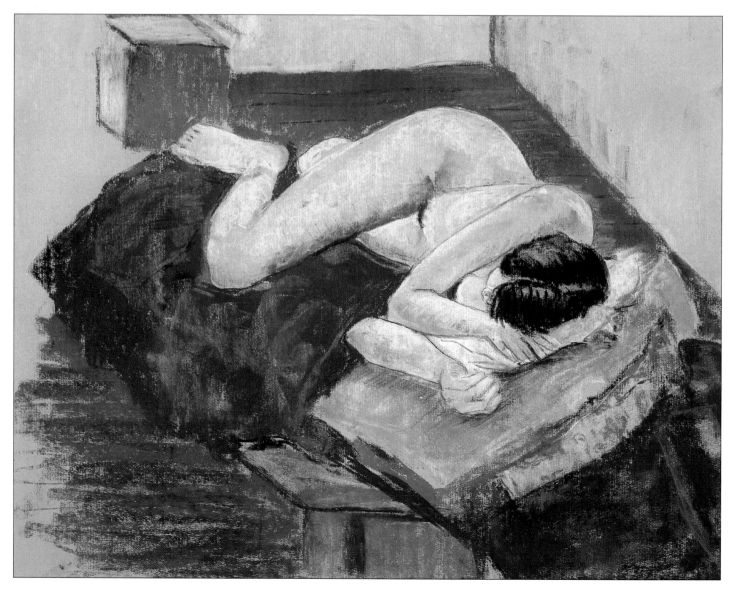

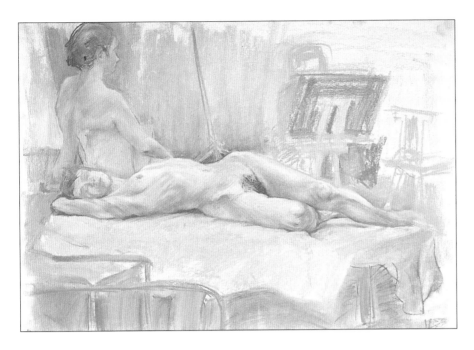

Above This pastel drawing explores the idea of using two figures, probably the same model, to make a more interesting composition. It is not entirely successful, as the figure in the background is disproportionately large – a common error when making a composite, since there is no opportunity to measure one against the other.

Below An interesting circular composition has been planned in this pen and ink sketch. Note the line of the floor, which is level with the eyes of the girl in front so that the artist gives us a feeling of looking into the picture with her. The other two figures diminish in size as they are placed further back in the picture plane, giving a feeling of space in the studio.

mind. For example, I always try to avoid placing the subject directly in the centre of the page or putting the horizon or floor line in the middle.

Modern composition

Although classical composition still has a place in art, the innovators of the 19th century introduced new concepts in which balance and harmony were less important than drama and movement. We naturally think of the Impressionists in the context of artistic revolutions, but Théodore Géricault in his brief life (he died aged 33) brought about changes that were in their own way equally significant. At the beginning of the 19th century French art was still held firmly within the confines of academic painting, and when *The Raft of the Medusa* was exhibited in the 1819 Salon it caused a sensation. Instead of the usual historical or mythological subjects, Géricault had dealt with a contemporary one (a shipwreck which had occurred three years earlier), and moreover he had depicted it realistically, with intense emotion.

The public were probably unaware of the way he had overturned the conventional rules of composition to do this. The painting portrays a raft being tossed about in a rough sea, with one man desperately waving a red flag for help. Because the essential element was movement, Géricault composed the painting along a diagonal, running from the left bottom corner of the canvas to the red flag at top right. Offsetting the centre of interest so dramatically allowed him to convey a vivid sense of the sea sweeping across the composition. This freedom to use both subject matter and composition to build drama is now so much taken for granted that it is difficult to imagine the furore it caused in the art establishment at the time.

From theory into practice

One of the concepts of composition is creating the illusion of space on a two-dimensional page. The more convincing the illusion the more effective the work will be. In any picture the position of the centre of interest – in this case the model – is of vital importance. In a classical composition he or she will be placed slightly off-centre. The space in the composition must be planned also, so consider the proportions of the room, and think about

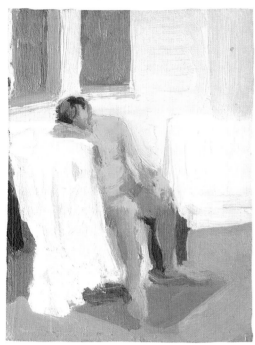

Left All the pictures on these two pages are small oil sketches exploring different types of composition. This is a very unusual arrangement, with the model viewed from the side, and a sheet thrown over the chair deliberately obscuring part of the figure. The simple structure is strengthened by the way the curve of the windowsills is repeated in the arm and shoulder, and also by the similar colours used for the windows and the rug.

Below There is a strong feeling of space and isolation in this work. The model is presented to us in the foreground of a large studio, whose back wall is high up in the picture plane, thus creating empty space behind the figure. The warm flesh tones contrast effectively with the cool colours of the studio.

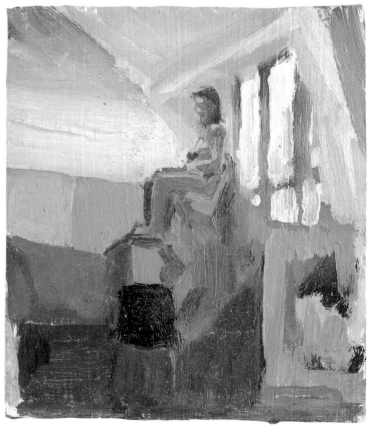

Above This is a typical classical composition, with the sizes of the shapes in perfect harmony with one another. The key to the work is the sharp, angular shape made by the dark fabric under the model, which not only produces a strong tonal contrast but also provides a firm diagonal line to offset the horizontals and verticals.

Right Here the model is on a high perch, and to make the composition convincing the artist has used dark colours in strong blocks to build it up firmly from below. The figure itself is a simplified, almost abstract shape, illuminated by the light from the window, and the dark window frame reinforces the architectural structure of the work.

Right Here the artist has taken a completely static pose and made it into a composition with movement, simply by using the diagonal angle of the easel to set up a tension with the figure. Without the massive, dark wardrobe, the composition would have slid off towards the right, but this pulls the eye back in and provides the perfect counterbalance.

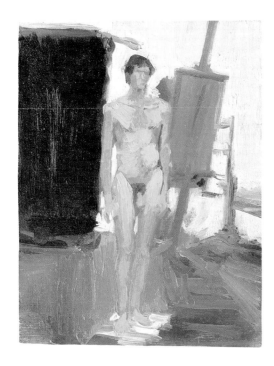

Left Mirrors are a great help in the studio, and here a mirror has given the artist a chance to introduce a background figure, whose bright blue clothing enhances the warm colours of the model. Technically it is fascinating that the flat plane of a mirror can contain all the space and jumble of shapes which make up the studio environment.

Left This is an extraordinary composition in that the artist has cleverly reversed the rules and avoided making the figure the real subject of it. A human figure will nearly always dominate a picture, but here the negative shape of the sheet is more important than the positive one of the body, and the light on it describes the form. This pattern of light is continued upward with the pillow, and finds a faint echo in the grey rectangles of the windows themselves.

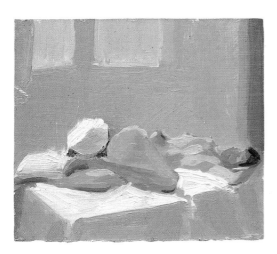

where to place the model in the three-dimensional "map".

You will probably choose just a small part of the room to draw, but the model can be as close or distant as you like. If you are working in a life class the easels, boards and other furnishings, such as heaters, mirrors and so on will become important elements in the composition and you will need to consider the placing of them in relation to the model. If you are fortunate the model will be in surroundings that already form an interesting composition, but often the "found" composition may be poor or your view limited. In such cases it is perfectly permissible to do a bit of rearrangement.

If the background is featureless and boring, select objects that could be used to divide the space. For example if you are faced with a completely blank wall you might borrow some ideas from another part of the studio – perhaps a large canvas or screen, which could be drawn in as part of the background. Shadow or reflected light can also be used to break up an area. The main consideration is shape, so try to think of your picture as an abstract composition, and map out a simple placement of all the elements before you start on the finished drawing (the following lesson suggests a way of doing this). Only if you give as much time and thought to the whole as you do to the model will the composition work as a whole.

However, a composition does not have to be balanced, and the role model for deliberate unbalancing to create energy and drama is Degas, who delighted in taking risks, pushing the balance of a composition to the extreme without losing it.

If you want to plan a composition with the model off-centre you could use a large drawing board or another student in the foreground as a counterbalance. If you are working at home a large piece of furniture or a bowl of flowers could serve the same purpose. As in classical composition you always begin with the centre of interest and plan the whole page before beginning to draw.

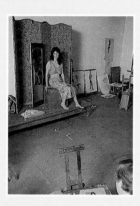

BRIEF

● **Exercise**

Working out a composition with cut paper shapes.

● **Objectives**

Allows student to experiment with different arrangements.

● **Equipment**

Coloured paper, various shades; scissors, glue.

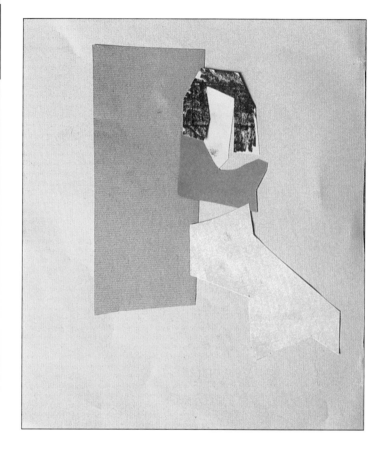

Left The model was arranged in a way that offered some compositional potential, and the artist chose a satisfactory viewpoint. She then cut out the main shapes and arranged them on the paper.

Right In the second stage, a board with a drawing of the model was added in the foreground to add a spatial dimension. The angle of the board, thrusting in slightly, unbalances the composition to give it more energy.

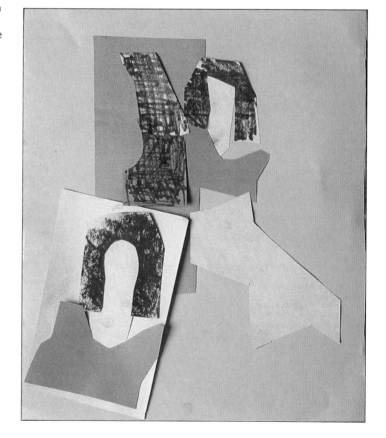

Composing with paper shapes

Above Adding the reflection in the mirror presented three separate images of the model. The variation between the three faces could be made into quite an interesting element in a finished drawing, particularly the profile in the reflection which looks away from the viewer.

It is all very well suggesting moving around different elements to find a lively composition, but working it out entirely in your head is very difficult. You can, of course, use small sketches to plan out possible variations, but a good alternative way of visualizing alternatives is to use scissors and paste, which provides a rapid means of experimenting with composition. This was a method taught to Picasso by his father when he was a young student.

You can either cut the shapes out of sheets of different-toned or coloured paper or you can tone your own paper by rubbing it with soft pencil or graphite, as shown on page 84. The idea is to cut out simple shapes to represent the model and the other elements in the room, such as drawing boards, easels and so on, and then move them around to make different arrangements. The cutouts need not be at all detailed, just as long as they represent the sizes and general shapes. Thus if the plan is not working one way new pieces can be quickly torn or cut to try another approach.

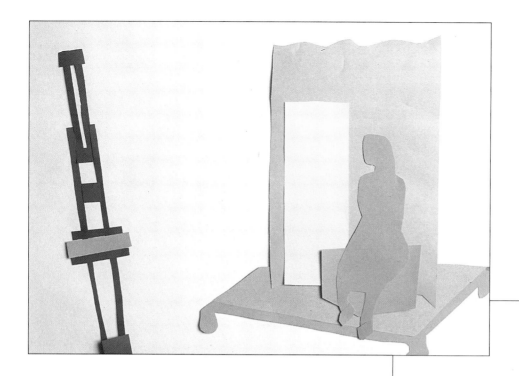

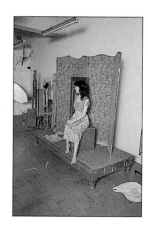

Above In the first arrangement, the stand and background are satisfactory, but the easel is too far to the left and divides the composition.

Right A simple silhouette of the model and box were cut out as a first stage. These can be moved about to try different compositions, and further elements added.

Below The advantage of paper shapes is that they can be turned over to reverse the image. The artist "flips" the model and stand so that she can consider a radically different composition.

The first decision to make is the placement of the model, because in the context of composition there are many different possibilities. For example, you could place the figure really far back on the page with members of the class in the foreground, which would give a nice contrast between the naked figure and the clothed one, or make her (or him) the dominant subject with just a simple background. Obviously there are potential compositions that fall between these extremes, such as using one large shape such as a drawing board in the foreground, perhaps obscuring part of the model.

Remember that you are representing three-dimensional space in a room, so cut out large pieces of paper to represent the wall or other background shapes, and the floor. By using different tones you can work out the dark and light pattern of the composition. If you want to use colour in the final work it can be related to the tonal values of the cut paper in your plan of the composition.

Right Since the shapes have not yet been pasted down, the artist can move the elements around as often as required to find better placements. The easel has now been moved to the opposite side, and its diagonal shape, now strengthened by the addition of a drawing board, leads the eye into the composition.

Below In the final composition; more easels have been added on the left. These counterbalance the strong diagonal on the right and hold the composition together, while the simple background frames the model nicely. This will now be pasted down and used as a plan for a painting.

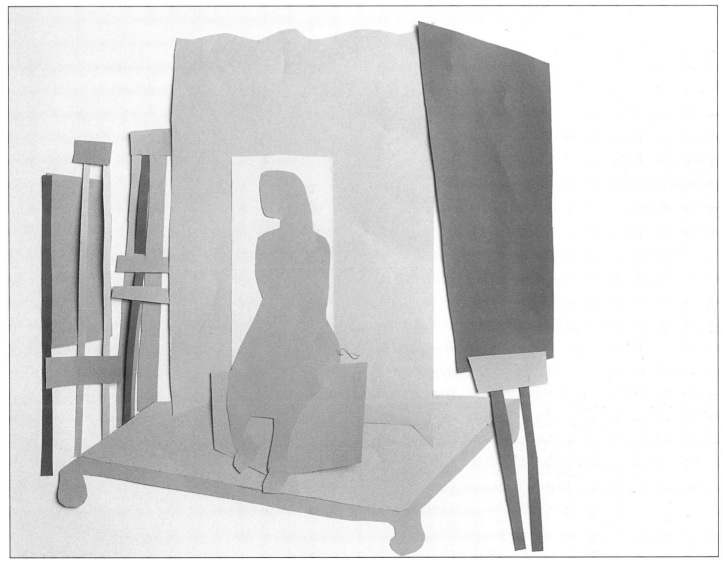

20

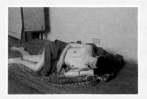

BRIEF

● **Exercise**

Drawing a draped figure.

● **Objectives**

Brings a new element into figure drawing. Helps the student towards drawing the clothed figure.

● **Suggested mediums**

Pen and wash, brush and wash, pastels, pencil.

● **Time**

One and a half hours minimum.

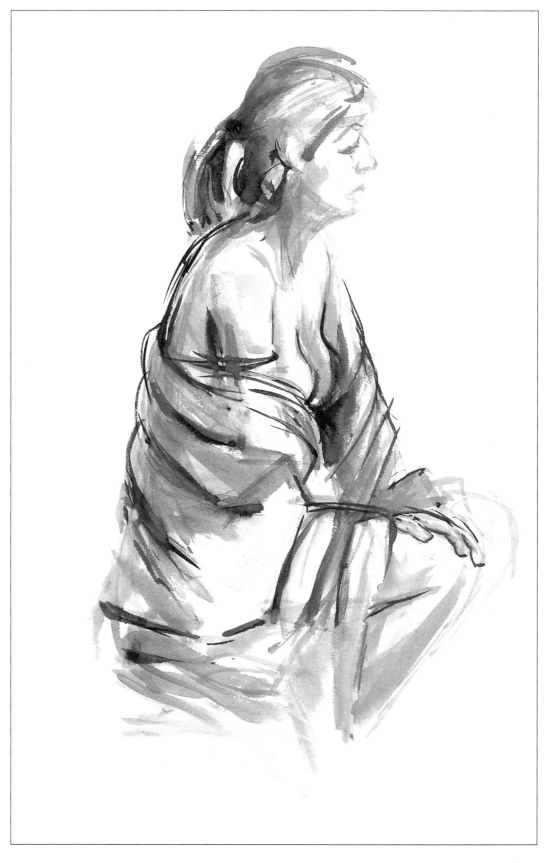

Above The model's shawl was a fairly heavy fabric, which did not cling to the forms. The strong line in this pen, brush and wash drawing gives a good impression of its bulk and weight.

Right Here the drapery has been used to enhance the natural curves of the figure, and the semi-parallel folds are very much in the Classical tradition. The drawing was done on rough, recycled paper, with only two pastel colours: red oxide for the shadows and white for the highlights. The colour of the paper itself serves as a middle tone.

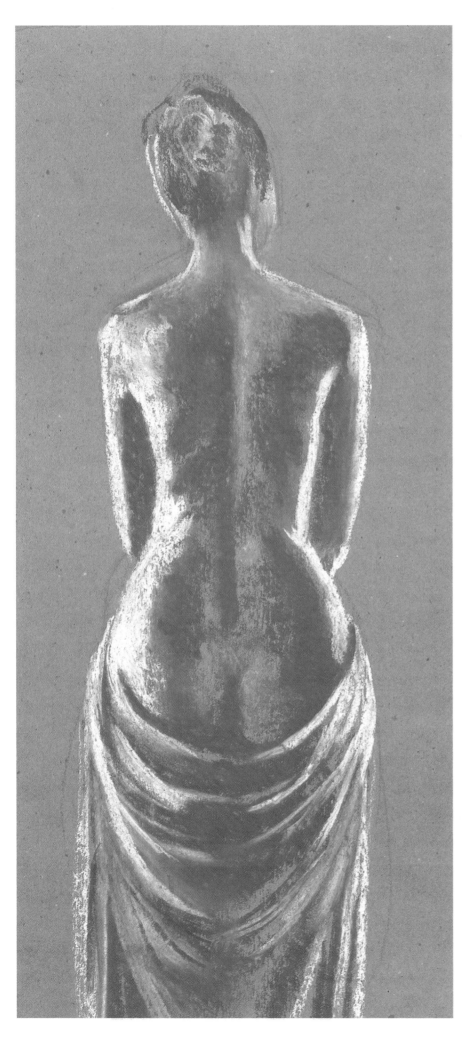

Drapery

Now that you have progressed from the life sketch to the composition, it is time to start thinking about the clothed figure, since the aim of learning to draw is to eventually make pictures that put people into a real-life setting. It is helpful to begin by drawing a draped figure, since this allows you to see the forms beneath more clearly than everyday clothing does.

Draperie mouillée is the French term for the soft clinging drapery first used by Greek sculptors of the 6th century BC. It was the custom of the young men to exercise completely naked, but the women were always clothed from head to foot (the only exception being the women of Sparta). Whether this was from modesty, piety or both is not certain, but there are no known sculptures of a nude woman before the 6th century BC.

Fortunately the Greek sculptors' admiration for the nude was able to overcome the problem, indeed what might have been an impediment was turned to great advantage. It was quickly realized that the drapery, by partial concealment, lent mystery and desirability to the figure, with the folds of the cloth delineating and enhancing the forms. Drapery became a compositional tool, employed to pick out and emphasize certain areas while covering others for simplification, an idea which, with modifications, has been used ever since.

The sculptors of antiquity used to dampen the drapery to make it cling and become semi-transparent on the form. Fortunately for the models this is no longer the practice, but making use of the folds in the cloth to delineate the form is still very helpful.

For this lesson any media can be used. Select a fabric that is soft enough to display the form underneath. The weight and texture of the cloth will determine the substance of the folds. The heavier the fabric the thicker and bulkier the folds. A fine, thin cloth will give a very linear effect. When you begin to draw the fabric try to trace the fold from its beginning and keep the clear direction of it over the form. Do your best to avoid small broken folds that do not help the composition.

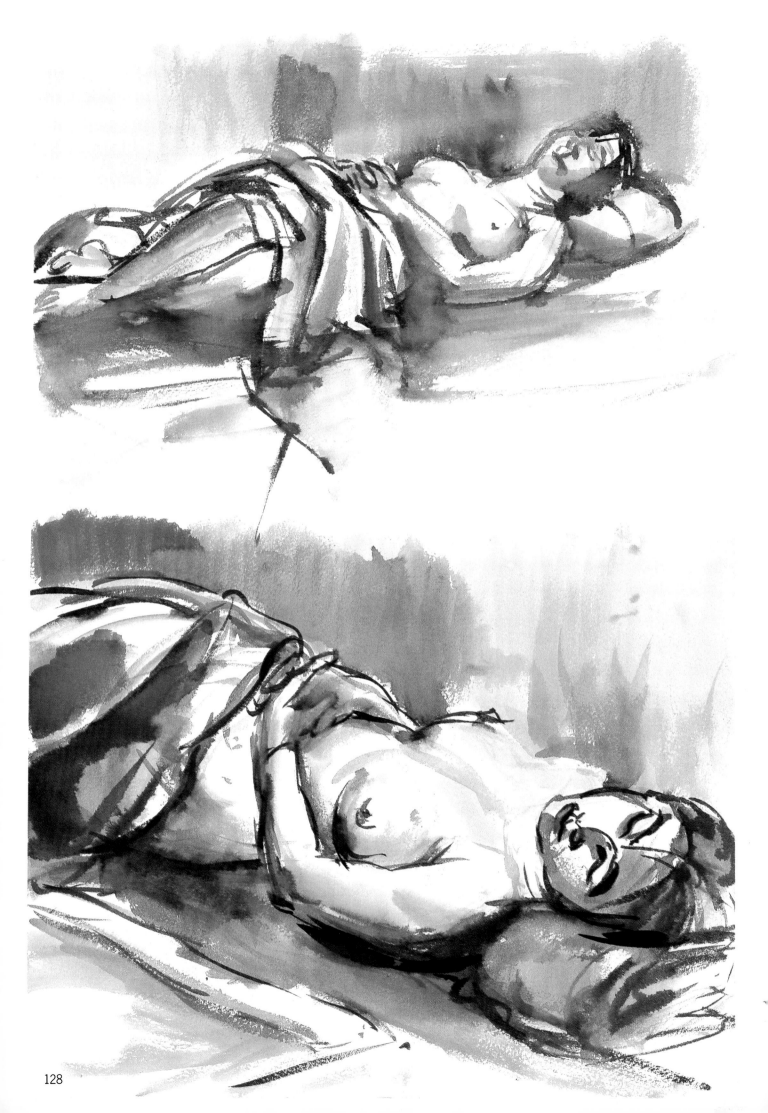

Opposite Partially covering the model with drapery in the life class has allowed the artist to produce natural-looking and intimate studies of a woman sleeping. The brush and wash technique has been used for both drawings.

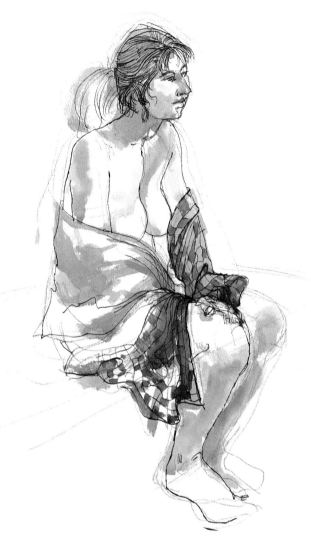

Left Pen and wash is an attractive medium for a draped or clothed figure, and here the pen line adds delicacy and softness to the fabric.

MASTER WORK

Henry Moore
1898–1986
Study for Northampton Madonna
Ink, black chalk and wax resist

Henry Moore was one of the greatest sculptors of the 20th century, and his drawings, although primarily made as studies for his sculptures, are profound graphic images in their own right. His concern for the underlying form and structure of the figure can be seen as each line travels over and around the form, moulding it as if it were clay. The wax resist method, which is explained fully on pages 168-9, was pioneered by Moore in the context of drawing. The study was made in 1943.

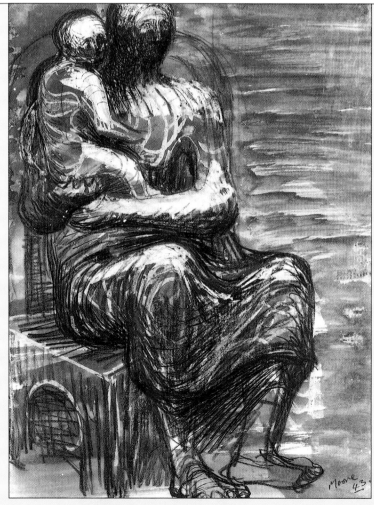

THE CLOTHED FIGURE

21

BRIEF

● **Exercise**

Drawing the model in everyday clothes.

● **Objectives**

Helps those interested in portraiture.
Teaches the student to look for the important forms.

● **Suggested mediums**

Any, but colour particularly suitable.

● **Time**

One and a half hours minimum.

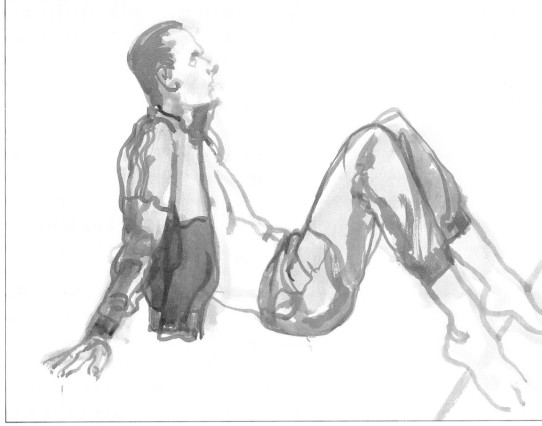

Above This sepia brush drawing shows how the artist has differentiated between the smooth lines of the body and the more fluid ones of the tracksuit. The bend of the arm is described by the folds of the fabric, as is the roundness of the leg.

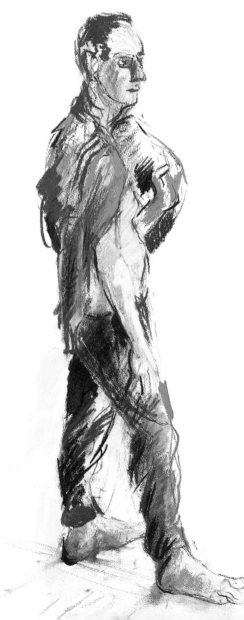

Above and right Here the artist has used pastels, beginning by outlining the figure in monochrome, and then gradually building up the colours.

The clothed figure

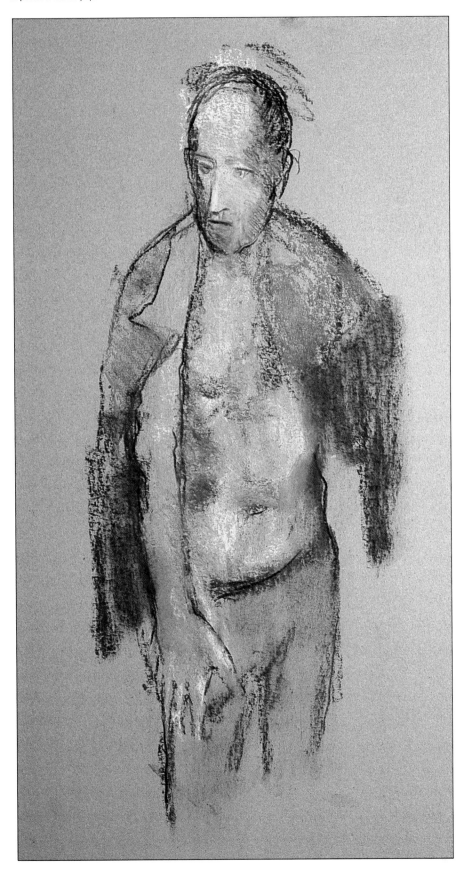

Below The importance of the jacket in the context of this drawing (also in pastel) is that it forms a kind of frame for the figure, so it has not been drawn in fully, allowing the head, torso and hand to assume more prominence. The drawing is in pastel on toned paper.

The previous lesson dealt with the idea of draping fabric deliberately on the figure to enhance the form below. The treatment of normal clothing is quite different. Ordinary everyday garments tend either to hang from one part of the body or to be gathered up or just wrapped around at another. They are at every point being interrupted by belts, seams and numerous other devices designed to make them into separate "compositions" in their own right.

This is the problem: at which point does the body intervene and change the shape and direction of the clothes? And how much do you show? If you draw the body underneath as the dominant force, the clothes will look as though they are a second skin without substance, weight or bulk. However, if too much attention is paid to the individual cut and design of a dress or suit you will have a drawing that looks like a fashion illustration. You must tread a careful line in between.

To begin with I advise lightly sketching in the important forms of the body under the clothes – the hips and breasts (if a female model) and the legs – and checking the position of the joints, the elbows and knees in particular. We lose our familiar points of measurement when the body is covered with clothing, and it is very easy to make the body too long or short.

It is important to try to differentiate between fabrics. A heavy, bulky pullover, for example, will be drawn as simple, rounded folds, showing the thickness of the fabric, but a thin silk blouse, lying close on the form, will be drawn with narrow, flat folds. You will need to practise drawing different fabrics, so I suggest making studies of clothes thrown over a rounded chair at home whenever you have time.

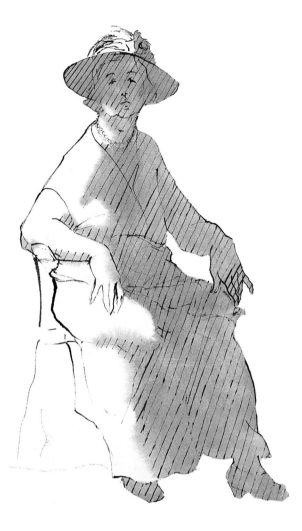

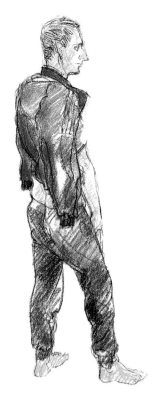

Right This drawing and that shown on page 130 are both of the same pose but are the work of different artists. Pastel has also been used in this case, but the approach is more linear.

Below Rich colours and tones have been built up with watercolour pastel. This is a versatile medium, as the pastel sticks can be used much like coloured pencils, as here, or spread with water to make coloured washes.

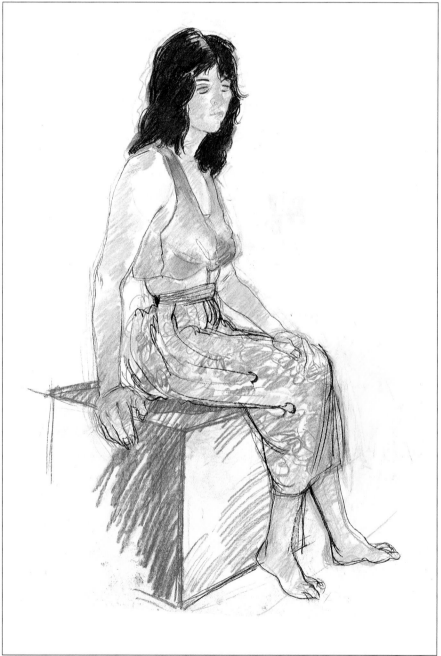

Above The drawing exploits the technique of wash on damp paper. The artist began with a line drawing in bamboo pen and ink. When the ink was thoroughly dry a light wash of water was laid over the whole figure, but not the background, and with the paper still damp, the watercolour wash was laid on the shadowed side. Notice that there is a soft edge where the wash has been applied to wet paper, and a crisp one at the outer edges of the figure, where the paper was dry.

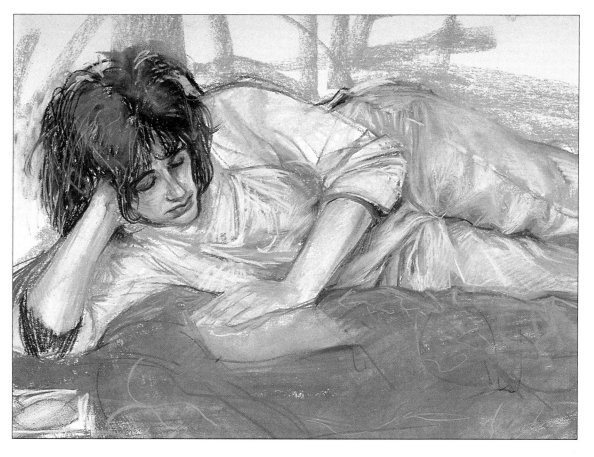

Left The fabric has been skilfully drawn and describes the forms below very accurately. This is basically a portrait study, in which the face has considerable importance, so the clothing has been "held back", by subtle colour and modelling so that it does not steal attention from the girl's face.

MASTER WORK

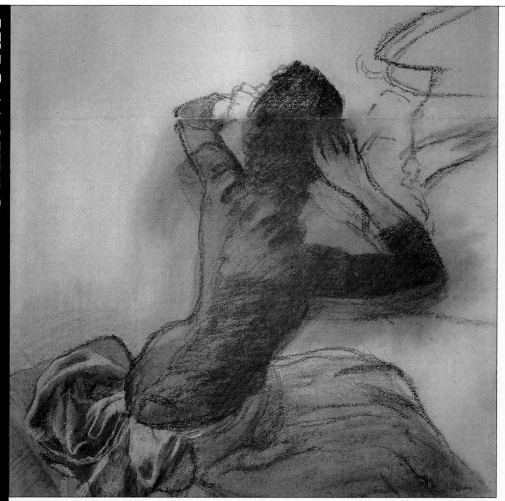

Edgar Degas
1834–1917
Seated Woman Adjusting her Hair
Pastel on buff paper

Degas differed from the other members of the Impressionist movement in that he almost never painted landscape – he once remarked sourly that "the gendarmes should shoot down all those easels cluttering up the countryside." His preferred subjects were the ballet, or intimate, unromanticized portraits of women washing or performing domestic tasks. Two important influences on his work were the Japanese prints which were then reaching Paris in great numbers, and photography. Many of his paintings have a flat, print-like feel, with little tonal modelling, and his compositions have a "snapshot" quality, as seen in this pastel sketch. The pastel has been slightly rubbed so that the blurred image appears to be moving, while the lines going around the bodice clearly define the twist of the body under the dress.

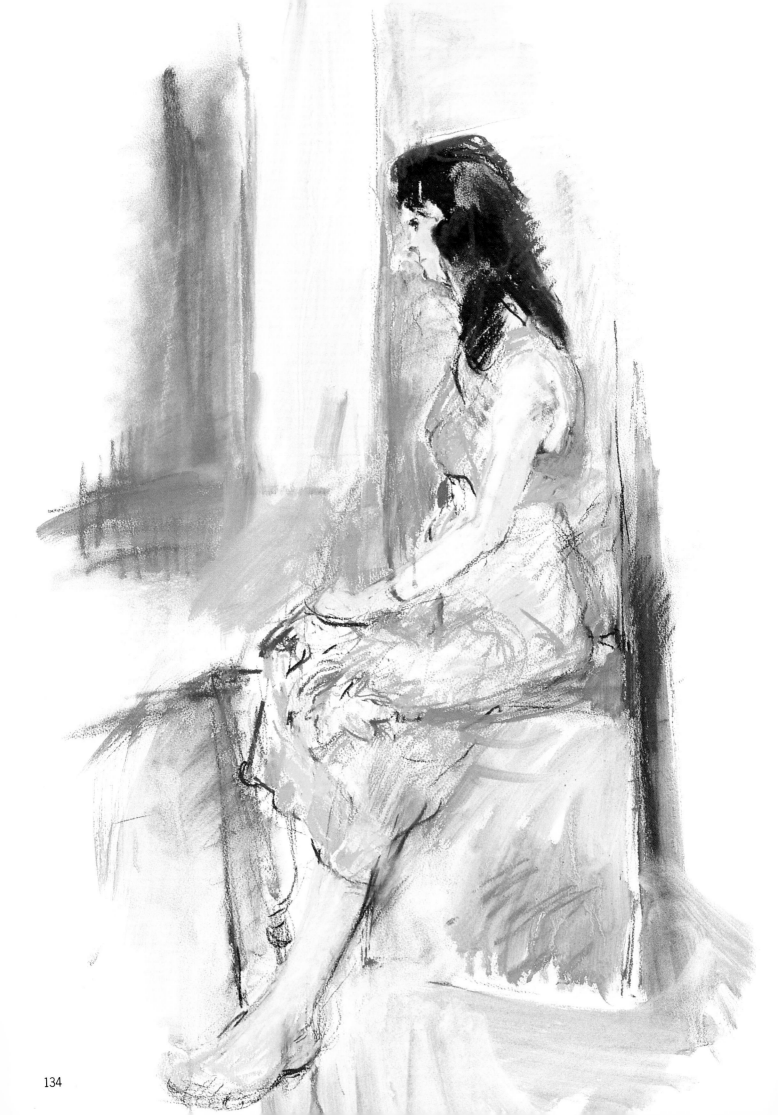

Above and below One of the advantages of drawing the clothed figure is you do not have to attend a class – you can draw out of doors, on buses or trains, or at home. These two pastel drawings were done in the artist's own home.

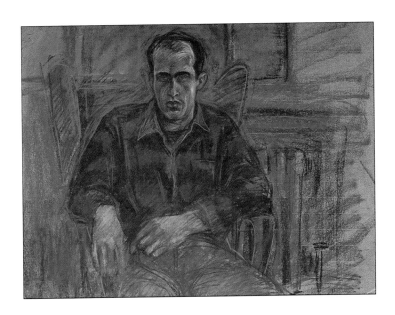

Opposite and above This has the spontaneous, lively quality of watercolour but is actually a pastel, worked on watercolour paper. The artist sketched in the figure and clothing very quickly, beginning with an almost abstract mosaic of colour and shapes (above). The composition was built up gradually, with the background and detail given more definition, and finally the whole drawing was pulled together with a wash of clear water. This causes the pastel to mix on the paper surface, and creates a very interesting and painterly effect.

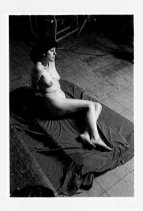

BRIEF

● **Exercise**

Drawing from a high or
low viewpoint.

● **Objectives**

Creates exciting and
unusual effects.
Avoids repetition of
preconceived images.

● **Medium**

Any.

● **Time**

One hour minimum.

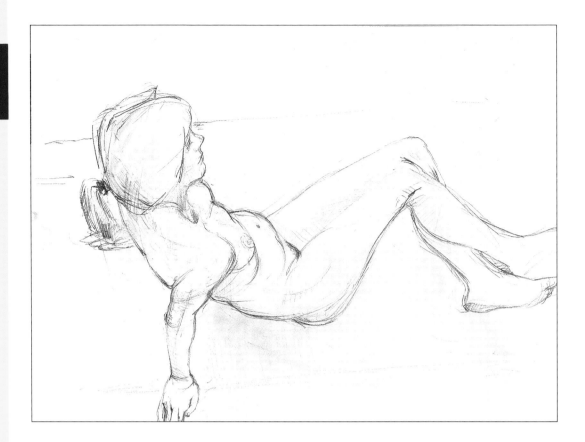

Above Drawing from an unusual
viewpoint involves, among other things,
coping with foreshortening (see lesson 7).
This was done from above: notice the
largeness of the head, the point nearest to
the artist, and the relative smallness of the
bent arm.

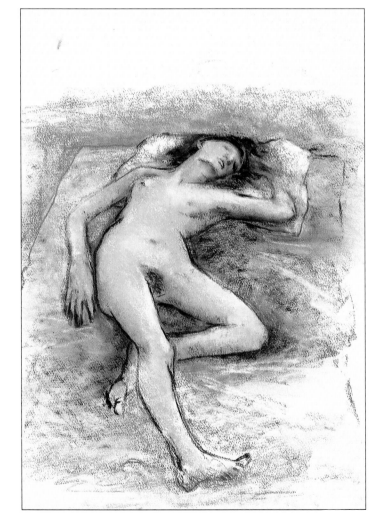

Right The model was lying on the floor
and the artist simply standing at an easel.
This angle gives a more exciting shape
than a level viewpoint, and makes a better
composition.

Left and below The pastel and the charcoal sketch were drawn from the same pose, both from a slightly low (seated) viewpoint. Even an undramatic shift in viewpoint completely alters a pose, so it is always worth walking around the room before you decide on a position.

Varying the perspective

Another "trick" from the photographer's repertoire which contemporary artists have quickly adopted is varying the angle from which the subject is seen. Since photographers often cannot change the subject itself to make it more interesting they need to be resourceful, using original methods to help them produce fresh and striking images.

The idea of looking at the model from an extreme angle of perspective was previously only exploited by artists who designed and painted ceiling decorations, and of all of the photographic practices now incorporated into fine art this is the most difficult to do without a camera. However, it can produce some very effective compositions. As in close cropping, discussed in the previous lesson, there is a subtle change when you look at a person from an unnatural angle. The contemporary artist Antony Green paints his family as though he were the proverbial fly on the wall (or ceiling), and the effect is both unnerving and intimate. Lucien Freud will sometimes paint a nude woman lying on the floor, which seems to increase the feeling of vulnerability and potential violation.

Without the help of a camera the best you can do is sit on the floor to draw when the model poses on a stand, or ask her (or him) to pose on the floor, with suitable blankets or cushions. The drawing will involve foreshortening, and if you wish to give the impression of deep space you can exaggerate the foreshortened effect.

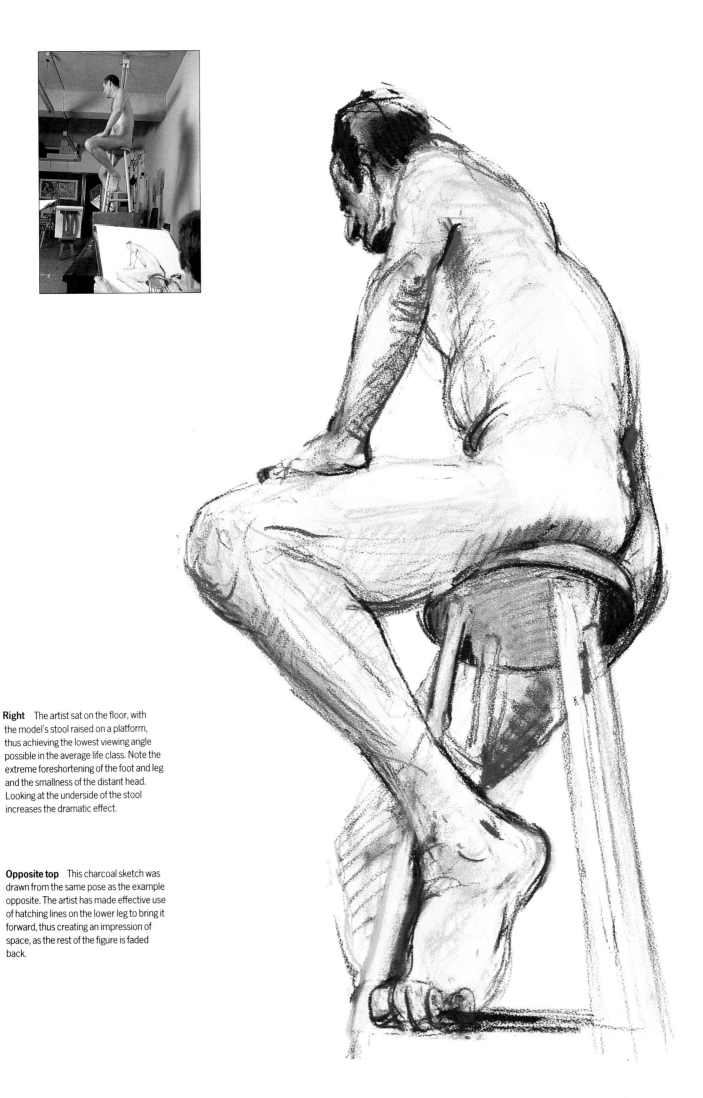

Right The artist sat on the floor, with the model's stool raised on a platform, thus achieving the lowest viewing angle possible in the average life class. Note the extreme foreshortening of the foot and leg and the smallness of the distant head. Looking at the underside of the stool increases the dramatic effect.

Opposite top This charcoal sketch was drawn from the same pose as the example opposite. The artist has made effective use of hatching lines on the lower leg to bring it forward, thus creating an impression of space, as the rest of the figure is faded back.

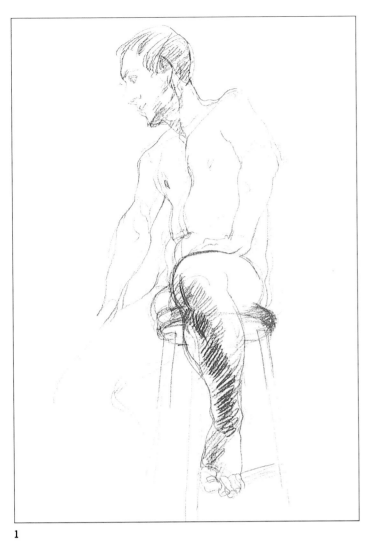

1

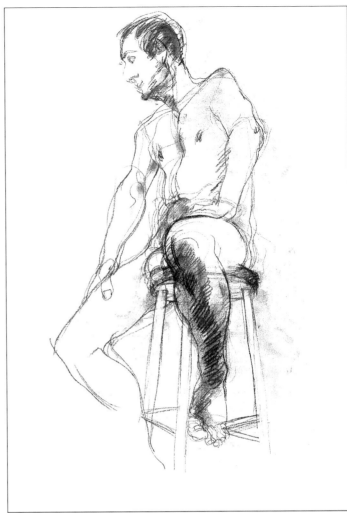

2

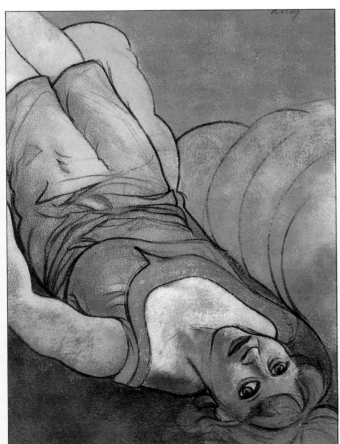

R.B. Kitaj
b.1932
The Green Dress
Pastel and charcoal on paper

Kitaj, born in America, is a leading contemporary artist, now living and working mainly in England. He was one of the inner circle of highly talented students at the Royal College of Art, which included David Hockney and Allen Jones. Although usually associated with the Pop Art movement, much of the inspiration for his figurative work has come from Degas' pastels, and he has made a great many innovations in the use of this media. He also shares with Degas a fascination with photographic imagery, which has enabled him to produce striking compositions. Here he has drawn the figure from a high angle, with the woman looking up at the viewer with an arresting glance. The composition is a simple diagonal counterbalanced by the soft curve of the arm and cushions.

MASTER WORK

CROPPING

BRIEF

● **Exercise**
Moving in close to draw
one part of the figure.

● **Objectives**
A further lesson in
composition.
Encourages a fresh way
of looking.

● **Suggested
mediums**
Charcoal, pastel.

● **Time**
One hour minimum.

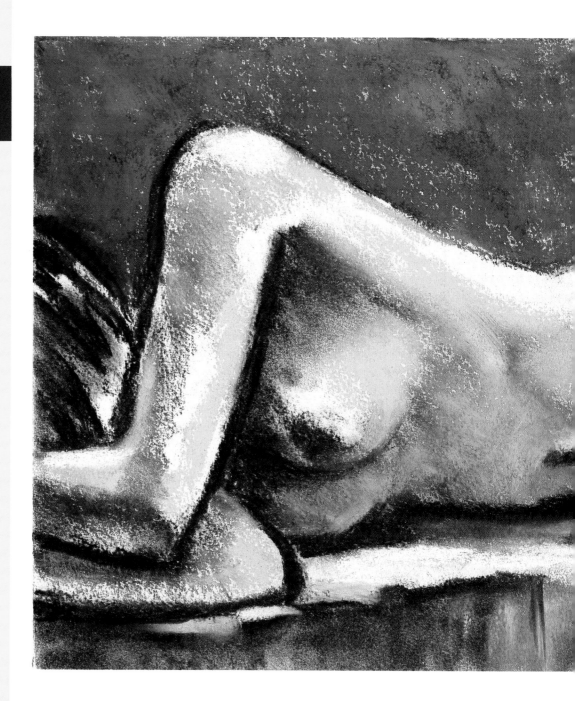

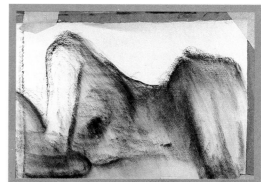

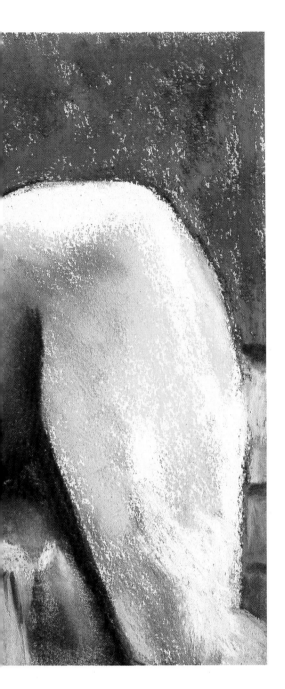

Cropping

Left and opposite below In this composition, like the one shown below, the artist selected a part of the figure that could be used to make an interesting abstract design. The way the shape of the figure fits into the page was an essential part of the overall design, and the negative background area is equally important. The medium was charcoal and pastel, with the first two stages (below left) done with charcoal alone. In the final stages, pastel was overlaid over the charcoal drawing, which was first smoothed out with a tissue, and the pastel colour was blended.

Below Pastel only was used for this drawing, in which the artist has used the graceful line of hip and buttock as a strong design element.

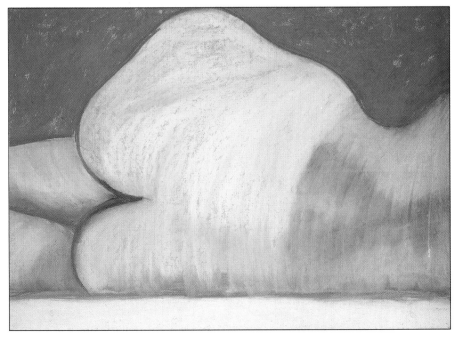

When photography was invented early in the 19th century it was widely believed, and often said, that "painting was dead". Of course it was not, but it was profoundly changed, and in many ways enhanced. The Impressionists were the first to take up the possibilities offered by photography. Degas brought his large camera to house parties, where he insisted on posing and photographing the guests, much to the discomfort of his hosts. He had an insatiable curiosity, not about new or different subjects – for he repeatedly returned to the same ones – but about new ways of seeing and composing, and he was excited by the way the camera cropped images.

If you have looked through a telephoto or zoom lens you have probably noticed how a view you know well becomes suddenly unfamiliar. When you move in close, the composition is usually simplified, indeed if you are very close it almost becomes an abstract design. There may also be a subtle change of mood, the image may become slightly menacing. I believe this has to do with our "natural" distance or the idea of our territory being encroached on. This shift of view, with its attendant change in mood, can make a portrait or figure drawing much more alive.

Another advantage of moving in close is that it creates a tight composition where you can work with bold, simple shapes. A view finder is an asset here. Cut a rectangle of the same proportions as your paper but much smaller out of a piece of card, and look through this frame to select the area to be drawn. You can draw just a part of the model or include a bit of a window frame or edge of furniture, but look for shapes that make a strong pattern. This is a good subject for charcoal, or pastel if you want colour. You can make a bold line drawing for a flat pattern, or use tone and colour. Make a complete plan with a simple placement before beginning the finished work.

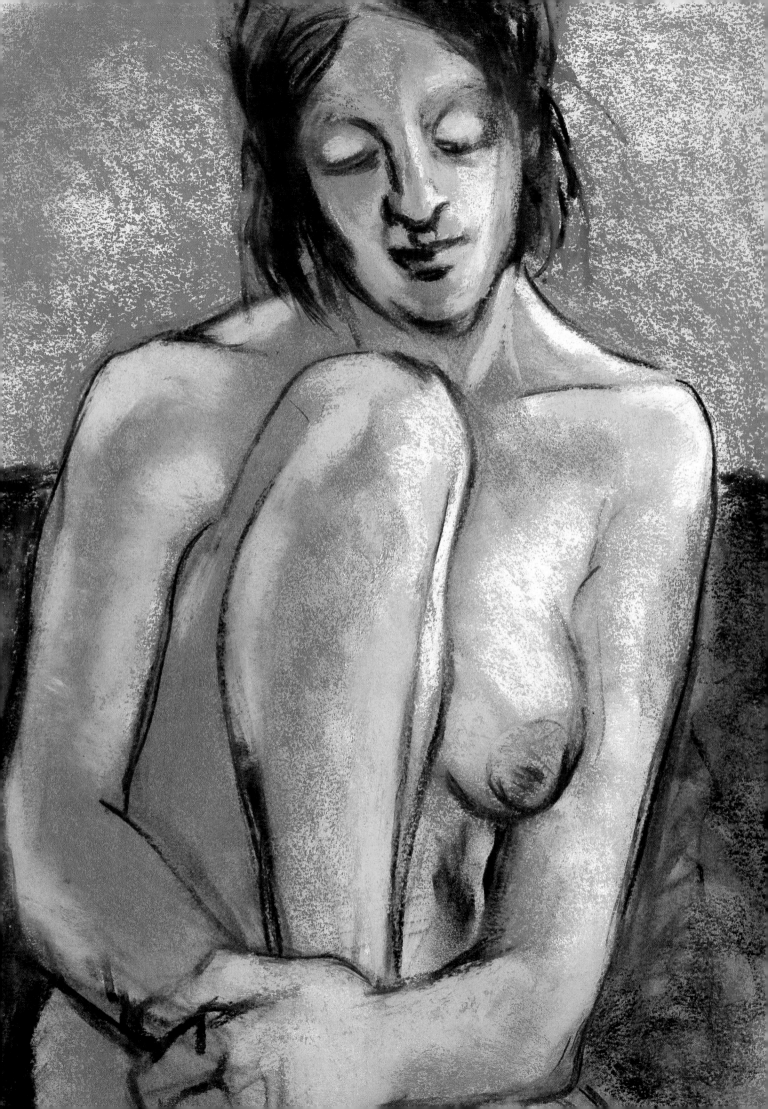

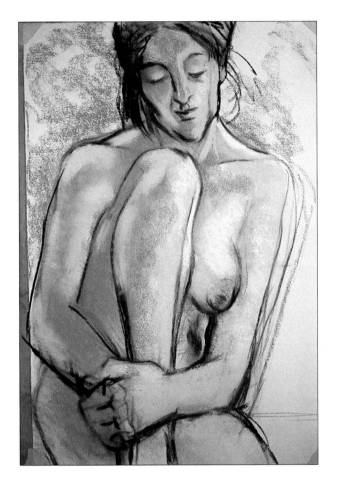

Opposite and left This pastel study conveys an impression of intimacy because the artist chose to concentrate on one aspect of the composition, thus pulling the viewer in. The leg effectively leads the eye up to the model's face with its rather pensive expression, making it something more than just a life study. The drawing on the left is the first stage, in which the main shapes were designed.

MASTER WORK

Henry Moore
1898–1986
Head (from the Second Shelter Sketchbook)
Ink and wax crayon

During the Second World War Henry Moore was commissioned as a war artist, and made a series of moving studies of Londoners sheltering in the Underground during air raids. This study of a sleeper's head was made from a quick sketch. The blanket, drawn as a parallel curve to the features, creates unity and harmonious rhythm, while the close cropping adds power and drama to the subject.

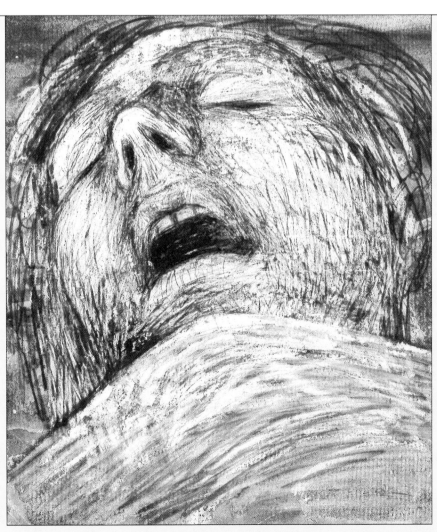

BRIEF

● **Exercise**

Using light as main
element in composition.

● **Objectives**

Creating mood and
drama.
Examining the role of
tone in picture-making.

● **Mediums**

Charcoal, dark pastel.

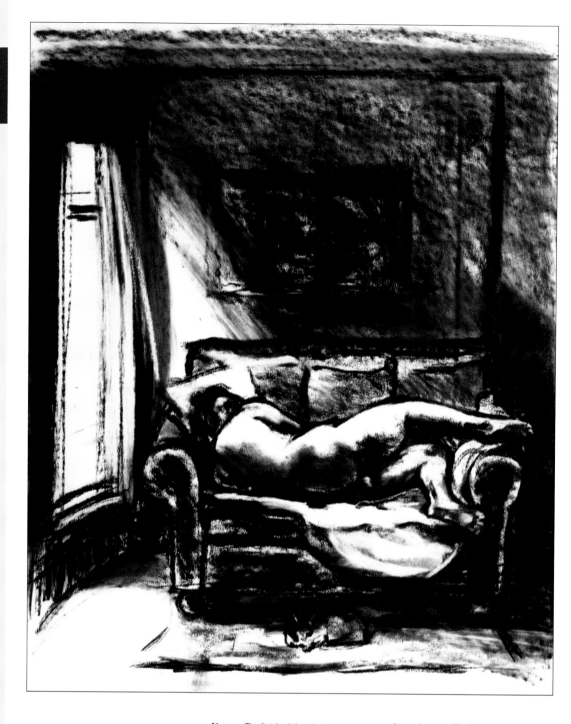

Above The finished drawing is a composite. The artist drew her own sofa in her living room but changed its position on the paper, moving it closer to the window to justify the strong light effect she wanted. The figure itself was taken from an old sketch, with the drawing of the legs changed slightly to fit over the sofa. The corner of the room on the right side was invented to balance the composition, as was the picture which was needed to break up the expanse of the wall. The cat was drawn from life, an opportunity seized when she came in to take up her normal position in the warm sun.

Opposite top The first rough plan of the composition was made with willow charcoal. Only the basic shapes were drawn in, and without detail, so that the overall design of the work could be assessed and changed if necessary.

Opposite A dark tone was added to the sofa to bring out the figure. The purpose of the white cloth under the model is now apparent: it will provide a light tone against the shadow, without which the clear definition of that side of the body would be lost. A picture added in the background served to break up the large wall area which might otherwise have overwhelmed the figure.

Composing with light

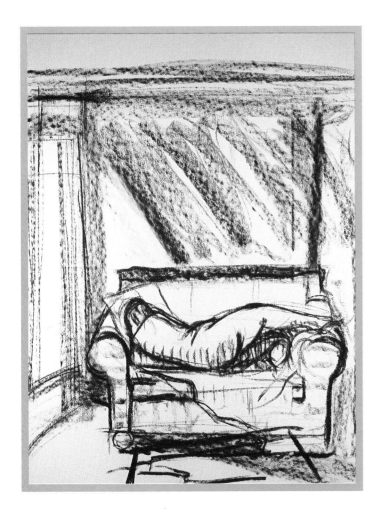

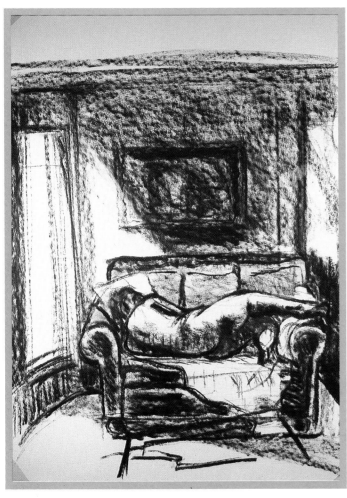

All we really see of the world is light. A blind man "sees" a face by touching and feeling it; we know it mainly by the light it reflects. Rembrandt well understood this when he painted his later portraits, which are really compositions of pure light. The faces are caught in a moment of time, so that we sense the short-lived quality of the light glancing from and defining the face.

Light, as well as giving us a dramatic presence, can form the whole basis of a composition. Rembrandt's etchings use light to illuminate the subject, while softening and pushing back into the shadow all distracting details. He focuses our attention on the centre of interest and creates a mood with it – only the essence of the composition is illuminated.

The light we use today varies a great deal, and you can use the different types to change the mood and meaning in a composition. Firelight or dim electric light can create either dramatic or intimate effects; the hard, bluish light of a fluorescent tube changes the colour in a work and gives a different feeling to a scene; a naked light bulb conveys a bleak message. The American painter Edward Hopper made very effective use of artificial light in his paintings to give a feeling of loneliness and isolation – it is well worth looking at his work.

Working methods

Charcoal or dark pastel, or a mixture of the two, can be used for this kind of drawing. Pastel colours include a charcoal-indigo and a charcoal-brown, which can relieve the overall blackness. There are two basic methods, one being a continuation of the method shown on pages 90-93, where the page was covered with charcoal and a putty eraser used to lift out the area of light.

The other method, which gives cleaner

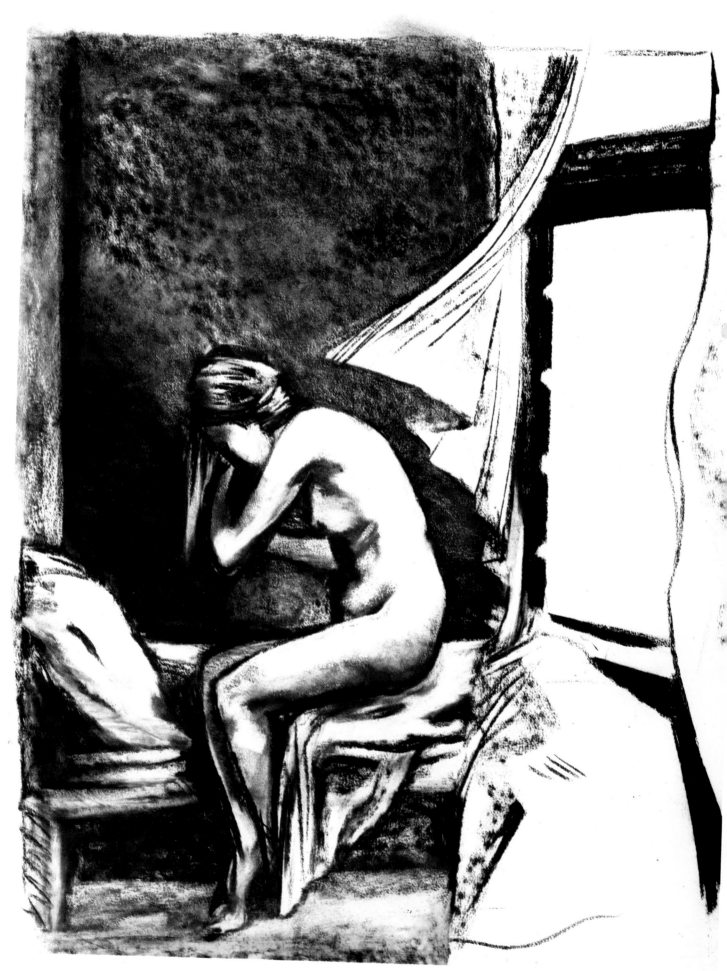

Above and above right The artist began by making a simple sketch with willow charcoal to place the different elements of the composition. The basic tonal structure was then laid in using a coarse block of charcoal, with the paper taped on a rough wall for a strong texture. The detailed modelling of the figure and

bed were not put in until the final stage of the composition. The background texture was then softened by lightly rubbing the surface with tissue, and some highlights in the hair were picked out with putty eraser (see Lesson 12). Charcoal is a forgiving medium, and many such adjustments can be made.

light areas, is similar to that used in etching. You sketch out the figure and composition – the area which is to be illuminated is left lightly drawn, while the areas in shadow are darker – and draw over both by cross-hatching with the flat of the charcoal. The best way to achieve crisp lights and deep shadows is to fix the drawing from time to time as you work, as this will prevent the dust from the charcoal turning the light areas into greys.

What you need to try for is a feeling of space and depth in the room as well as a pattern of light on the figure, so that the light moving across the room itself forms the composition. To do this you will probably have to give an indication of where the light is coming from, for instance a window, doorway or lamp. Cast shadows can be used to give depth and weight; an intense light source will throw a deep shadow. The light will touch various pieces of furniture in the room and may fall on part of a wall. A scene like this can sometimes be done in the life class if the lighting is satisfactory, but if not you could try drawing at home without a model to gain experience of composing with light.

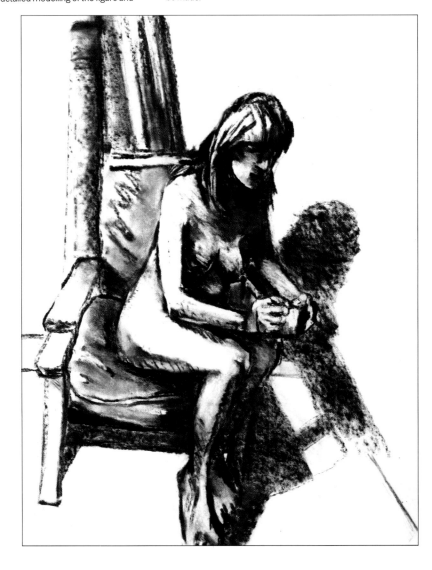

Left Unlike the other drawings in this lesson, where the light falling on the subject was the main compositional element, this also uses a cast shadow as a pictorial device: it and the shadows on the body itself bind the work together and give it mood.

Opposite Like the drawing on the previous pages, this is a composite, with the window copied from an etching by Edward Hopper. The figure is from an old sketchbook of the artist and the interior of the room and bed are invented. The soft

curve of the model's back set against the jagged angles of the billowing curtain give the composition its vitality.

It does not take long for a student to amass a large quantity of drawings, some successful and others less so, and this chapter provides some ideas on how you can "recycle" these. By turning existing work into monoprints, linocuts or collages you not only give the drawings a new lease of life but also take a step further in the direction of true artistic expression.

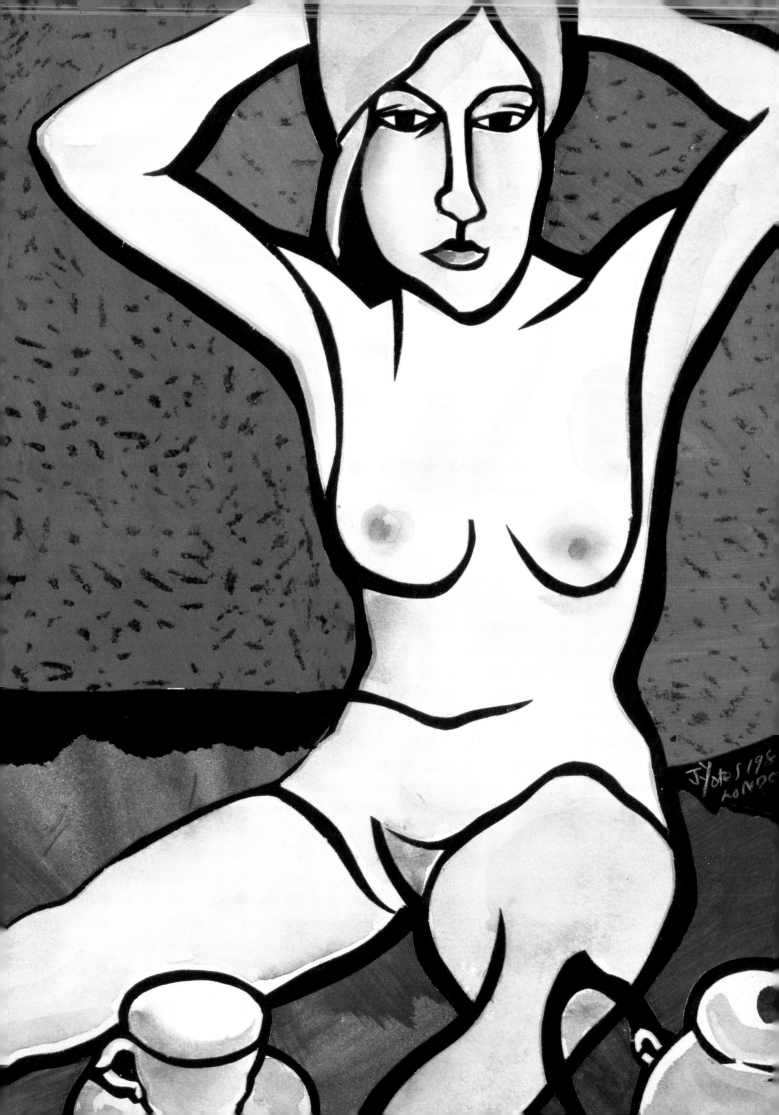

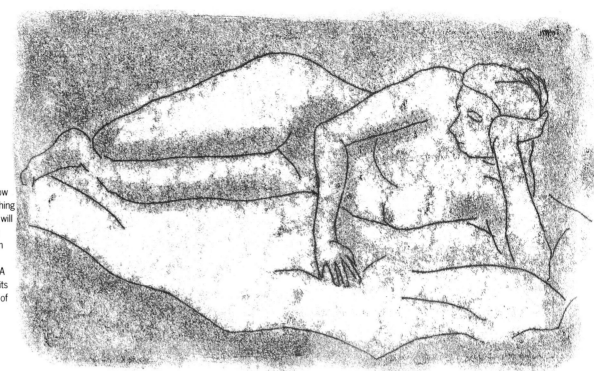

Above and below The drawing below was the basis for the monoprint; one thing you must remember is that the image will be reversed. Notice that the artist has made no attempt to copy the sketch in every detail, and has omitted the crosshatched modelling of the figure. A monoprint has a definite character of its own, and should not be seen as a way of reproducing a drawing.

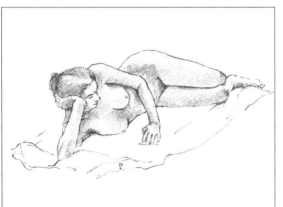

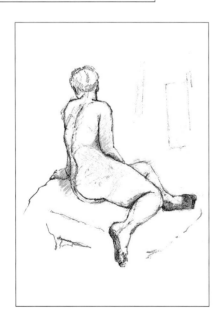

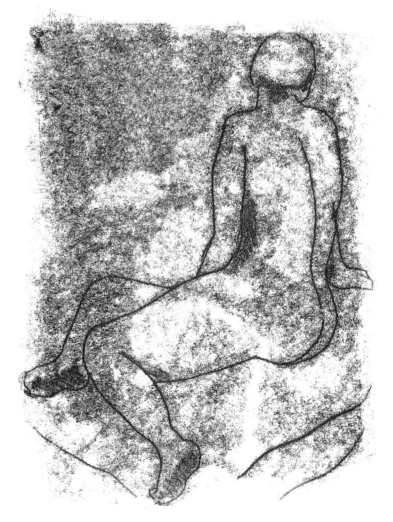

Above and above left You can use any colour of ink you like, and for this rather stronger drawing the artist has chosen black ink instead of the brown which suited the more delicate reclining figure. The choice of paper is an important factor also, as it is in any printing technique, and here a fine, absorbent Japanese paper, specially made for printing, has been used.

Monoprints

◄ **1** The basic materials needed for this method are a plate-glass slab, ink (or oil paint), a roller, a palette knife and printing paper.

► **2** A dollop of ink is placed on the slab with the palette knife preparatory to rolling out. Water-based lino-printing ink has been used in this case.

◄ **3** The ink is now rolled evenly over the area to be used for the print.

► **4** The paper is placed carefully on the inked slab.

Monoprints are a fascinating cross between painting and printmaking, extremely easy and very enjoyable to do – perfect for transforming a routine drawing into something that looks really professional and sophisticated.

There are a great many different ways of using the method, several of which are shown on the following pages. The pictures on these pages, however, have all been made by the "classic" monoprint technique, which involves inking up a plate glass slab, placing a piece of paper on top of it and then making a pencil drawing on it. Because you are applying pressure with the pencil, all the drawn lines will print, and some ink will come off onto the paper in other places, in a random and unpredictable way, providing an attractively textured background.

▲ **5** Using her sketchbook drawing as reference (see top photograph), the artist makes an outline drawing with a pencil.

▲ **6** Care must be taken not to rest your hand on the paper as you draw, as this will smudge, but small smudges can be made deliberately, as here.

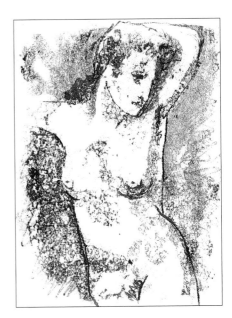

Above The attractive combination of drawn line and texture is a characteristic of the monoprint technique.

▲ **7** The paper can be lifted up to view the progress of the print. If more work is needed you can replace it on the slab as long as you have not lifted it away completely.

◄ **8** There is always an element of surprise in monoprinting, as the printed line looks very different to the rather mechanical drawn one.

▲ 1 The equipment needed for this method is the same as for the previous one, and the ink is initially applied with a palette knife, as before.

▲ 2 It is then rolled out to provide a smooth, even surface.

▲ 3 The drawing is made directly into the ink with a pointed implement.

▲ 4 A very thin Japanese paper was used for the print, as the artist was aiming at a delicate, linear effect.

▲ 5 The printing is done by lightly brushing the paper with a soft brush. Because of the fragility of the paper and the fineness of the line, firm pressure was not needed.

▲ 6 One side of the paper is peeled away to view the progress of the print. If satisfactory, it can now be removed completely.

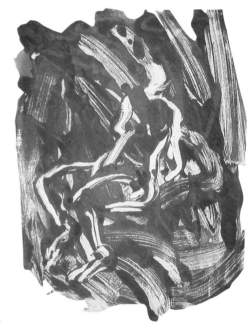

Right Here oil paint has been used instead of ink, and it has not been rolled but applied with a brush before being drawn into. The sweeping brushstrokes and broad lines give a strong feeling of movement to the composition.

▲ 7 The finished print. The artist has chosen quite a fine point for drawing into the ink, but any implement can be used, so it is worth experimenting with a variety of different ones.

Right The method used here was slightly different, as it is a combination of two techniques. When a print is made by drawing on the paper, as shown on the previous pages, white lines are left on the inked slab wherever ink has been pulled off the paper during printing. You can then make a "shadow" print from the same slab, which gives this attractive soft blurring.

Drawing into the ink

In this version of the monoprint method, the glass slab is rolled up with ink or paint as before, but the image is formed on the slab rather than on the paper. Any implement can be used for drawing into the ink, which produces white lines on the print. For broad, sweeping lines you could use a finger or thumb, for finer ones a paintbrush handle or the point of a pencil, and you can make interesting areas of texture with combs, toothbrushes or pieces of cardboard cut into serrated edges.

Above and above left The drawing was propped up behind the slab so that the artist could refer to it as she drew into the ink. Notice the variety of lines produced by different drawing tools, including a small, flat-ended wooden implement.

Left This print was produced by the drawing on paper method. Because of the pressure of the pencil, the drawing left white lines on the slab which yielded the "shadow" print opposite.

153

▼ 3 The cut-out shape is now placed in position on the ink. This will produce a negative image, as it acts as a block between the ink and the printing paper.

▲ ▲ 1, 2 The artist is cutting out a stencil from cartridge paper, which she will then place on the inked slab. An outline drawing can be done first as a guide, but she prefers to cut freehand, referring to one of her existing sketches, and using a scalpel, which is a very delicate and responsive instrument.

▲ 4 Because the paper is very fine and absorbent, much of the ink will adhere to it without any pressure. The artist wants some areas to be darker, however, so she rubs these gently with her thumb.

▼ 5 A few drawn lines are now made to reinforce the foreground and prevent the figure floating in space.

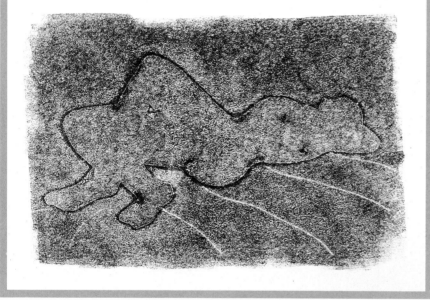

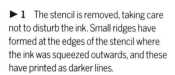

Above The same inked slab was used for this print, but this time without the stencil. The photographs below show how the effect was achieved.

► 1 The stencil is removed, taking care not to disturb the ink. Small ridges have formed at the edges of the stencil where the ink was squeezed outwards, and these have printed as darker lines.

► 2 Because there is less ink on the slab after a first printing, more pressure is needed to make the print, so a roller is used.

► 3 The white lines are caused by the earlier drawing (see **6**), as the pressure of the pencil removed most of the ink onto the printing paper.

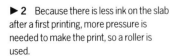

▲ 6 The paper is lifted to review progress.

▲ 7 The print is satisfactory, and the artist decides to try a further experiment (see left).

Stencil monoprint

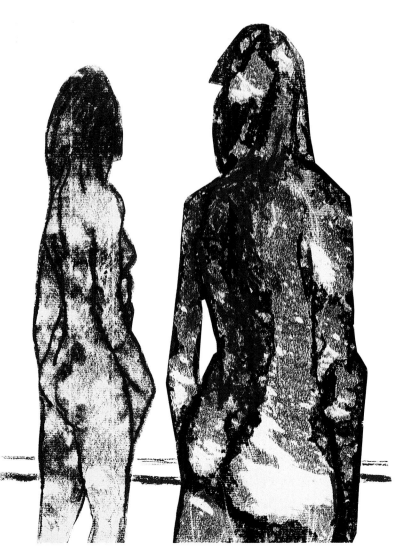

Stencilling is a very old technique: it was and still is used for printing textiles, and was for long a favoured method for patterning wallpaper and making decorative friezes on walls or furniture. In this context it is now undergoing a popular revival.

Basically the method is very simple: a shape is cut out and paint is pushed or dabbed through it. Stencils, however, can be negative as well as positive, making white shapes on a coloured ground. These "negative" stencils are the basis of silkscreen printing, where they are used to inhibit the flow of ink through the mesh onto the printing paper, and here a similar idea is explored by combining stencils with monoprinting.

Left This gives the effect of a stencil, although it was not done in the same way. Two separate prints were made, both on tracing paper, which the artist liked because its transparency enabled her to see the image forming below. These were then cut out and pasted onto cartridge paper. The size difference of the figures and the way they face one another makes a powerful composition.

Below This represents a second stage of printing. In the first, a stencil was cut and a negative image of the figure produced, as shown opposite. The stencil was then removed and the ink still remaining under it was drawn into by the method described previously (pages 150-1), thus producing what is in effect two monoprints in one.

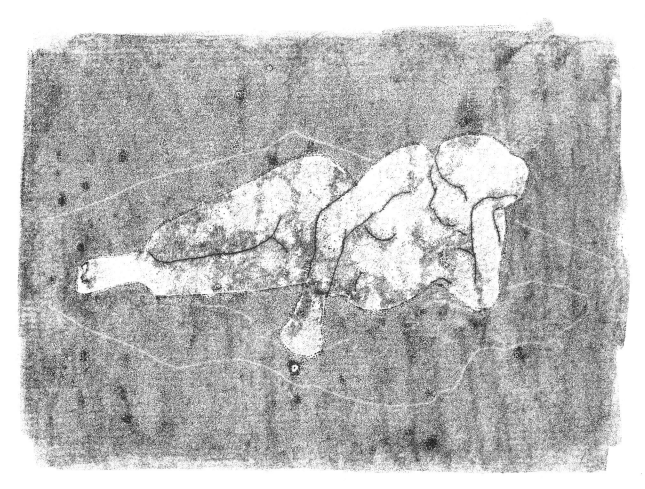

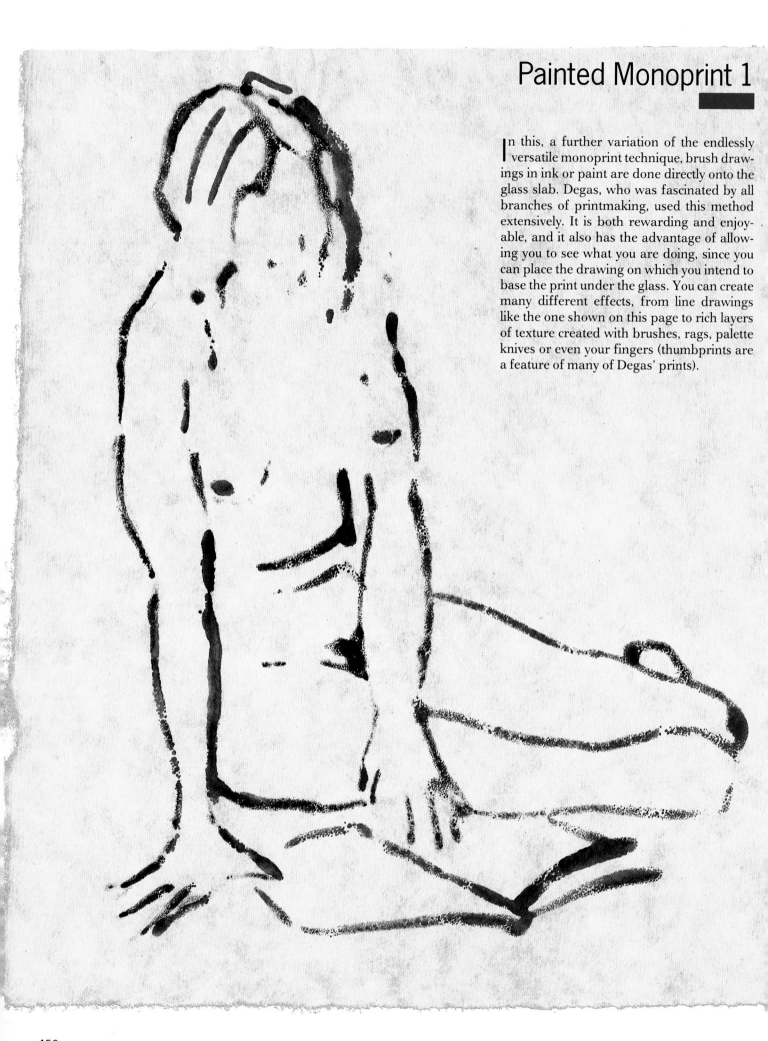

Painted Monoprint 1

In this, a further variation of the endlessly versatile monoprint technique, brush drawings in ink or paint are done directly onto the glass slab. Degas, who was fascinated by all branches of printmaking, used this method extensively. It is both rewarding and enjoyable, and it also has the advantage of allowing you to see what you are doing, since you can place the drawing on which you intend to base the print under the glass. You can create many different effects, from line drawings like the one shown on this page to rich layers of texture created with brushes, rags, palette knives or even your fingers (thumbprints are a feature of many of Degas' prints).

▲ **1** The artist began the brush drawing with her original sketch under the glass. She now removes it, having completed the main outline.

▲ **2** Having painted ink on the foreground area, she dabs into it with a cloth to provide some texture.

▲ **3** Fine Japanese printing paper is placed over the ink drawing.

▲ **4** The surface is lightly brushed to help the ink adhere to the paper.

▲ **5** The print is lifted off the slab.

▲ **6** The finished print, although quite promising, is perhaps a little pale, and the textured area in the foreground has not come out strongly enough to provide a contrast with the more linear work. A heavier paper and more pressure would have produced a darker, better-defined print.

Left This pleasingly simple drawing is enhanced both by the attractive broken line produced by the printing and by the colour of the paper.

Left In this example, as in the monoprint opposite, water-based ink was diluted so that it was quite sloppy, and thus quickly absorbed by the paper. A similar effect could be achieved by using oil paint, or oil-based ink, thinned with white spirit.

Painted Monoprint 2

▶ **1** For this technique you will need oil paints, brushes, a plate-glass slab, a palette (or another piece of glass), and white spirit for cleaning up.

The technique demonstrated here is an extension of that shown on the previous pages, but this is as much a painting as a printing technique, and oil paint is used instead of ink. Any of the various types of monoprint can be produced in more than one colour because you can print one over another, but painting on glass is a particularly direct way of making a colour print. It takes a little practice, since glass is much more slippery than canvas or painting board, and the paint tends to slide about. You will need to use it fairly thick, and avoid allowing the colours to mix too much on the glass, or you may find the print confused and muddy. It is easy enough to correct mistakes, however – all you do is wipe down the slab.

▲ **2** With the drawing placed under the glass, the artist begins by filling in the blue background and then the red foreground.

▶ ▶ **3,4** She then mixes a flesh colour, using a clean brush, and applies it to the figure.

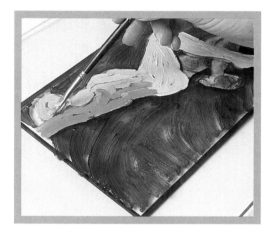

▲ **5** The edge of a piece of cardboard is used to scrape into the red area to provide a hint of pattern and texture.

◀ **6** The artist has not tried this method before, and although not entirely satisfied with the painting, she decides to take a print, so rubs the paper gently with her hand before pulling it away.

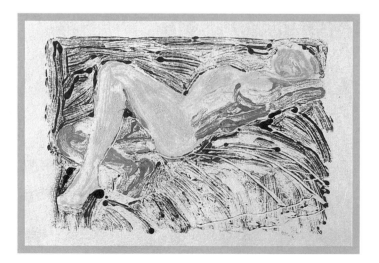

◀ **7** The print is surprisingly successful, looking much less crude than the painting itself. Because the paper picks up the top layer of paint, the brushstrokes have become an important element in the picture.

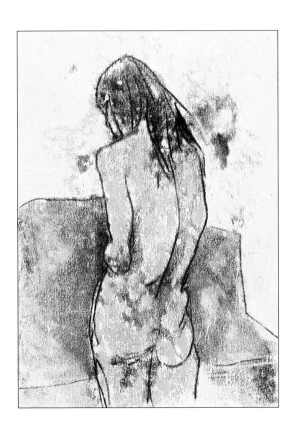

Right The same drawing can be used as a basis for several completely different treatments. This simple and energetic brush drawing, painted directly onto the glass slab, shows the same model and pose as the more intricately coloured and textured composition below.

Above One of the beauties of the monoprint technique is that you can take a print a stage further by working over it with any drawing or painting medium, and this monochrome print has been used as the basis for a sensitive study in pastel. The ink must be left to dry thoroughly for several hours, and you will have to choose a printing paper suitable for the final medium; this print was made on cartridge paper.

Above This artist specializes in painted monoprints, and has evolved many of her own methods. This is a more elaborate image than any of the others shown here, and was the result of several stages of printing, with further colours and textures added to the original painting on glass each time. Intriguing effects can be created, as the paint builds up on the glass to give different textures to the print. The white lines were produced by drawing into fairly dry paint with a brush handle. Some registration system is required for overprinting, but it can be very simple; all you need to do is tape one edge of the printing paper to the glass so that it can be lifted off and then replaced in exactly the same position.

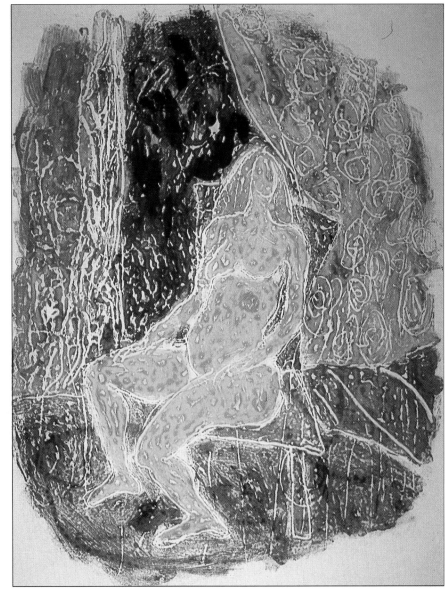

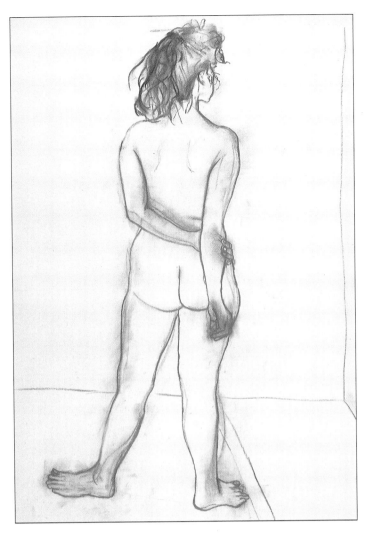

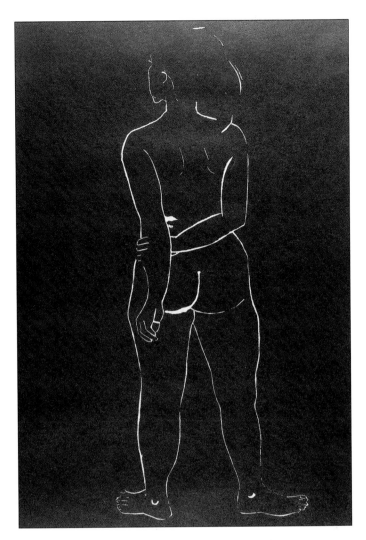

Above left Simple, strong images are most suitable for linocuts, as you cannot include as much detail as you might in a drawing. The artist has looked through her life studies and chosen one that will translate well into a print.

Above right This line print was taken from the first stage of cutting the block. The artist intends to develop the image further, but it is very successful as it is. Notice how the figure is given solidity by the variations in the thickness of the cut lines.

▲ **1** You do not need a great deal of equipment: the lino itself, the cutting tools (gouges), a roller and inks, and the printing paper are the only essentials, plus something to draw on the lino with.

▲ **2** In this case the artist has used a waterproof marker for the drawing. More intricate designs can be drawn out with Indian ink applied with a small brush, but the ink must be waterproof or it will smudge or rub off as you cut.

▶ **3** The fine outlines have been cut with a V tool, and now a broader, chisel-shaped one is used to remove larger areas. Whichever tool is being used, you must always cut away from you, and make sure never to hold the lino above where you are cutting. The tool can easily slip, and could seriously damage your hand.

Linocuts

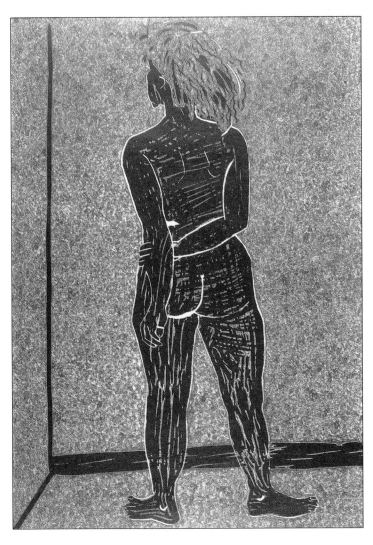

Above For the second stage, further work was done on the block, including cutting away much of the figure so that only the slightly raised areas left at the edges of each cut would pick up the ink. White ink was then printed over the original black, giving an attractive mottled grey.

Linocutting is the simplest type of relief printmaking, that is, the method in which the areas of the design which are not required to print are lowered by cutting away with hand tools. The beauty of the technique is that it allows you to take one or two rather indifferent drawings and turn them into an edition of prints with the minimum of expense. It is also valuable in that it forces you to revalue your ideas about composition since you are in effect producing a negative image – cutting away to form the light shapes. These can constitute the whole design, or you can cut around a shape, leaving a positive image. With a bit of experimentation you can learn to use a mixture of techniques and an intriguing variety of textures, from wide cuts to fine scratched lines and small punched holes made with a nail.

◄ 4 During cutting, you should rotate the block to make it easier to push the tool through the lino. With practice, you will learn which tools to use for which effects.

Right This is the block used for the final print shown above. Notice that the artist has chosen the direction of her cuts with great care, so that they help to describe the form. This is an important element in linocutting; the marks made by the tool are rather like the brushstrokes in a painting.

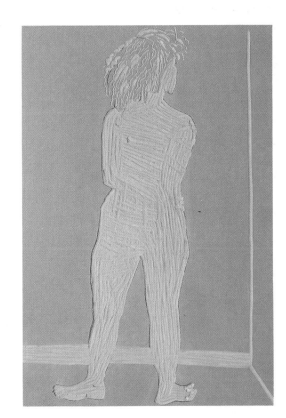

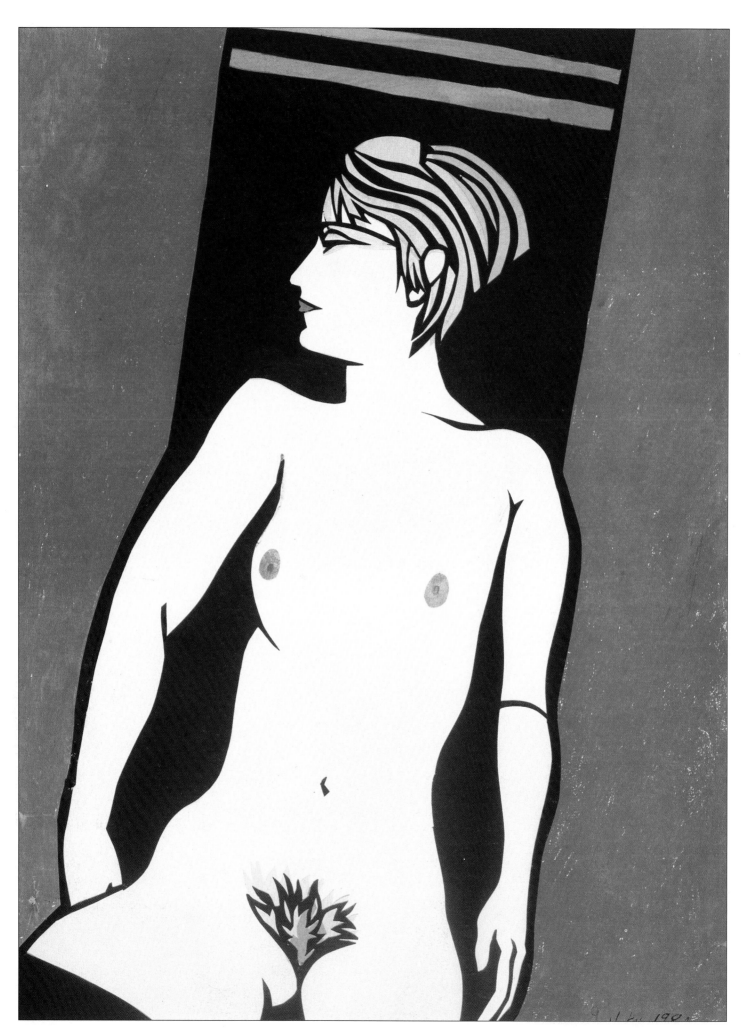

Papercuts

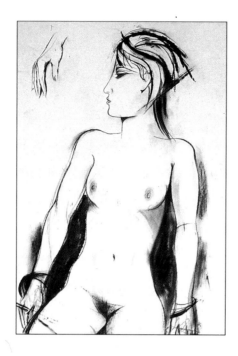

▲ **1,2** The drawing used as a basis for the papercut (above left) was redrawn in reverse and slightly altered to make a more interesting composition (above). Notice the sketch of the hand, which is to become an important element in the finished picture.

Papercutting is an ancient technique; for centuries in China the itinerant papercut artist was a well-known figure, rapidly cutting out colourful designs for the villagers' homes. The Japanese used similar pictures to decorate the Buddhist altars in their homes during New Year celebrations.

The work of Jack Yates, shown here, is a modern adaptation, combining this old Eastern tradition with the Western one of stained glass. He begins by cutting a design, which resembles a stencil, in black paper, and then slips other pieces of cut paper, sometimes hand-coloured and sometimes bought, behind the "window" formed by the original cutting. When he is satisfied, he pastes the coloured pieces in place on the reverse side of the black sheet.

▲ **3** A stylized chalk drawing is made on the back of the black paper. The shaded areas are to be left black; the white ones to be cut away.

▶ **4** The artist uses a special paper which is black on one side and white on the other. Plain black paper can be used instead, in which case the drawing can be made with a light-coloured pastel pencil.

◀ **5** Holding the scalpel like a pencil, the artist starts cutting from the top. This prevents the paper from tearing.

▼ **6** The more intricate areas are left till last to avoid damaging them. A scalpel is a very delicate instrument, and extremely precise cuts can be made.

▲ **7** The cut-out red paper shape, which has been hand-coloured, is placed over the central black panel and glued with PVA glue, used sparingly. The smaller yellow pieces are slipped behind the cut-out areas.

Left The completed papercut, with the yellow pieces glued into position between the black cut-out and a sheet of white cartridge paper. Final touches such as the lips and nipples are stuck directly onto the white paper.

163

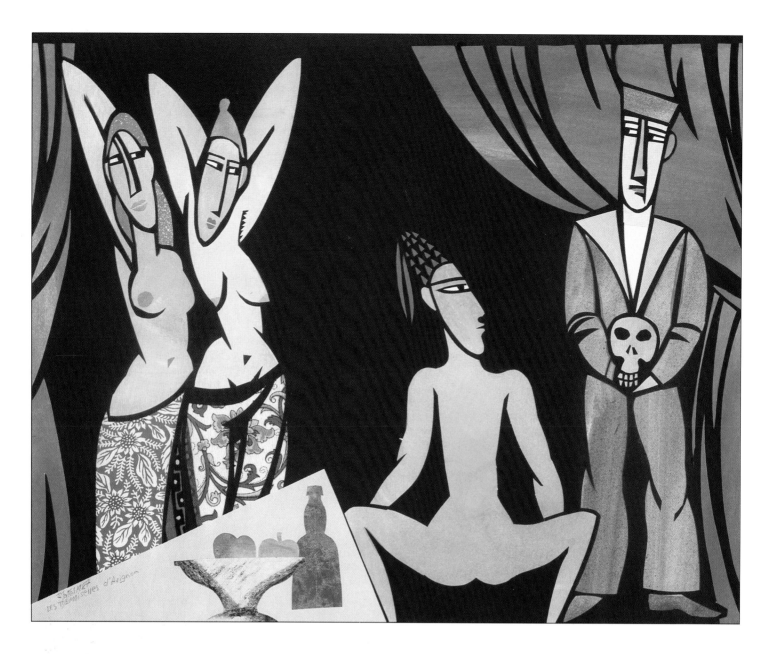

Above All the pictures on these pages are by Jack Yates, and all have been made by the same papercut technique, sometimes combined with painting and collage (see pages 166-7). Here washes of watercolour have been laid over coloured paper in places to build up subtle nuances of tone, and pieces of patterned fabric have been used for the skirts. The work is one of a series paying tribute to Picasso's painting *Les Demoiselles d'Avignon*.

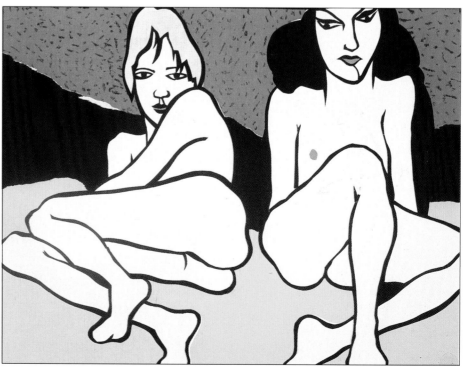

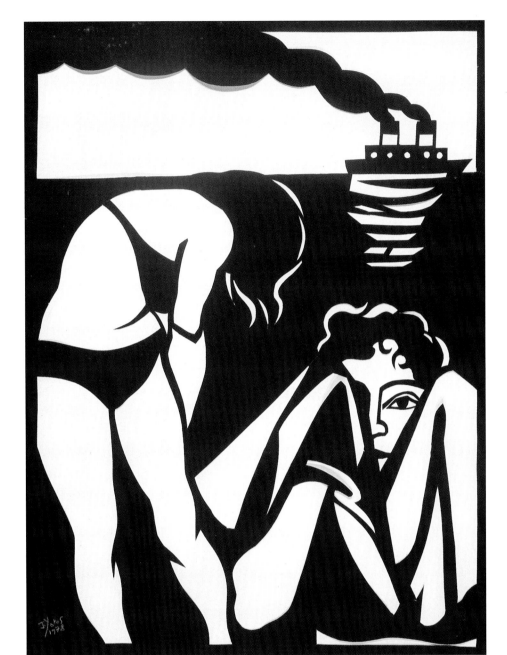

Left This black and white papercut is rather similar in appearance to a linocut (see pages 160-1), a technique Yates also uses, but because of the very dense, matt surface of the paper, it is crisper than a print. The action of cutting with a scalpel also produces a rather different kind of line, and can be used to make very precise, clean-edged shapes.

Below Here the face and parts of the body as well as the still-life objects have been painted in watercolour, and sweeping brushstrokes of gouache overlay the blue paper in the foreground and parts of the red-wallpaper background. The delicate watercolour work contrasts nicely with the stark black lines and vivid primary colours.

Left Technically, this is a simpler work than that on the right, with hand-painting restricted to the yellow hair. The red background is wallpaper, torn to give a slightly ragged edge. The composition is masterly: the eye is encouraged to travel through the picture, up and around the elegant lines of the limbs to the centre of interest – the serene gaze of the yellow-haired girl.

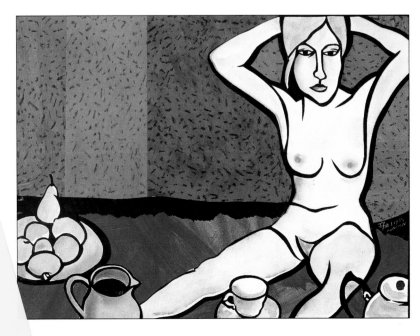

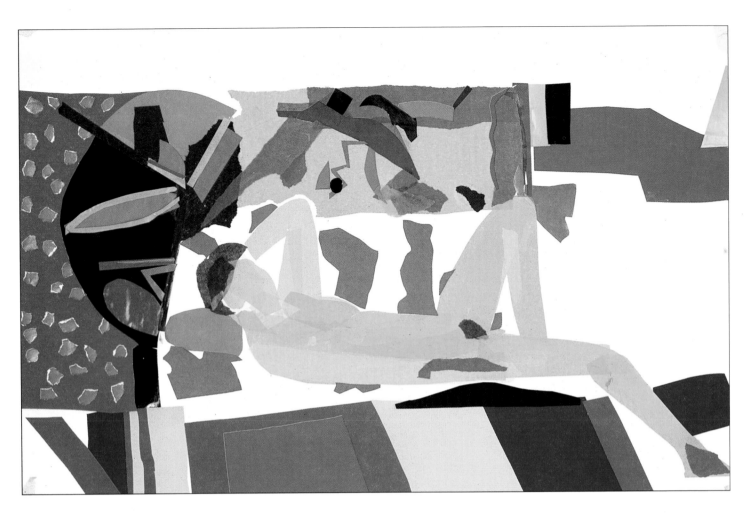

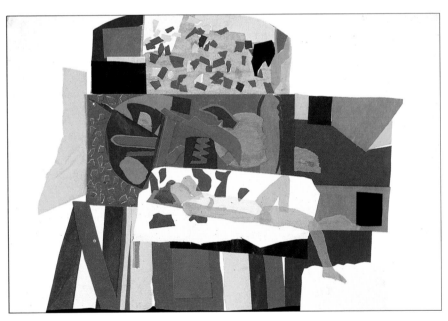

Top and above An advantage of using ready coloured paper for collages is that shapes can be cut out and assembled very rapidly, allowing you to try out several different treatments of the same subject. The example above, which is rather crowded and confused, was an experimental stage on the way to the top picture, a successful and well-balanced composition.

Right Here a much wider selection of collage elements has been used, including patterned paper and pieces of type, and some painting and drawing has been done on top of the glued-down pieces. The variety of textures greatly enhances the overall effect.

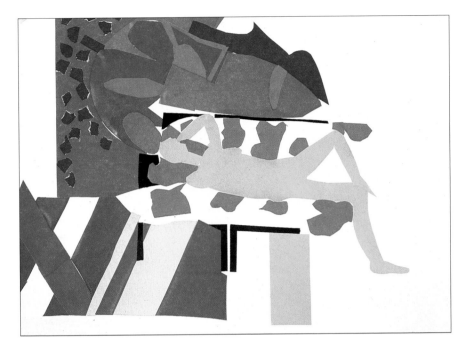

Collage

Collage is an exciting technique, and basically a very simple one, involving no more than cutting and pasting pieces of coloured paper (or fabric) to make a picture. You can use ready coloured or printed materials or, for more subtle effects, colour your own by drawing or painting on plain paper before cutting it.

The Cubist painters were the first to recognize the potential of the technique, incorporating in their paintings some of the detritus left in cafés, such as fragments of theatre programmes, pieces of newspaper and bus tickets. Today we are even more inundated with printed matter in the form of newspapers, magazines and catalogues, and collage provides the perfect method of recycling such throw-away materials.

Any drawing can be used as the basis of a collage, and you can play with a myriad of elements, from fine lettering, photographs and textures to plain paper. The key is the word "play"; let your imagination run free and you will discover completely new ways of creating an image. You can also use the technique as a preliminary planning stage, working out a composition with paper shapes as shown in Lesson 19.

Top Another preliminary investigation of the subject shown on the facing page (opposite top), also done with coloured paper.

Left For this delightfully lighthearted composition, the artist has combined sensitive drawing and painting with pieces of fabric and textured paper. Anyone seriously interested in collage should try to amass a collection of suitable materials, as you need to have as much as possible to choose from. And never throw away old drawings; even if not entirely successful, they can often provide a starting point for a collage.

Right The outline brush drawing was made with coloured ink. When this was dry, white wax crayon was rubbed vigorously into the area to remain light coloured, and a wash was placed over the whole drawing.

Below A bamboo pen was used for the drawing, and again white wax crayon for the highlights. The wash was lighter in this case in order not to submerge the drawing.

Far right A similar method was employed here, with the addition of pinkish crayon on the body. For variation, pale blue crayon was also used for parts of the background, and dark ink was dropped into the grey watercolour wash while still damp.

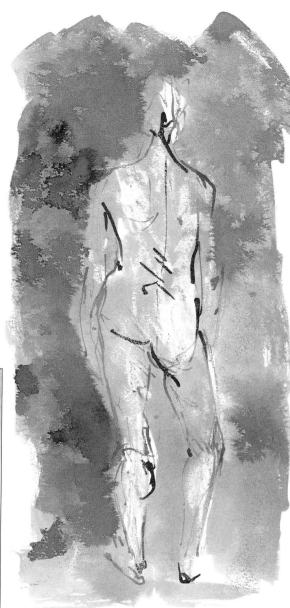

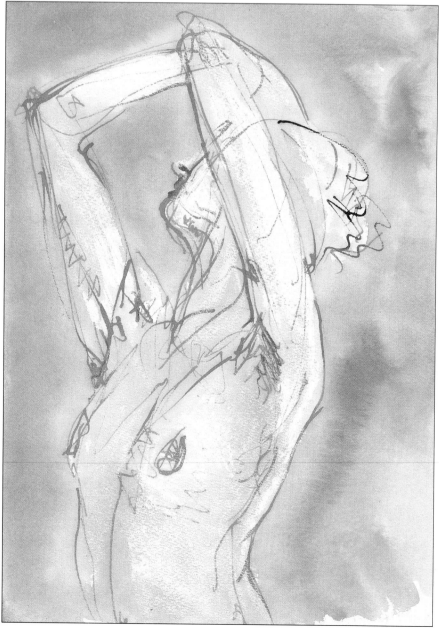

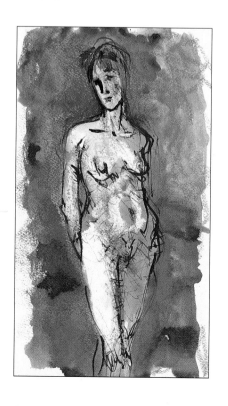

Wax resist

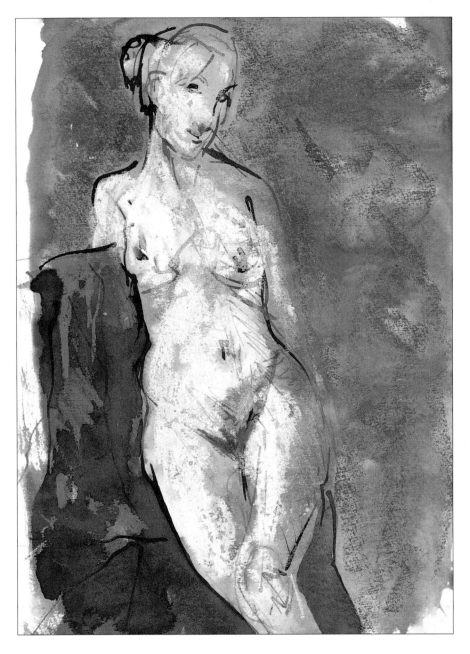

ike lithography, wax resist is based on the principle that oil and water do not mix. If you draw or scribble on paper with wax crayons or an ordinary household candle and then overlay this with a wash – either ink or watercolour – the latter will slide off the waxed areas, leaving them light in tone. The sculptor Henry Moore, also a draughtsman of great brilliance and imagination, developed the technique in his Shelter Sketchbooks (see page 143), and it is now extensively used both for wash drawings and watercolour paintings.

Wax resist is a robust and forgiving technique as well as an enjoyable one, and is thus ideal for improving old sketches. It can also be used when working directly from life. In this case, begin with a basic drawing in pen or brush with Indian ink or coloured inks (I prefer the latter as they dry quickly and will not be smudged by the crayon). A light-coloured crayon (or candle) is then rubbed into the areas which are to remain light and a wash is laid on top, with a soft brush or even cotton wool. Several colours of crayon can be used to lay in a background if desired, and a tapestry of colour can be built up with two or more overlaid washes.

Exactly the same technique can be used with existing drawings, but if these are in charcoal or pencil the lines must be drawn over with ink to strengthen them and prevent them being submerged by the wash. Or they could be reworked with a dark crayon for an interesting variation.

Right and above The drawing on the right is the first stage of that shown above. The figure has been drawn in bamboo pen on watercolour paper, white crayon used on the figure, and brown and blue on parts of the background. A grey wash was then laid over the whole drawing, and a deeper blue and yellow added to the background while still damp. Notice the effect of the drapery on the left, where the vivid blue crayon marks come through the darker blue watercolour.

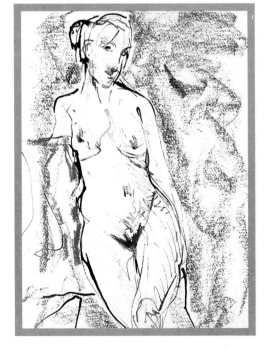

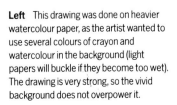

Left This drawing was done on heavier watercolour paper, as the artist wanted to use several colours of crayon and watercolour in the background (light papers will buckle if they become too wet). The drawing is very strong, so the vivid background does not overpower it.

Picture making

Trouble-shooting

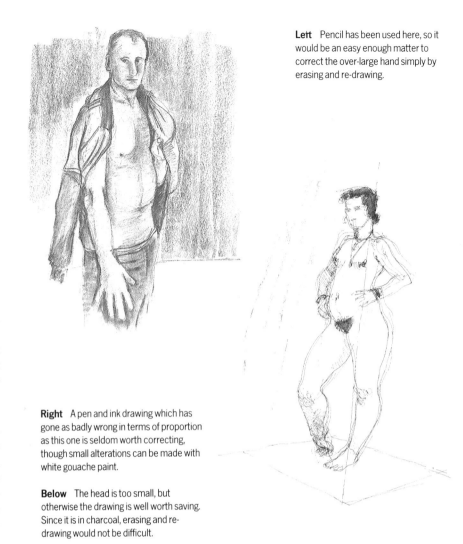

Even famous artists are often dissatisfied with their work. Matisse destroyed countless drawings, and the great Japanese artist Hokusai lamented shortly before his death at the age of 89 that had he but lived another five years he might have mastered his craft.

The ability to be critical of one's own work is part of the learning process, and artists have developed many methods to improve and analyse their drawings and paintings. It is vital to know how to diagnose mistakes; you will learn nothing if you yield to the urge to throw a failed drawing into the bin. Unless you understand where you have gone wrong you will repeat the same errors again and again. This will slowly erode your confidence and enjoyment in your work.

Right A pen and ink drawing which has gone as badly wrong in terms of proportion as this one is seldom worth correcting, though small alterations can be made with white gouache paint.

Below The head is too small, but otherwise the drawing is well worth saving. Since it is in charcoal, erasing and re-drawing would not be difficult.

Checking for mistakes

The mirror method If you hold the drawing up to a mirror the reversed image will be less familiar and thus easier to see critically. One of the problems in checking for mistakes is finding a new way of looking at the image, so enabling you to see it afresh. The mirror check is also useful if you are slightly astigmatic, since the axis of your astigmatism will be reversed, and any distortion will become apparent.

The measuring method Check the proportions of the figure, using the head from your drawing as a measurement. Depending on the model, the figure should be between six to seven and a half heads high. For a standing pose, check that the half-way point – the pubic area – is correctly placed, and also measure the hands and feet. A common error is making these too small. The foot, seen from the side, is roughly one head in length, while the hand will cover the face from chin to forehead.

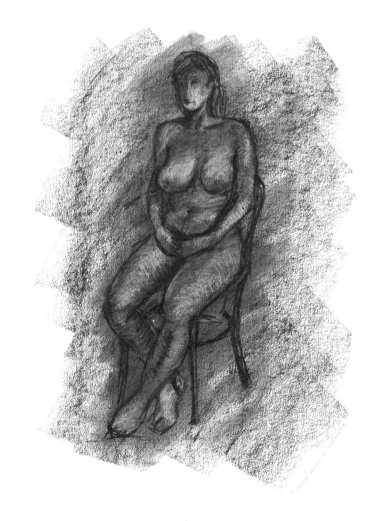

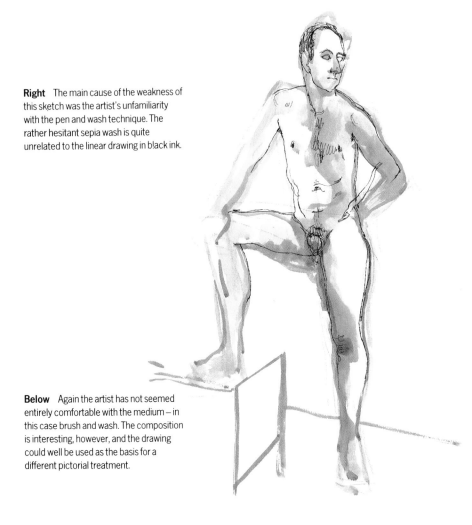

Right The main cause of the weakness of this sketch was the artist's unfamiliarity with the pen and wash technique. The rather hesitant sepia wash is quite unrelated to the linear drawing in black ink.

Below Again the artist has not seemed entirely comfortable with the medium – in this case brush and wash. The composition is interesting, however, and the drawing could well be used as the basis for a different pictorial treatment.

Checking the balance If a standing figure looks awkward, draw a line down from the balance point – the pit of the neck, or the middle of the ear for a side view. The weight must fall on one foot or between the feet; if the balance line falls beyond the feet the figure would be unable to stand. Check also to see if the hips and shoulders are at the proper angles; with the weight on one foot the hip over that leg will be pushed up, while the shoulder will drop down slightly to counterbalance the body. If the weight is equally on both feet the hips and shoulders will be straighter.

Tracing Another method of checking for mistakes is to make a tracing of the drawing, using a soft, dark pencil, a 4B or 6B. When you have finished the tracing, turn it over and put a piece of clean white paper under it so that you can see it more clearly. As in the mirror method, you should be able to see any mistakes in the reversed image. The advantage of this system is that you can try out corrections on the tracing paper to make sure they work before committing them to the drawing itself.

Assessing the strength of a drawing

Artists and illustrators whose work was to appear in printed form used to look at it through a reducing glass to see "how well it held up." The modern equivalent is to make a reduced – or enlarged – photocopy. If parts of a drawing are too light they will drop away and the wholeness of the sketch will be lost. This method has interesting possibilities: you could try adjusting the photocopier to its darkest tone to see what your work would look like if you used a heavier line – it might be a revelation.

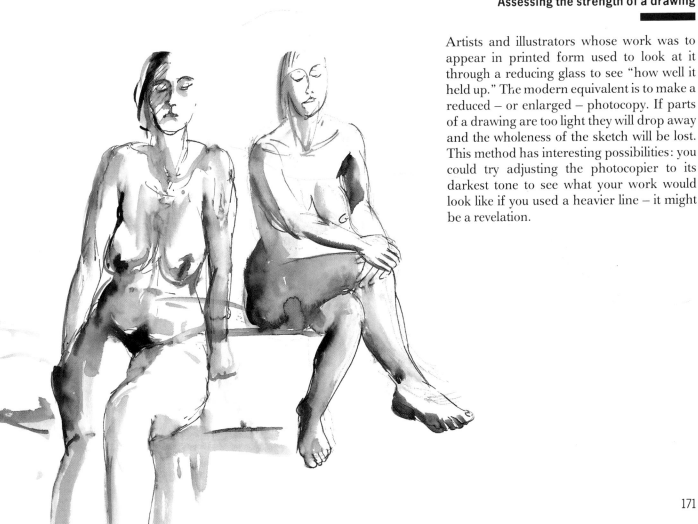

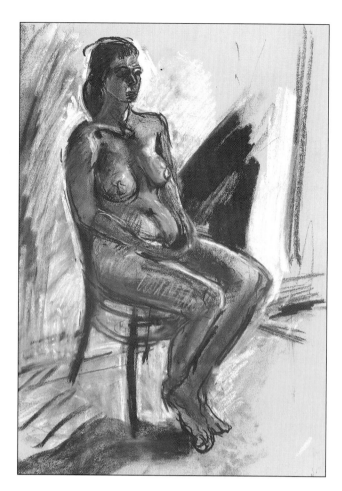

Checking the tone and composition

Up until now we have been looking at mistakes in drawing. When you begin to put the figure in context new considerations of composition must be met. There are generally two problems, placement and tone.

If a work looks dull or static it may be that you have placed the centre of interest too squarely in the middle of the page, or made all the shapes in the work more or less the same size. Either or both of the above will create a monotonous effect and thus deaden the composition. If the drawing looks awkward, on the other hand, you may have destablized the composition by putting the figure too close to the edge of the paper or by cutting off a limb at the side of the page. This can cause the eye to follow the line of the limb and be drawn off the paper.

A good balance of tones, the lights and darks in either a colour or a monochrome composition, is equally important; they should provide a strong structure for the design of the work. The larger the work, the more important tones become in holding it together. To check the tonal balance, hang the work upside down and if possible lower the light in the room. If this is not possible, half-close your eyes so that you see only lights and darks, with no distracting detail. This will help you judge whether the composition of the tonal structure is strong enough. Generally you want to avoid a "bitty" look, with small, weak shadows scattered about with no sense of design. Nor do you want a composition where the weight of tone is concentrated at the edges or in just one area.

Making the corrections

Having established what is wrong with a drawing the next step is making the corrections cleanly and with as little damage to the paper as possible. For charcoal or pastel, fresh bread is by far the best eraser I know of. The slight moisture in the dough lifts off the colour cleanly, whereas other erasers tend to smear it and push it into the texture of the paper. Heavy pencil or conté may need a putty eraser or soap eraser, but here again it is worthwhile to go over the erased area with bread to give it a last, even finish.

Small corrections in Indian drawings can be made by carefully scraping off the line with a sharp blade. Care must be taken not to make a hole in the paper with the tip of the blade, however. Corrections in a brush drawing are best done with white gouache, and if tinted paper has been used colour can be added to match the background.

To correct bad placement, for example if

Below This promising picture was left unfinished due to lack of time in the life class, something that happens all too frequently. Because all the dark tones are concentrated at the front, it looks unbalanced, but some further work on the background, with areas of tone added, would stabilize the composition.

Above The composition and distribution of lights and darks are both excellent, though the drawing is slightly shaky in places. This is well worth saving, and would make an excellent monoprint (see pages 150-59).

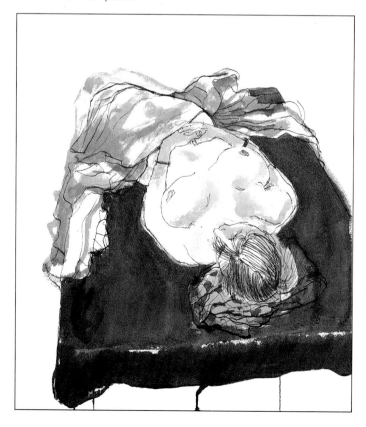

the figure is too central or not central enough there is no reason why a piece of paper should not be neatly added. Many of Rembrandt's lovely pen and wash landscapes are done on joined paper. In fact he probably joined the paper for economic reasons, but the practice still provides a lesson for us – the important thing is understanding the problem and saving the work.

Below There is not much wrong with this charcoal sketch except for the bad placement, giving rise to uncomfortable cropping of the feet. An extra piece of paper could easily be joined on, and the feet completed.

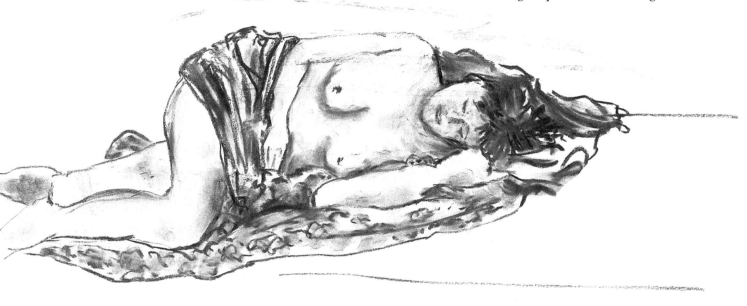

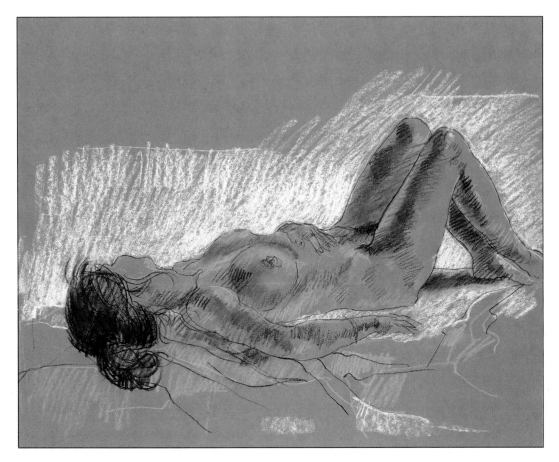

Left This also suffers from bad placement, but is otherwise excellent. Again, a new piece of paper could be joined on, but alternatively the drawing could be cropped just beyond the knees. This would make a more pleasing composition than the existing one, where the eye tends to follow the incomplete feet out of the picture. Your drawings can often be improved by deliberate cropping, so never rule out this possibility.

Index

Credits

Quarto would like to express their gratitude to the following artists and students who kindly agreed to provide drawings and other works for this book:

Chloë Alexander; David Carr; George Cayford; Moira Clinch; Diana Constance; Rania Georgopoulous; Ben Gifford; Ingunn Harkett; Hazel Harrison; Penny Leyton; John Petti; Paul Vining; Jack Yates.

Quarto would also like to thank the M.O.T. model agency and all the models who posed for the life drawing sessions set up for this book.

Quarto would also like to thank the following for providing photographs, and for permission to reproduce copyright material. While every effort has been made to trace and acknowledge all copyright holders, we would like to apologize should any omissions have been made:

P.6 Cabinet des Dessins, Louvre (photo R.M.N); **pp.41, 47, 70, 81** Reproduced by courtesy of the Trustees of the British Museum; **p.42** Musée Rodin, Paris (photo Bruno Jarret); **p.96** Staatliche Graphische Sammlung, Munich; **p.98** Musée Condé, Chantilly (Photograph Giraudon); **p.103** The National Gallery, London; **p.115** Graphische Sammlung Albertina, Vienna; **p.129** The Detroit Institute of Arts, Bequest of Robert H. Tannahill; **p.133** The Courtauld Institute of Art, London; **p.139** Marlborough Fine Art, London; **pp.143, 129** Reproduced by kind permission of the Henry Moore Foundation.